in the company of stone

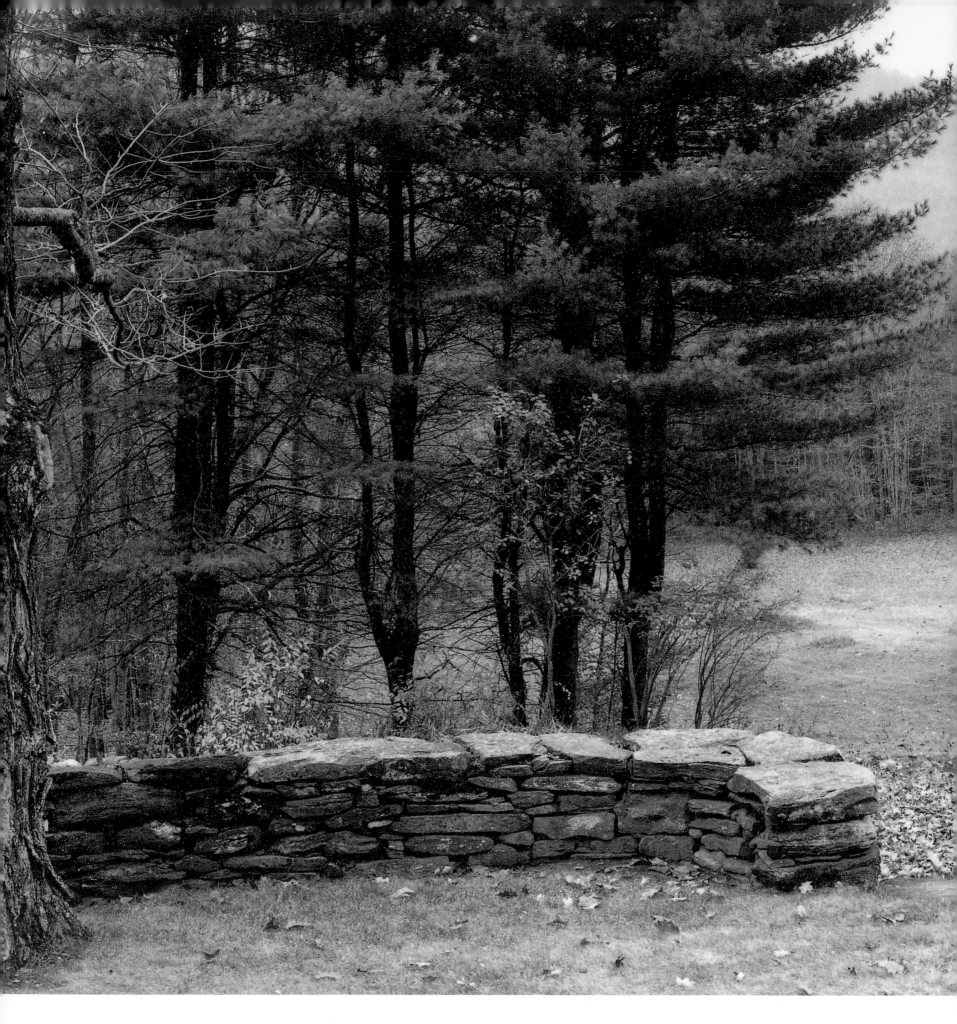

in the company of stone

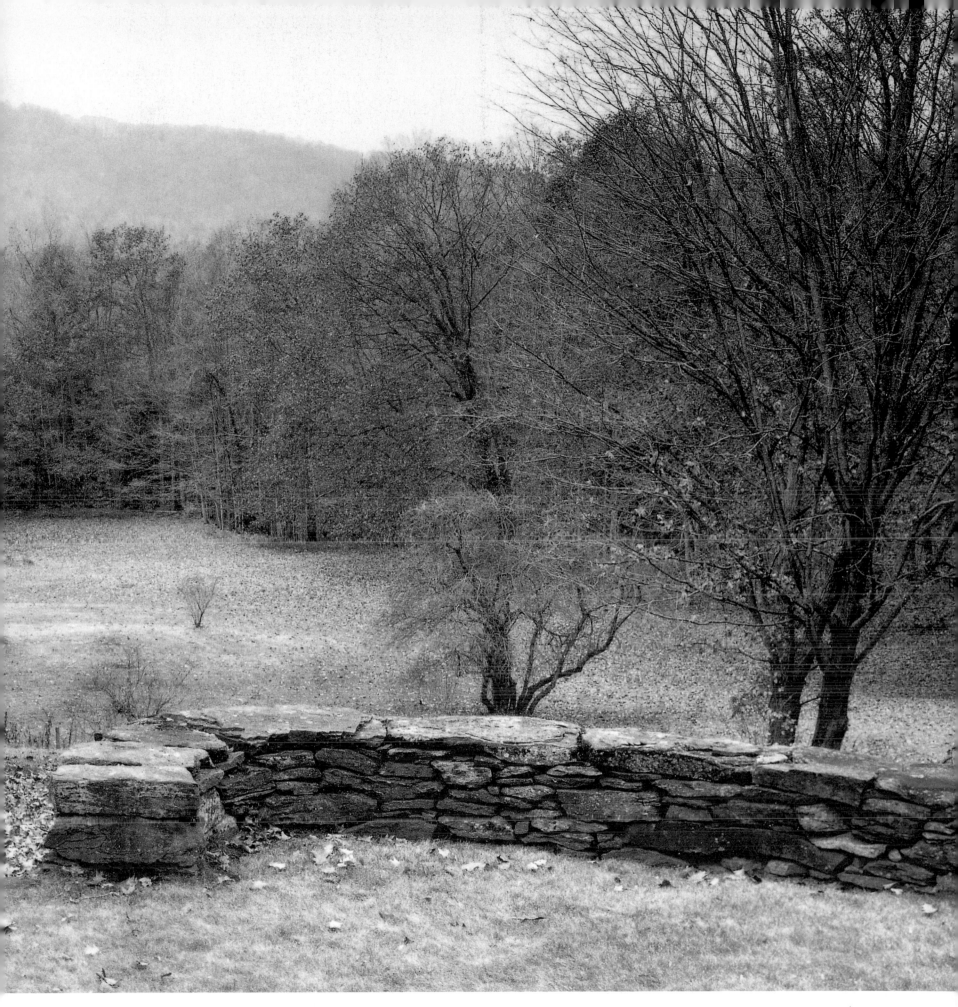

THE ART OF THE STONE WALL

walls and words • Dan Snow photographs • Peter Mauss

artisan | new york

This book is dedicated to Albert H. McAuslan, Jr., our splendid friend and neighbor. He truly loved to help all of us, he made it look effortless, and he left the impression that we had done him the favor.

Text copyright © 2001 by Dan Snow

Photographs copyright © 2001 by Peter Mauss
Photograph of Peter Mauss on page ix, copyright © 2001 by Tom Thornton

Published by Artisan
A Division of Workman Publishing Company, Inc.
708 Broadway, New York, New York 10003–9555
www.artisanbooks.com

Library of Congress Cataloging-in-Publication Data

Snow, Dan.
 In the company of stone : the art of the stone wall : walls and words / Dan Snow;
 photographs, Peter Mauss.
 p. cm.
 ISBN 1-57965-134-8 (hardcover) ISBN 1-57965-150-X (paperback)
 1. Dry stone walls. I. Mauss, Peter. II. Title.

 NA8380 .S66 2001
 624.1'832—dc21

 2001018903

Printed in Italy

10 9 8 7 6 5 4 3 2

Book design by Dania Davey

On a knoll in the woods not far from this piece, there is a half circle of standing stones. Local lore tells that it is a prehistoric Native American campfire site. No one really knows who built it, or why, but one does get a feeling when standing there that spirits inhabit the site. I sometimes wonder what will be thought of the stone structures I've built, long after the memory of their construction has passed. It didn't take long for this construction to be dubbed "the Flintstones' picnic table."

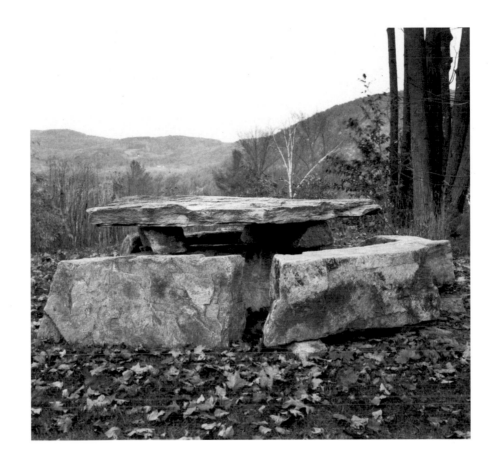

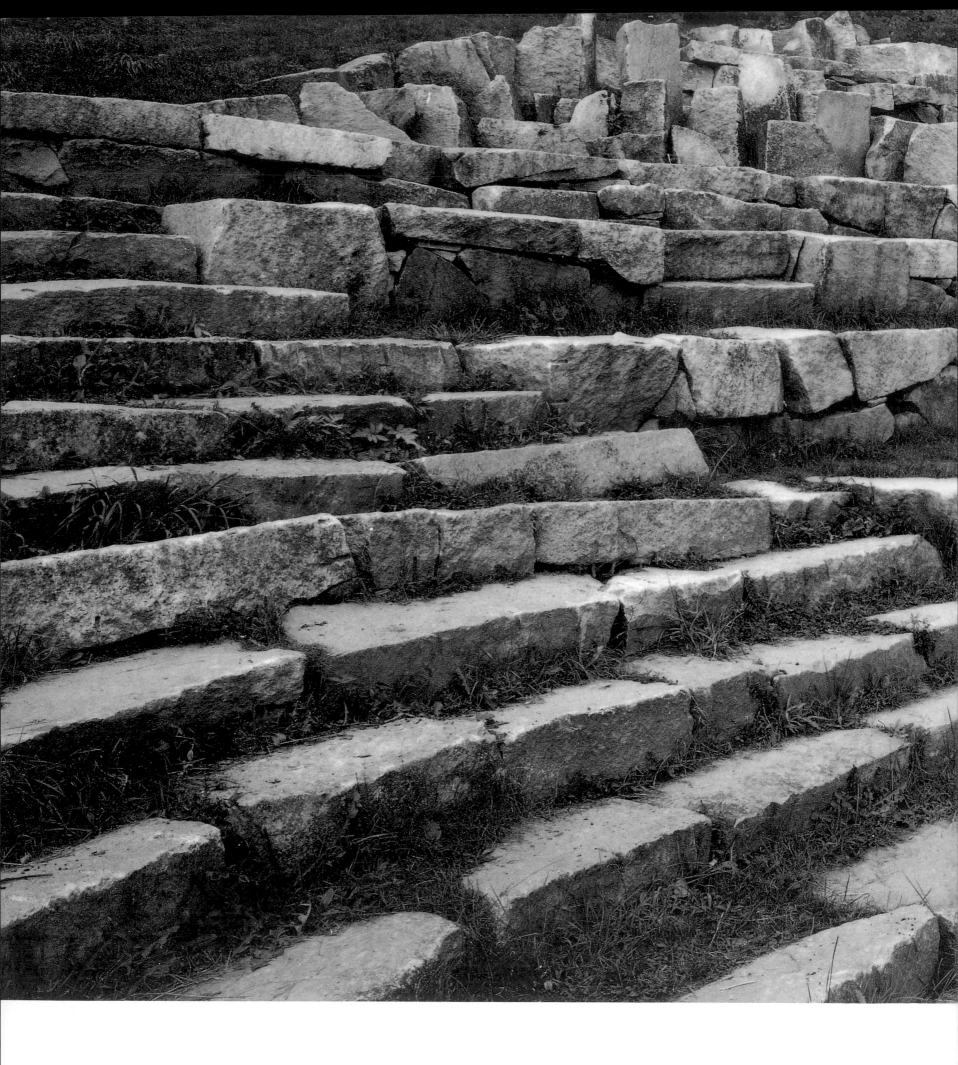

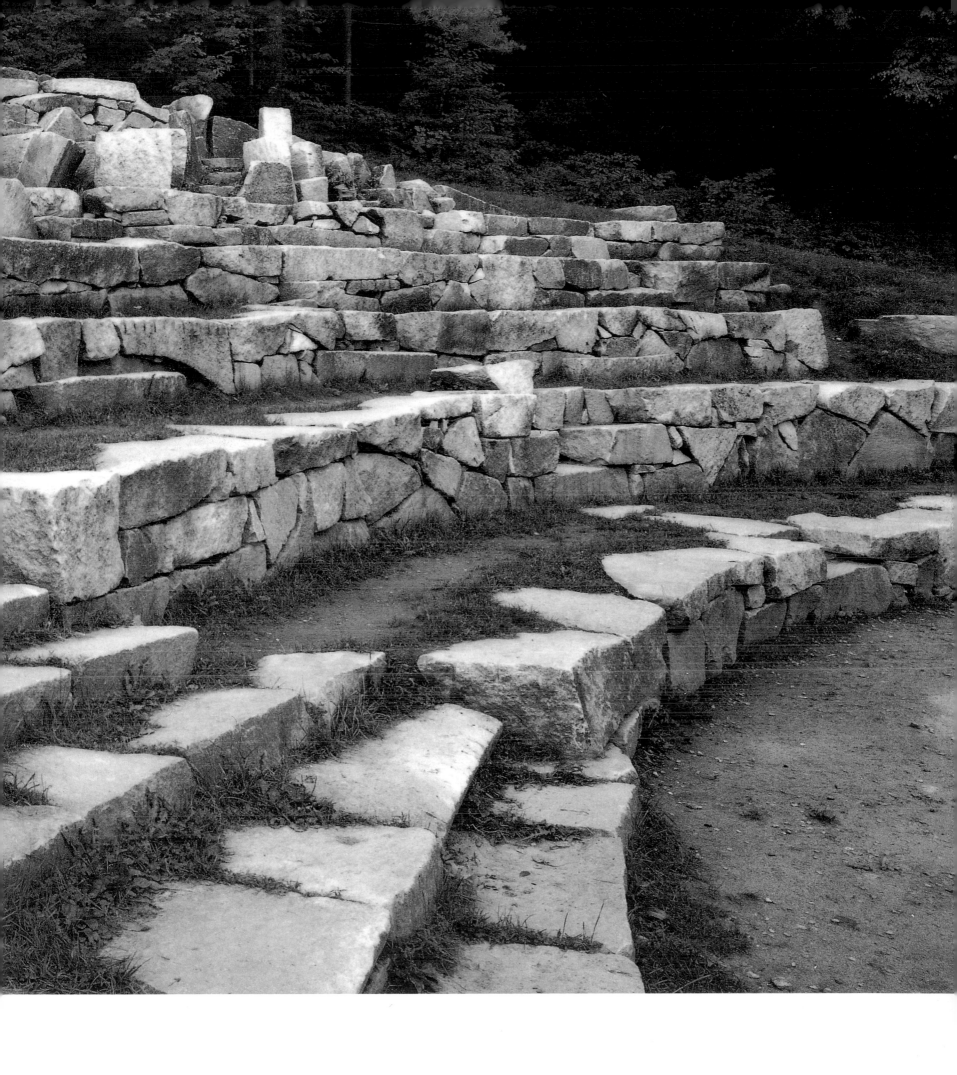

I could say that drystone walling is a silent and solitary pursuit. In the text of this book there is plenty of evidence to support such a claim. But that's just not the way it is. Throughout a day of walling, as the light of the sun comes from below the horizon or is subdued from above by clouds, crickets bow their wings in symphonic harmony. When the sun breaks out, the day is further brightened by songbirds in solo performance. The importance of these subtle additions to a waller's "soundscape" needs cannot be overstated. The air is infused with the music of these tiny creatures.

Just as it is never really silent, a day of walling is never completely solitary either. Friends and family surround me; their caring and love bring joy all day long. This page is a happy chance for me to acknowledge their gifts.

The things of beauty on the following pages are the accumulated efforts of many people. There is a choreography of earth- and stone-moving as I prepare to wall, and thoughtful gardening that follows.

PAGES VI–VII: **A quarry in my town was once a major supplier of granite to the building and monument industry. Mountains of grout (cutting waste) are all that remain of the once-thriving business. Some of the castoffs were collected and trucked to a town-park softball field, where I fashioned them into bleachers on a slope behind home plate. The discovery of worth where it hasn't been noticed before is the art of drystone walling.**

The Clark brothers, Archie and Win, have literally moved mountains for me. They have always gone the extra mile to satisfy my whims. As Win says, "We can do the impossible; it just takes longer!"

Many gardeners, including Gordon Hayward, have designed and planted the gardens around the walls. Gordon designed the "barn ruin" garden and identified the plantings in the captions.

Besides the places I take stone to, there are the places I take stone from. Three families have been particularly generous: Mary and "Shorty" Forrett, Ann and Jonathan Tobey, and Carol and Jerry Ward. More important, they have offered me their trust, and for that I am eternally grateful.

I have had the good fortune to be invited into the worlds of fellow wallers and dykers in England and Scotland. In addition to being part of their work worlds, as a guest in their homes. I have been made to feel a part of their families. To Nick Aitkin, Steven Allen, Philip Clark, Dave Goulder, John Fielder, Allan Jones, Norman Haddow, Steven Harrison, Neil Rippingale, Michael Weitzner, and Jacqui Simkins, thank you.

There is a very special group of individuals who may not be familiar with each other, but in my mind they are an irrepressible whole. "Customers" isn't really the word I want to use for the people who have allowed me to construct with stone on their land. "Boosters," "supporters," or "believers" is perhaps a better word to describe them—with the enthusiasm they express for my work. I won't attempt to list everyone, but I want to mention a few—you've all been wonderful to me over the years, and I thank you from the bottom of your walls: William Ackerman, Teddy and Peter Berg, Barbara and Ernie Kafka, Mallory Lake, Phyllis Odessey, Peter Mauss, Joan and Nicholas Thorndike, Peter Hetzel, and Carol Schnabel.

I wish to add a few personal notes that are both outside of stonework and at its very core.

To my teachers, George Laine and David Lee Brown, thank you for giving your time to young people.

For sharing with me the miracle of a daughter's birth, I thank you, Connie.

For showing me that wisdom is with us from the beginning, I have Angela to thank.

I am grateful to my mother and father for putting a foundation under my feet. Thank you, Ann and Leslie.

When I was growing up, my younger brothers, Doug and Les, were loyal companions and durable playmates. When we weren't fighting, we were on each other's sides. Thanks, guys.

Ed, you taught me that the less one has, the more one has to give.

For the hardest laughs of my life, I am indebted to Karen and Rebecca.

Thank you, Will, for not flinching in your friendship and for staying close every time I've fallen flat on my face.

Thank you for your enduring tenderness, Elin.

—DAN SNOW

Waller and photographer at the top of their games

I would like to extend my heartfelt thanks to the following people, without whom the photographs for this book could not have been realized. My wife, Phyllis Odessey, whose sure sense of style and constant encouragement have so thoroughly influenced me; my parents, Ev and Irv Mauss, whose consistent nuturing of my work has been genuine and generous; Ezra Stoller, whose wonderful images proved to me that art and commercial work can coexist seamlessly; to my sister, Susan, and her husband, Paul Tunick, whose rapture for the visual arts is highly contagious and has been an inspiration for four decades; Erica Stoller, whose advice, acumen, and unflagging support have steered me through many years and assignments; Virginia and Peter Vogel, whose friendship and laughter have buoyed me through good times and bad; Peter Aaron, whose masterful photography, perpetual innovation, and generosity of spirit have delighted and stunned me time and again; Carlos Richardson, whose unsurpassed gifts as mentor and teacher are truly matched by his skills with the camera; Leland McCoy, whose early enthusiasm and encouragement had immeasurable impact; Richard Haas, whose support, friendship, and art have been a continual boon; Cathy Kurland, whose enthusiasm and friendship have smoothed the way from early Vermont to New York; Burr, whose wide ranging pursuits, from barefoot mushroom gathering to globe-trotting transit research, opened our eyes and commanded our admiration; Dania Davey and the staff at Artisan, whose keen eyes and attention to detail have pulled this project so smoothly together; all the home owners, who have graciously allowed me to photograph their projects and to share their pleasure in stone; and finally, Dan Snow, whose unique vision and ways with stone continue to amaze and inspire me, challenging my ability to describe them.

—PETER MAUSS

This is a very old story.

One that has been told many times before. Here I am, about to tell it again, believing it is my own contemporary tale, just as every teller before me has believed it to be his or her own.

The same inscrutable mystery lies at both the center of a stone and the core of the earth. Standing in the hollow interior, the mystery comes alive for me.

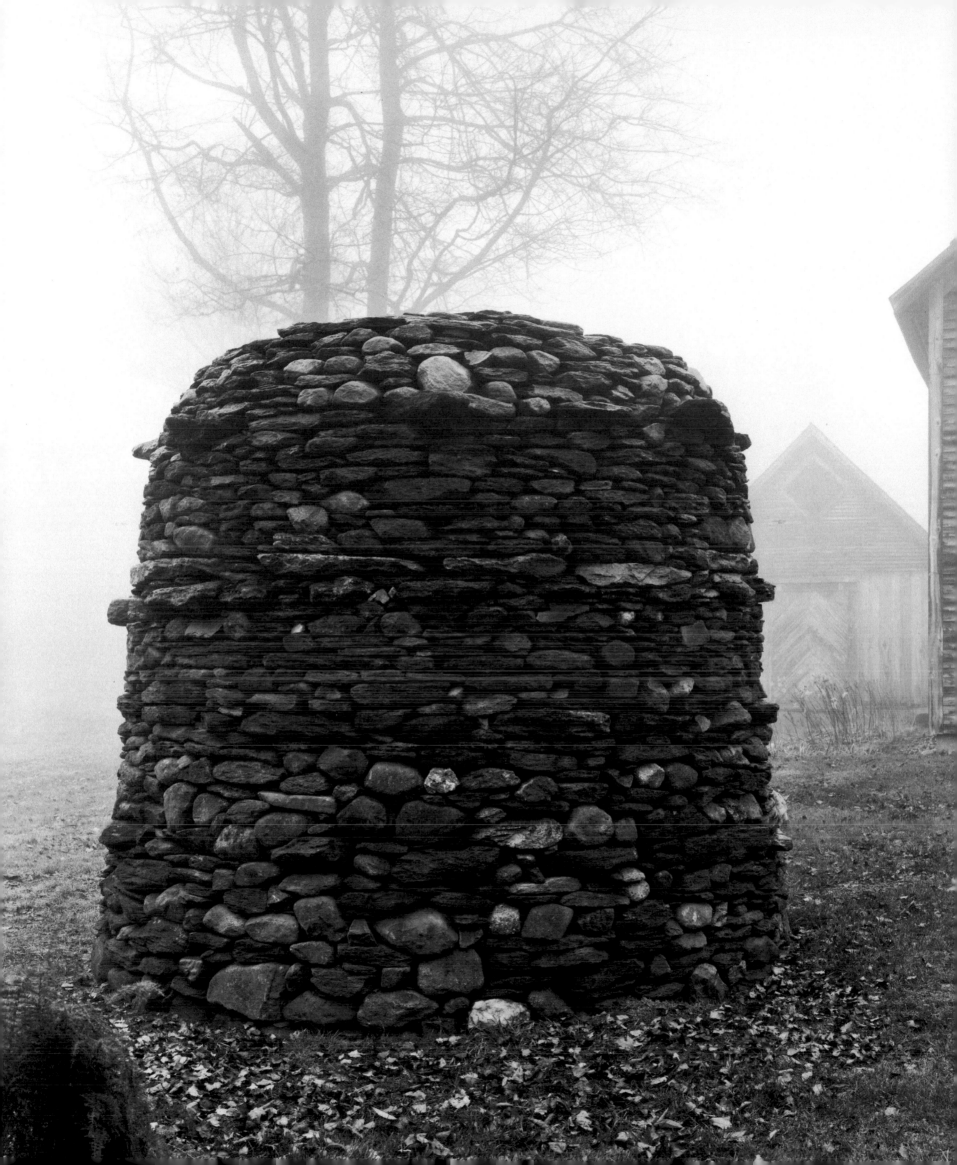

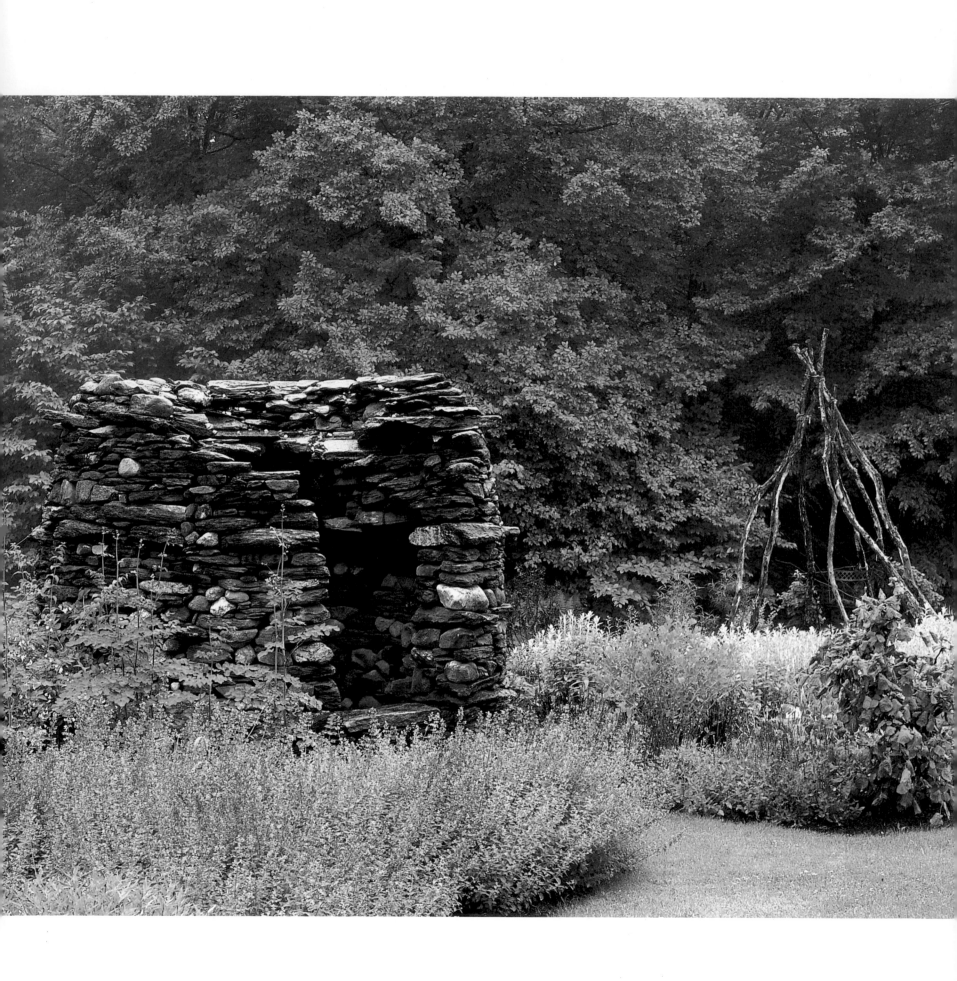

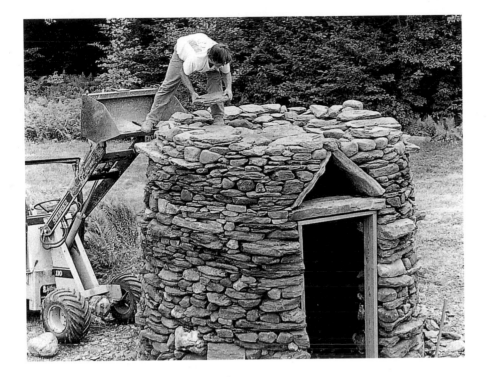

The part of the story that became this book

began when two explorers crossed paths deep in the wilds of their own neighborhood. It was a midsummer day; the heat of the sun baked the stone, and the stone heated the still air above it. Peter Mauss found me, sweat dripping from my brow, looking for an answer to the question of what was needed next to keep the wall in front of me growing into a foundation for a new timber-frame barn. I was digging for the answer in the heaps of loose stone lying in a jumble all around me. As usual, I knew what I needed; I just had to find it.

When I looked up from my prospecting, I found Peter clambering up and over one stone pile after another, staring intently at the scene before him. When he stopped moving, it was just long enough to introduce himself and ask who I was before he

bounded back to his car. I thought I'd just met a madman until I saw him assemble a large camera and tripod on top of one of the stone piles—and then I was sure I had. He asked me to sit in the foreground and be still. I asked him if he wanted me to get rid of the shirt flung over a batter board. No, he said, he liked to photograph things the way he found them. I knew then that I was going to like this guy's style.

Peter began photographing the work I do in southeastern Vermont, where we both live, that day and has tenaciously continued year after year. I've watched him compose shots with unflappable concentration as snow began to fall and daylight dimmed. Without his determination to photograph these assorted creations, this book never would have come together.

Cleitean (the plural of "cleit"), found on St. Kilda and some other islands off the west coast of Scotland, were used to dry and preserve birds and keep eggs in peat ash; they were also used to store fuel and crops.

OPPOSITE AND ABOVE: The roof structure of this cleit required incremental corbeling of courses. As the roof grew higher, the hole at the center grew smaller until it disappeared completely. The cantilevering was counterbalanced by the weight of additional stone laid along the exterior circumference. No temporary supports were needed under the roof structure as it was erected. What I thought would be an attractive detail proved to be the Achilles' heel of the cleit. The two stones in the triangular doorway lintel, visible above, pried apart the top portions of the doorway's sides, forcing me to remove the stone from above the opening.

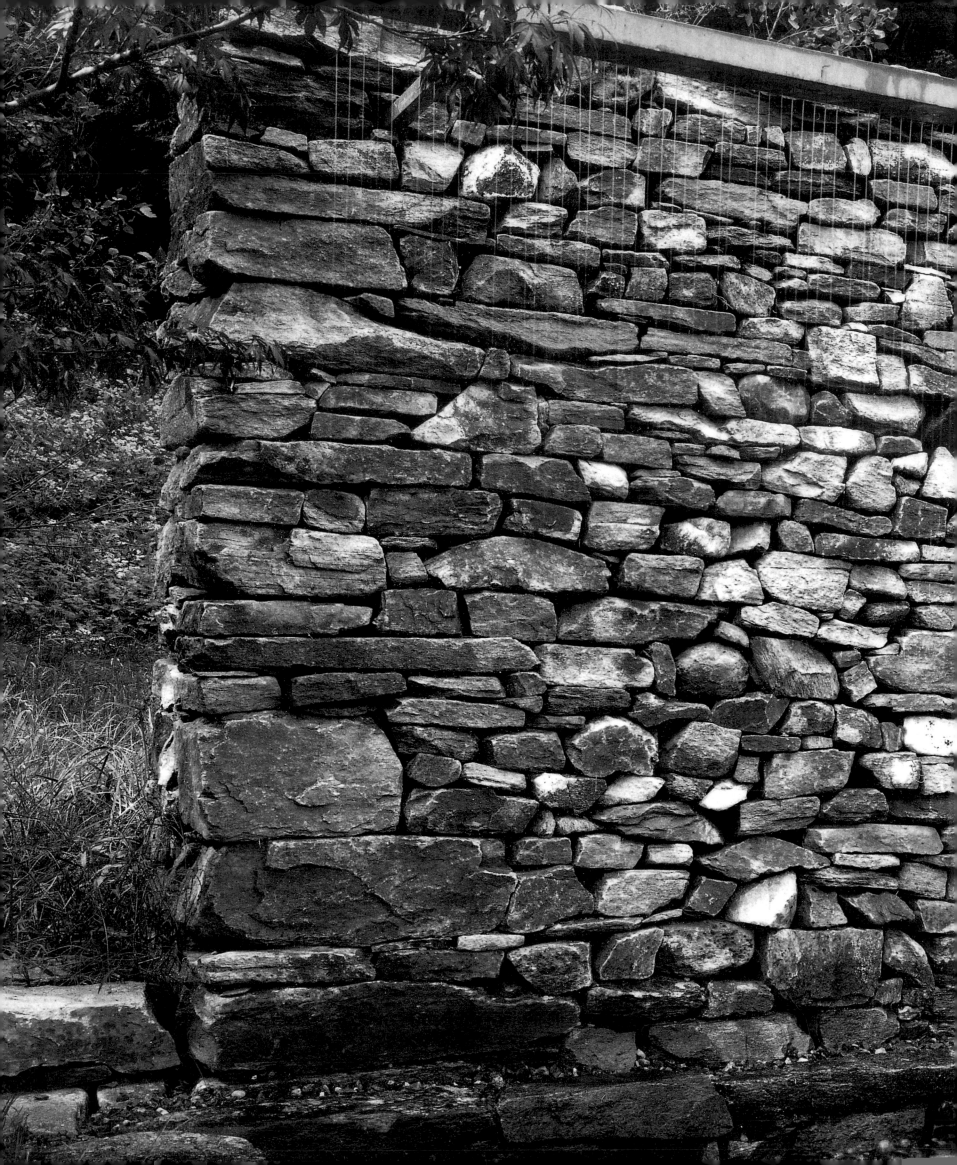

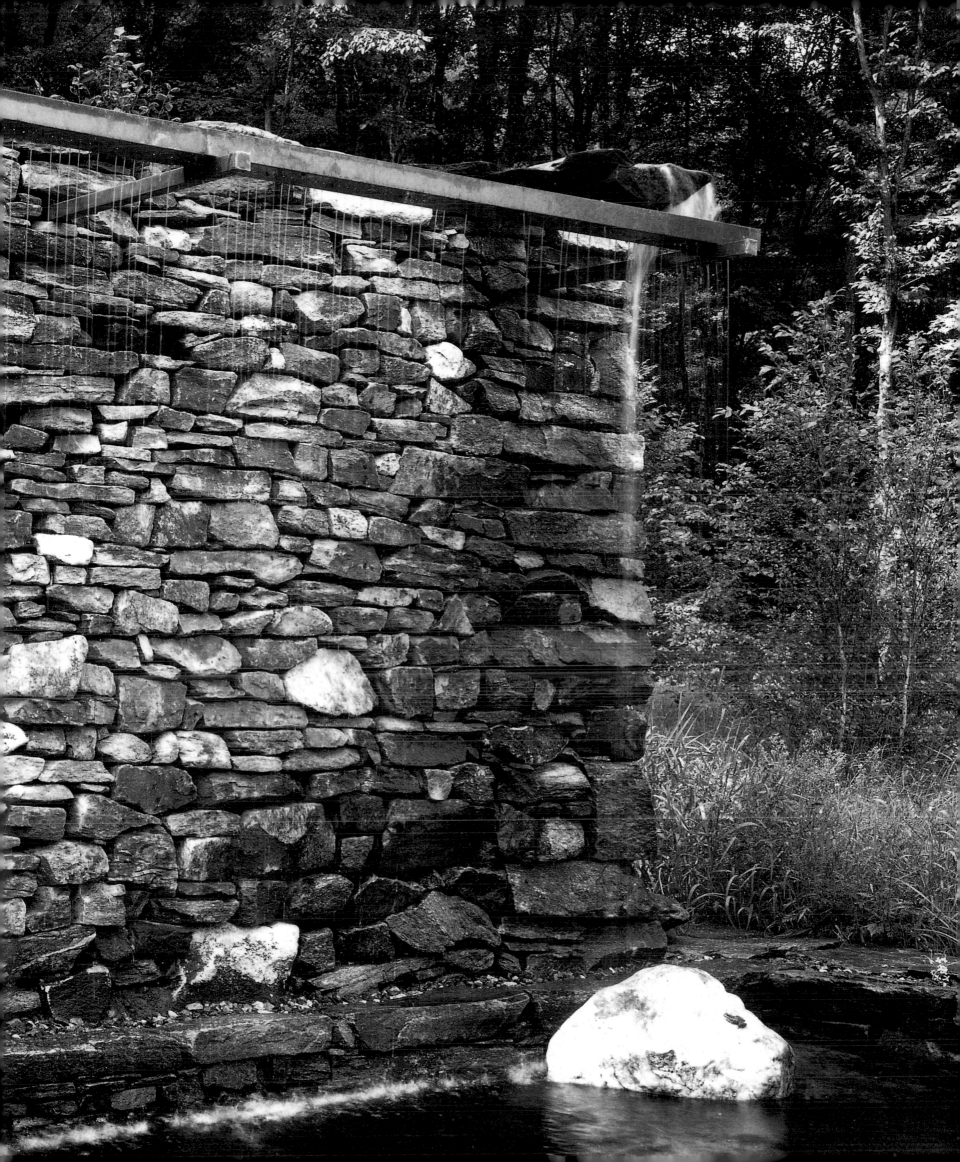

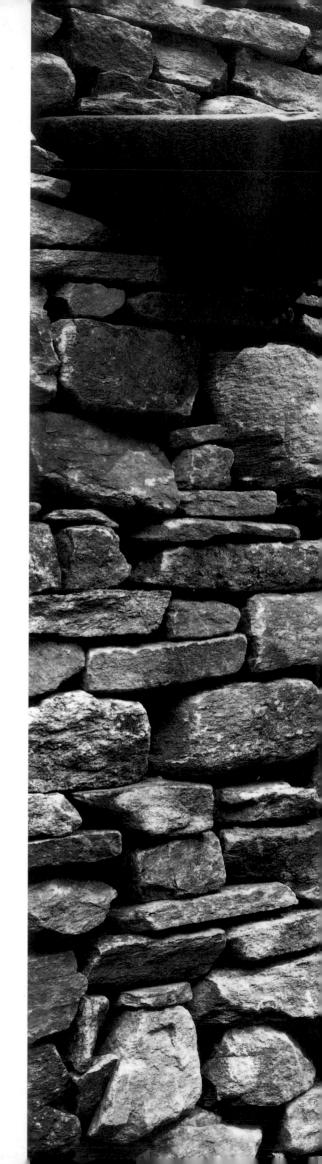

I built these walls out of necessity, or by way

of that motherless invention known as art. Whatever reason they came to be, it is their "coming to" that I can tell you about. I am a drystone waller and art maker. Walling is my occupation and has been since 1976. It is also my preoccupation—when I'm not working, I like to think about it. Of the many good reasons to do this for a living—working outside, being physically active, being my own boss, creating something lasting—the one that keeps bringing me back for more is walling's endless capacity to surprise.

My surprise is in how my perception is changed as stones enter relationships with one another on their way to becoming a wall. When now and again a stone falls into a place that is utterly inevitable, I feel I am suddenly standing under a shower of grace. For an instant I become inevitable, too. I share the compatibility that stone finds with stone. If I'm lucky, it happens a lot. Then again, some days it doesn't happen at all. Grace may fall in the next moment or never again. I know only that if I put myself with stone, it may happen again, so I keep on walling.

I am continually surprised and delighted by what the earth has to offer through the handling of its loose stone. Can you imagine anything in static form with greater variety than the stone scattered loosely over the earth? The sky is full of clouds of intense variety, but before we can take a second look at them they've changed. Stones keep their shapes for so long, I don't have to wonder how they may someday change. For the purposes of a waller, stone is immortal.

I work alone most of the time, gathering the stone myself for each job, either from a place of my own where loose stone lies naturally in abundance or from the property where I'm building. Finding stone, choosing it, and letting go of it are the three things a waller does. I'd miss any one of them too much if I asked someone else to do them for me. I may work by myself, but I'm not alone. I'm in the company of stone.

PAGES 4–5: **A veil of water drops in front of the sheer eight-foot-high face onto the surface of a reflecting pool. The soft sound of water splashing on water lends the right note to this musician's garden.**
RIGHT: **Steps climb behind the "wall of water," offering access to the top of the wall.**

6

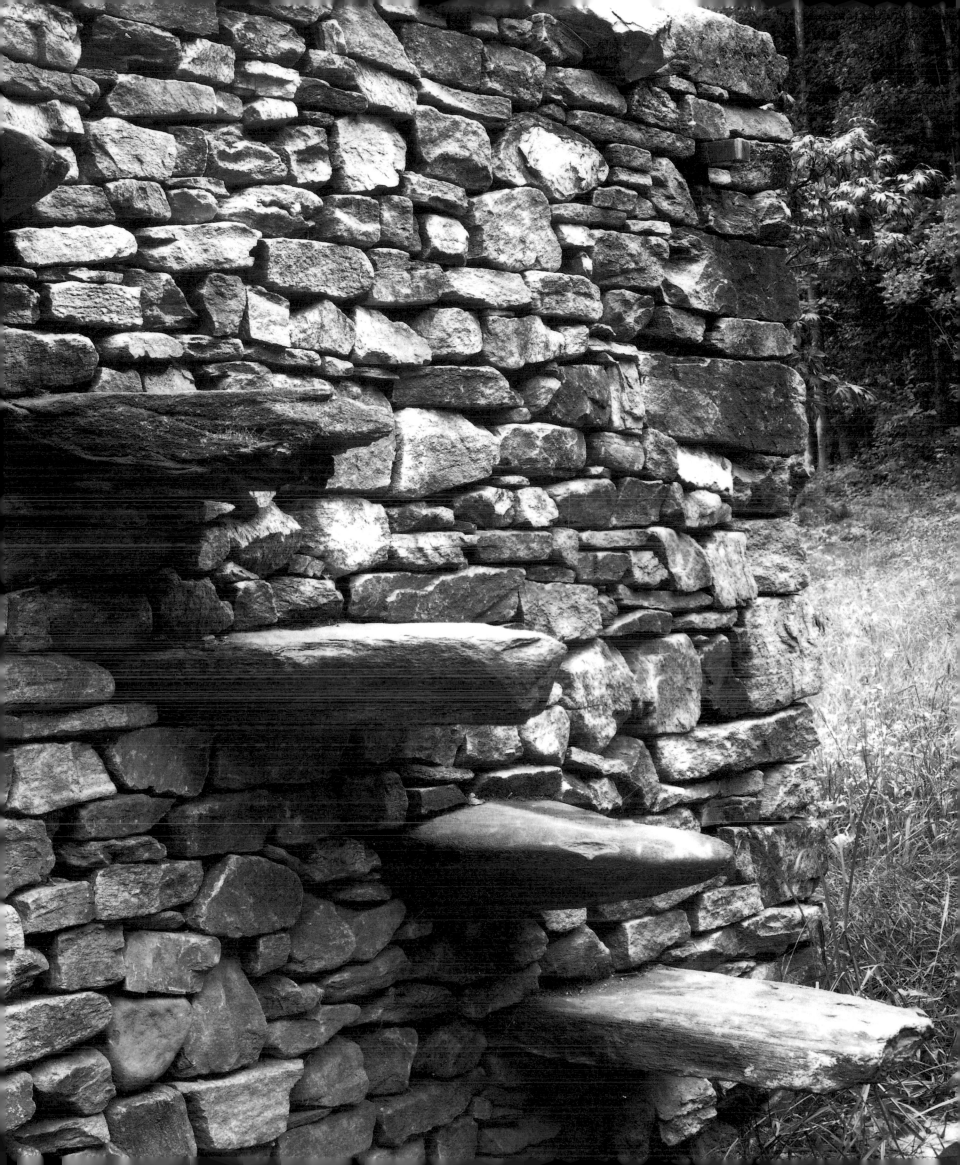

I have been fortunate to discover my place in the world by way of an intimate contact with the earth's "offspring." The handling of stone sets me squarely between imagining and knowing.

All loose stone was at one time part of the living earth. In walling, I bring stone back together, even if artificially and only temporarily, and reunite it with the earth. Walling puts back what has come apart.

I spend my days close to the ground. My shoes are scuffed from stamping in the dirt. The palms of my hands are burnished from grabbing stone. I bend so low my head dips below my heart. I'm always trying to get a little closer to the land and its boundless gifts.

Others have been here before me, filling themselves full of this place as I do. They pulled themselves to the ground by planting and harvesting. The first steps I take in the construction of a drystone wall are a continuation of those taken long before. Land that was free of stone was prized by earlier generations. Removing stone made the ground more accessible. Plucking it from the surface of the ground opened the ground up for foraging and growing crops. Set into a wall, it acted as a barrier between livestock and crops. Farmers harvested it along with their potatoes and pumpkins.

For more than two hundred years a wave of agriculture rolled across our landscape. The deep woods were turned to cropland and pasture. But the tide turned by the end of the nineteenth century and agricultural life has been, for the most part, retreating from the land. Left undisturbed, forest reclaims open land quietly and completely. It is ironic that what former generations wanted out of the way in their time is today an enduring visual proof of their existence: collections of stone.

I detect weakness in the stone's structure with the first hammer blow, then exploit it with subsequent hits until a seam opens and the stone pops apart.

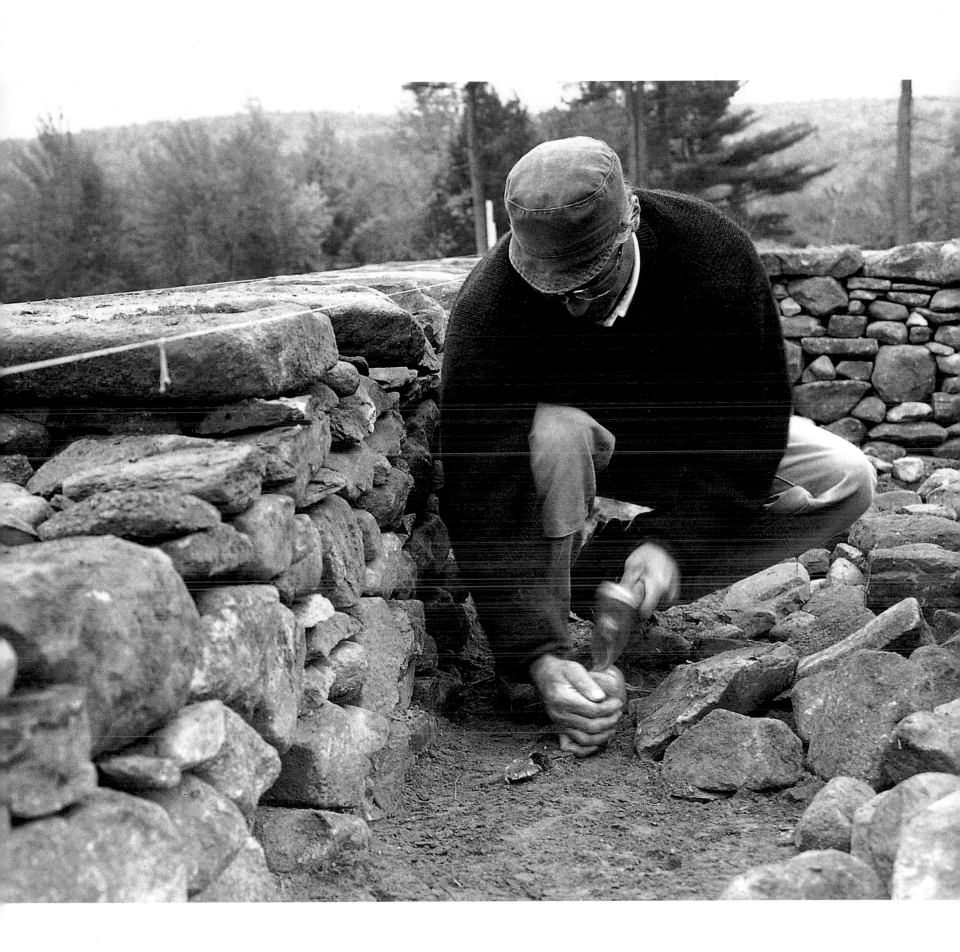

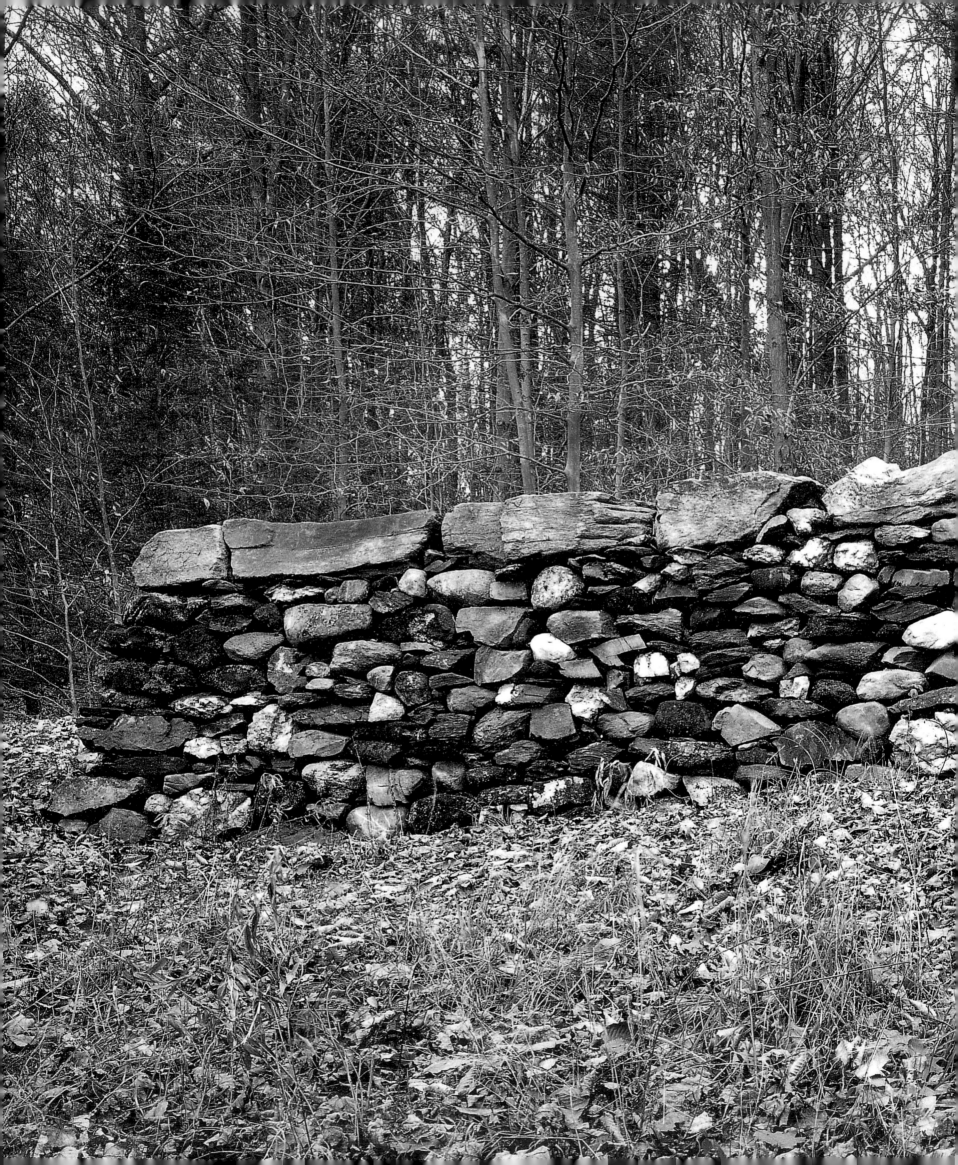

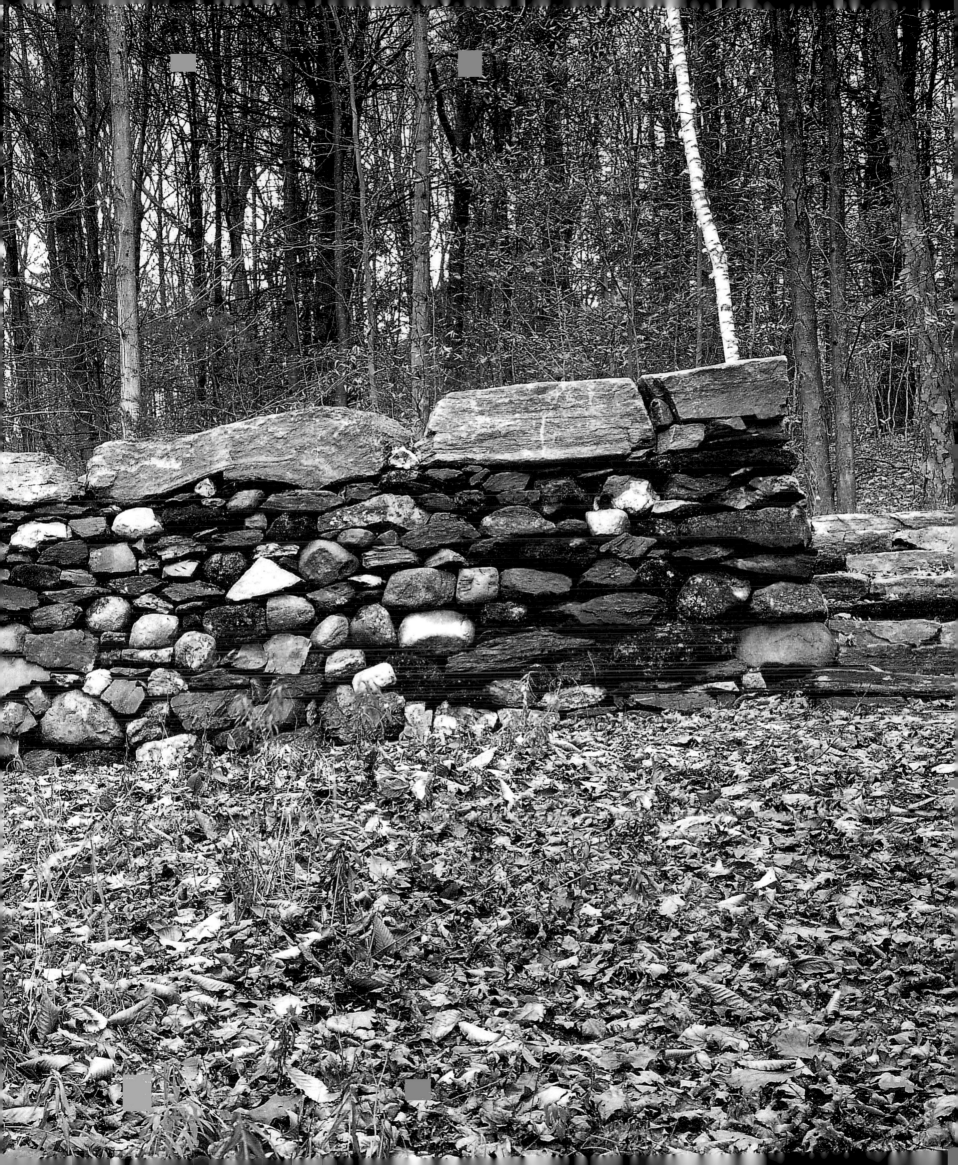

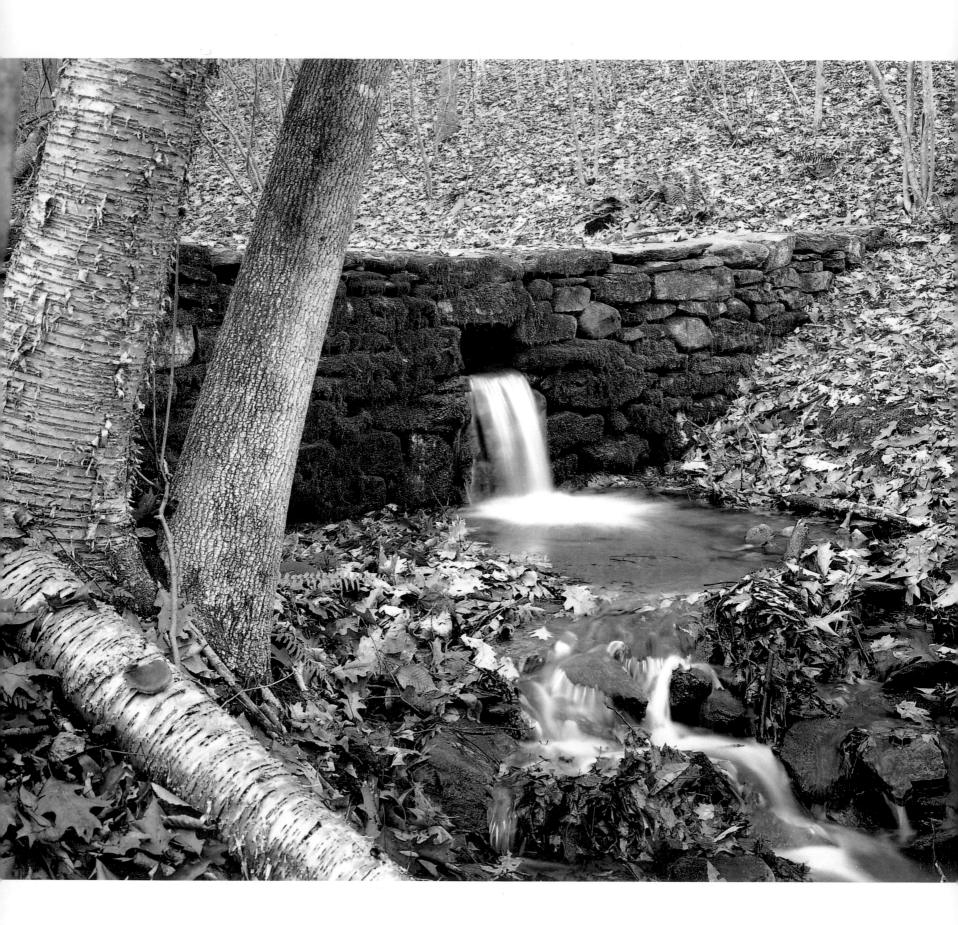

The earth is alive and continually tries to take back what it has given up. Stone walls are pulled down by many forces; perhaps the strongest is the earth they stand on.

There is a ton of stone in every yard of drystone wall three feet high. In summer, the earth is warm, soft, and impressionable. Day after day, a wall's heft is pressed by gravity into the soil. The soil compresses and is squeezed out in the direction of least resistance. As the soil moves away from the wall, the wall's base stones follow it, shifting down and out into the surrounding ground.

What was soft and malleable in summer turns hard and irresistible in wintertime. Frozen ground pushes harder than a wall can resist. Even with its tons of stone bearing down, a wall is heaved up by frozen earth. (Moisture drawn out of soil particles freezes around them, expanding the earth.) Stones are displaced when the wall is raised up on frost. More damage occurs when the wall comes back down during a thaw. The weight of the wall flushes water out from under it and soil particles run out with the water. With less soil under the wall, the base stones sink farther down.

In late fall and early spring, the freeze-thaw cycle can happen daily as night temperatures fall below freezing and then warm again during the daylight hours. This process can be a very specific phenomenon in a wall, occurring on the south-facing side but not on the colder north side. This causes an uneven amount of settling to occur between the two faces.

PAGES 10–11: What to do when croquet balls refuse to stay in the yard? Wall them in, of course. The predominantly dark-colored wall face is salted with a scattering of lighter-colored stones. Eight great blocks lie in formation across the top. Since I completed this wall, there have been few runaway balls.

OPPOSITE: Depending on the season, this woodland fantasy is a dam or a bridge. When the brook swells in the spring, water is impounded in a pool behind the dam and spills over its top edge. By midsummer, the dam top becomes a dry pathway for crossing the brook.

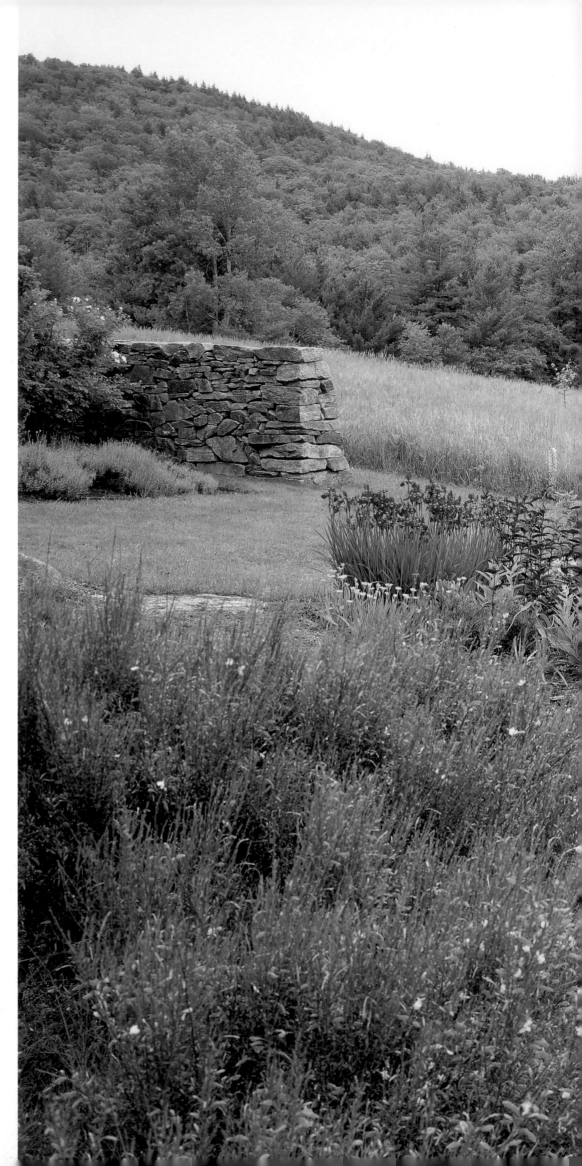

One of the wonders of a seemingly immovable wall is that it is flexible. Walls bend and slouch over the years, but they decline to break. While they may not have the straight spines and narrow waists of their youth, walls of a certain age, whose bottoms have spread and who have lost their original height, are still impressive. In fact, their strengths become more apparent through their signs of aging. Walls that manage to settle down into themselves over time press their parts together in an ever-tightening lock. The shifting base can sometimes turn what was a straight wall into a serpentine line wandering across the landscape. Here it bulges to the north, there to the south, shifting without ripping apart its woven fabric.

I overheard a gardener friend describing to a group of listeners a garden he maintained in an old abandoned barn foundation. When it finally occurred to me what he was talking about, I had to laugh. The "old foundation" was this heavy wall of chunky fieldstone built by me less than twenty years earlier.

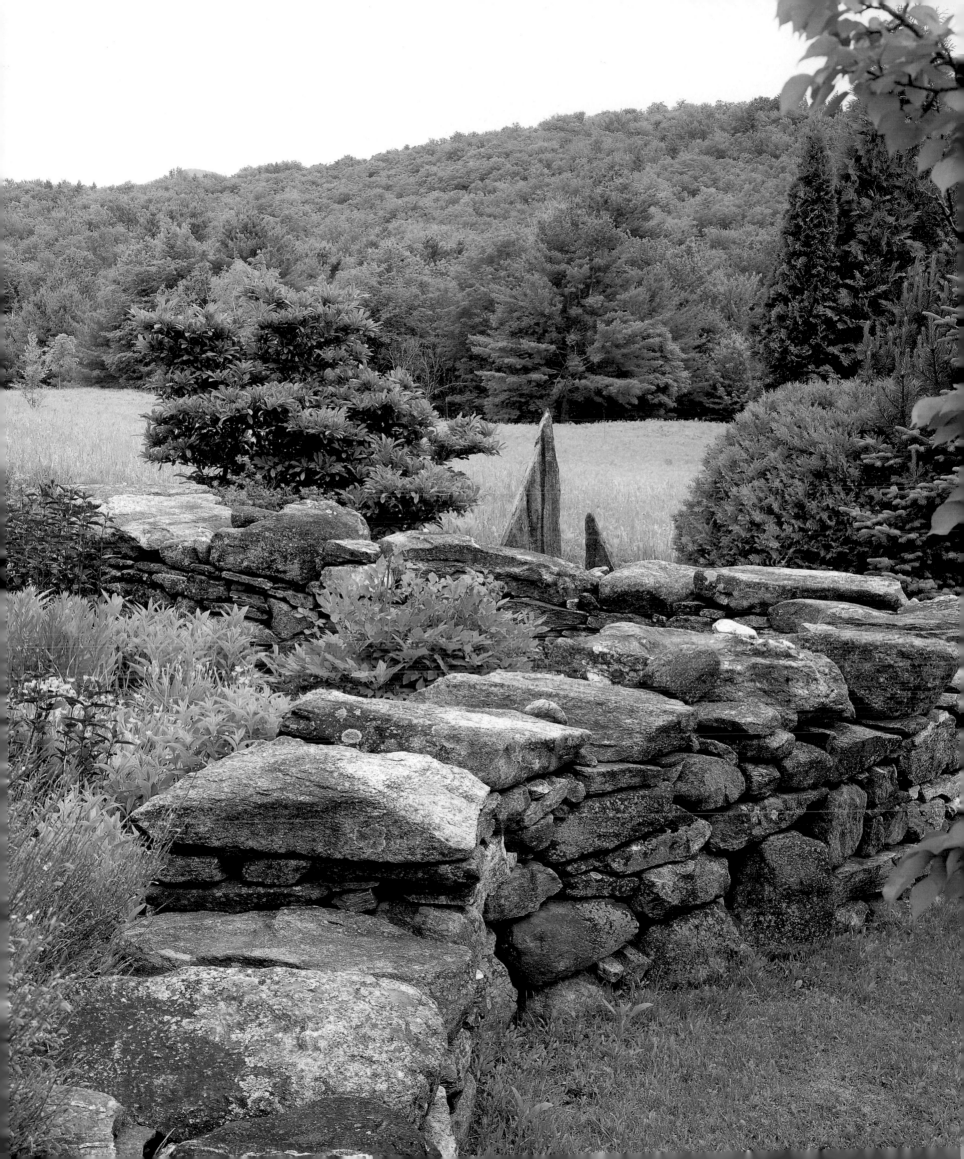

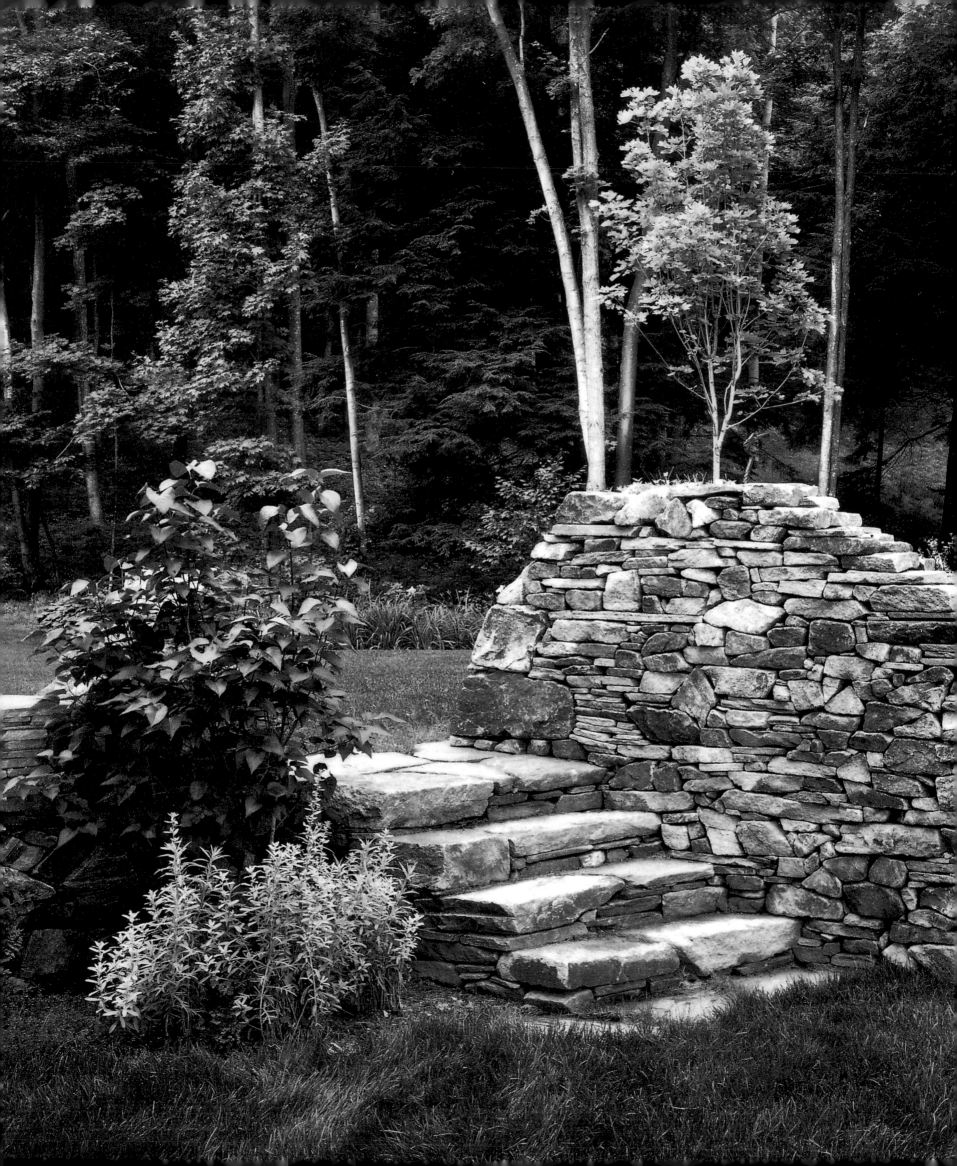

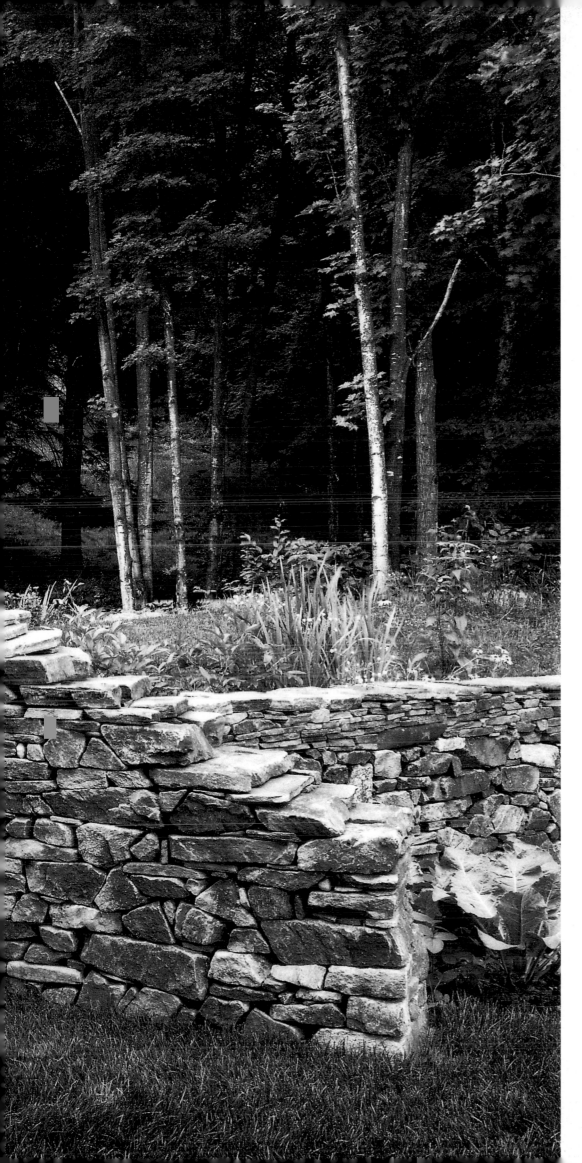

I need loose stone and plenty of it, whether I'm restoring an old drystone wall or building a new one. A moral issue arises when I contemplate using the stone from an old wall for the construction of a new one. Wallers are a practical bunch. If those who built what remains of the old wall being disassembled could speak through time, they would probably say, "Use it where you need it."

For me, part of the allure of walling is in making something from nothing. Collecting what has been overlooked or unappreciated and creating something useful with it feels like an alchemist's trick. To make the most of not much is the waller's magic.

Some areas of the country are more blessed than others with building stone. Higher elevations tend to have more angular stone, more recently detached from the earth's mantle, while the lowlands are littered with glacial till. I try to do the best I can with what I have. By reusing stone out of derelict walls, I both honor the honest efforts of those wallers and discover what the land has to offer today.

An opening in the woods on the shoulder of a hill is crisscrossed by rising and falling wall tops. Assembled over a period of years, one idea following another, these walls began innocently enough: A neighbor led me to the edge of a grassy slope behind his house, threw his arm out in a sweeping gesture toward the opposite side, and declared, "Wall!" That was all I needed to get started.

17

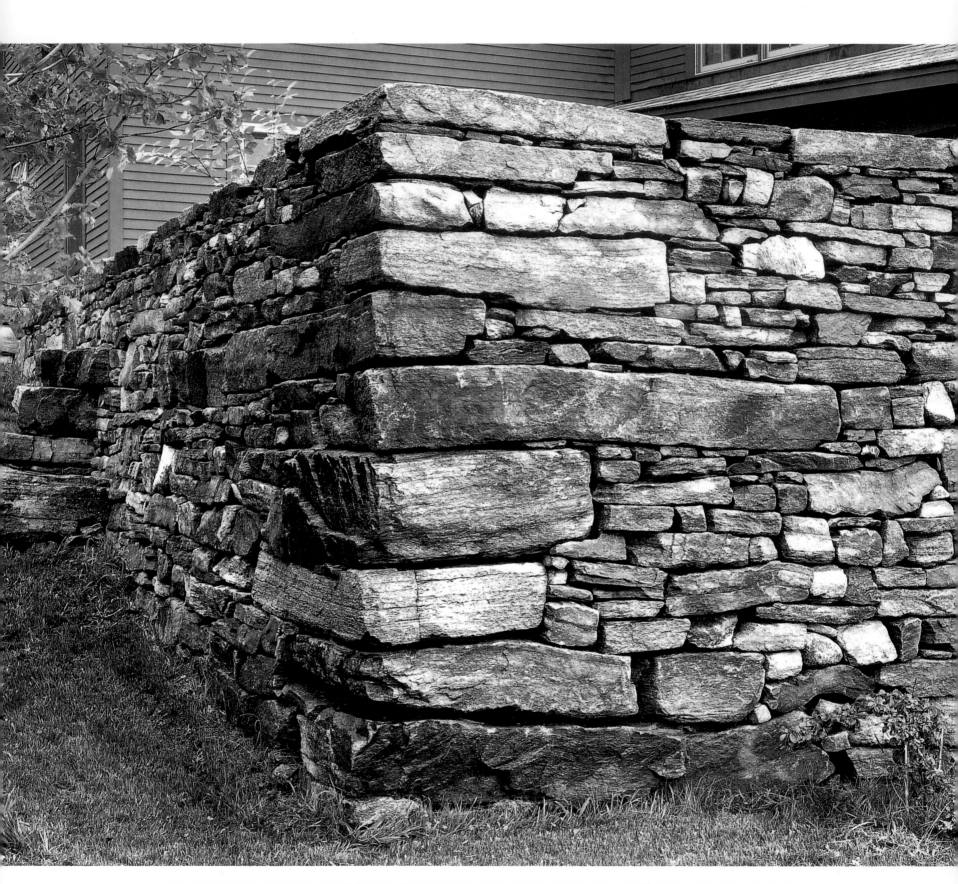

It's a blessing when you happen on the right stone when you need it. That's never truer than when you're looking for stones for a corner. Though most of these cornerstones had some odd twist to them, their compatibility became evident as they knit together the two adjoining wall faces.

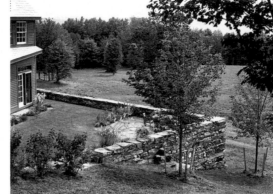

reckoning

Helping hands have reached out in my direction on many of my projects, and, in one case, on a nefarious mission. At twenty-one, I was cking out a living in New York City as a scale-model maker and doing what I really wanted to do—making sculptures— at night. For materials, I scavenged in the neighborhood.

One late night at 2:00 A.M., I was making my third trip to a street repair site for distressed timber when I spotted a police patrol car stopped and idling less than a block away. I made a mental note to take a different route home when I returned with my booty. For days, I had been watching a heap of wood stacked in the gutter alongside a municipal project, and it had become irresistible to my salvager's eye. The work-hardened surfaces of the old cribbing pieces were not something I could duplicate using freshly sawed lumber.

I knew what I was doing was stealing, but I rationalized my act with the belief that any dunnage left on the streets of lower Manhattan was fair game and that the sculpture idea I had burning in my brain required those particular pieces of wood. Sighting the patrol car had spooked me, though, and I resolved to make that my last trip.

Having loaded both shoulders with all I could lift onto them, I began trudging back through the empty streets to the former billiard ball factory that served as my studio and home. Within minutes I heard a car roll up beside me. I peeked out from under my pile of dark timbers to see the bottom half of an NYPD squad car. As I turned to face the officer at the wheel without putting down the load, he began to ask me some questions. "Where did you get the wood?" "What are you going to do with it?" When he asked me how many trips I'd made, I suddenly realized that I'd probably been watched the entire time and that it would be a mistake to lie. So I told him I planned to make a sculpture from it and this was my third trip. "Make this your last one,"

he said, obviously trying to suppress a smile. He then drove off as quietly as he had come.

When I finally got back to my building, I saw the police car cruise by. If my determination to collect that lumber had been less of an amusement to that patrolman, I might have been arrested that night. Although I've continued to be attracted to materials that "show their age," since that experience I've made sure to have rightful possession of all the materials I collect.

Walls make a visual and psychological transition between our dwelling place and the world at large. How dramatic the transition depends on the shape of the wall. When the wall becomes furniture, the transition is softened. Broad, flat-topped walls that rise from the ground to a comfortable seating height are both barriers that separate and furniture that brings people together. Blossoming Gay-feather (*Liatris spicata*), next to a seating wall, further eases the transition between house and countryside.

Stone is the consummate material of mass. When it is used to define a space, that space takes on significance by association, as though solidified by the contrast between the weightiness of stone and the lightness of air.

Without its "sacred grotto," this eight-foot retaining wall would have been functional but unremarkable. With a cavity in the corner where two wall faces meet, the space became alive and inviting. A rainwater drain from the house disgorges itself at the top of the cavern, spilling down over the centerpiece.

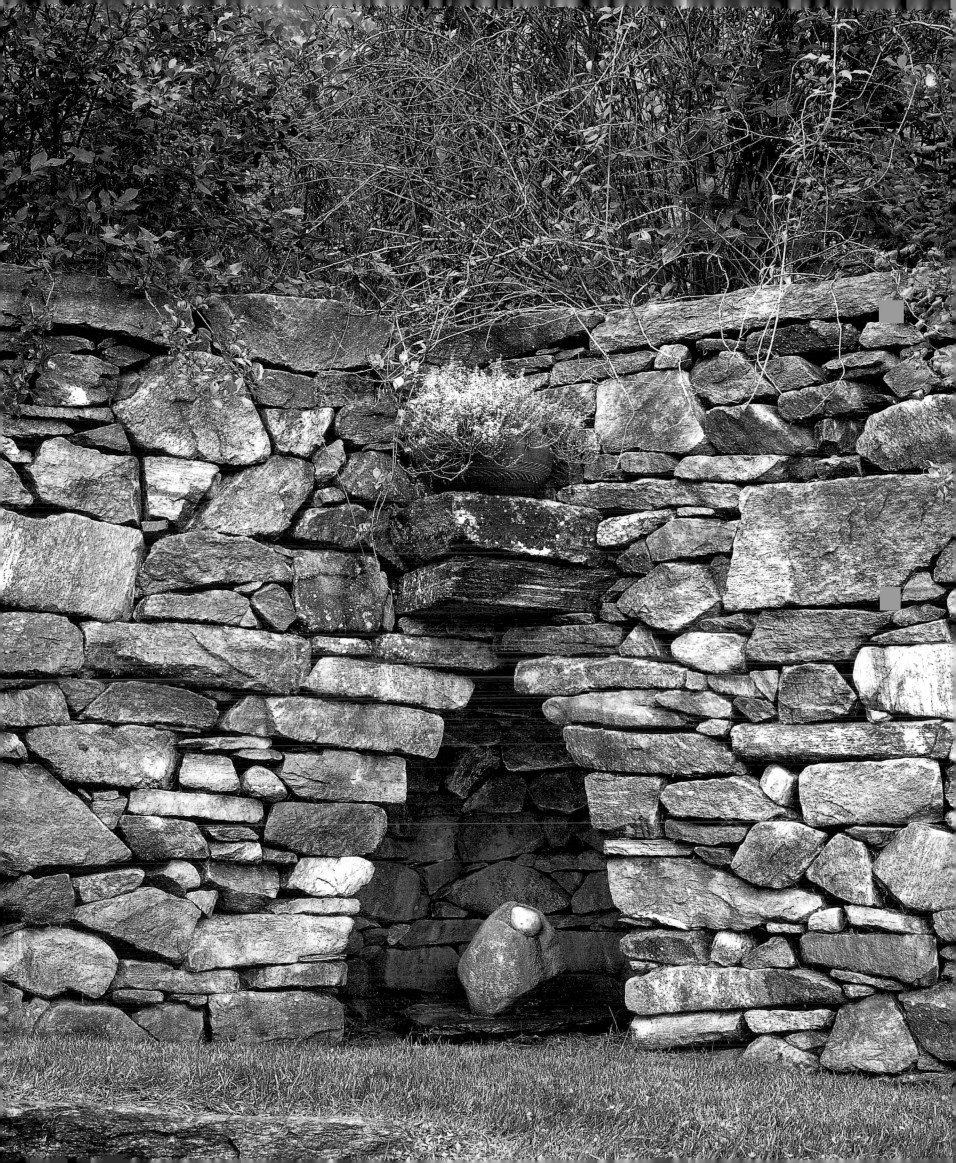

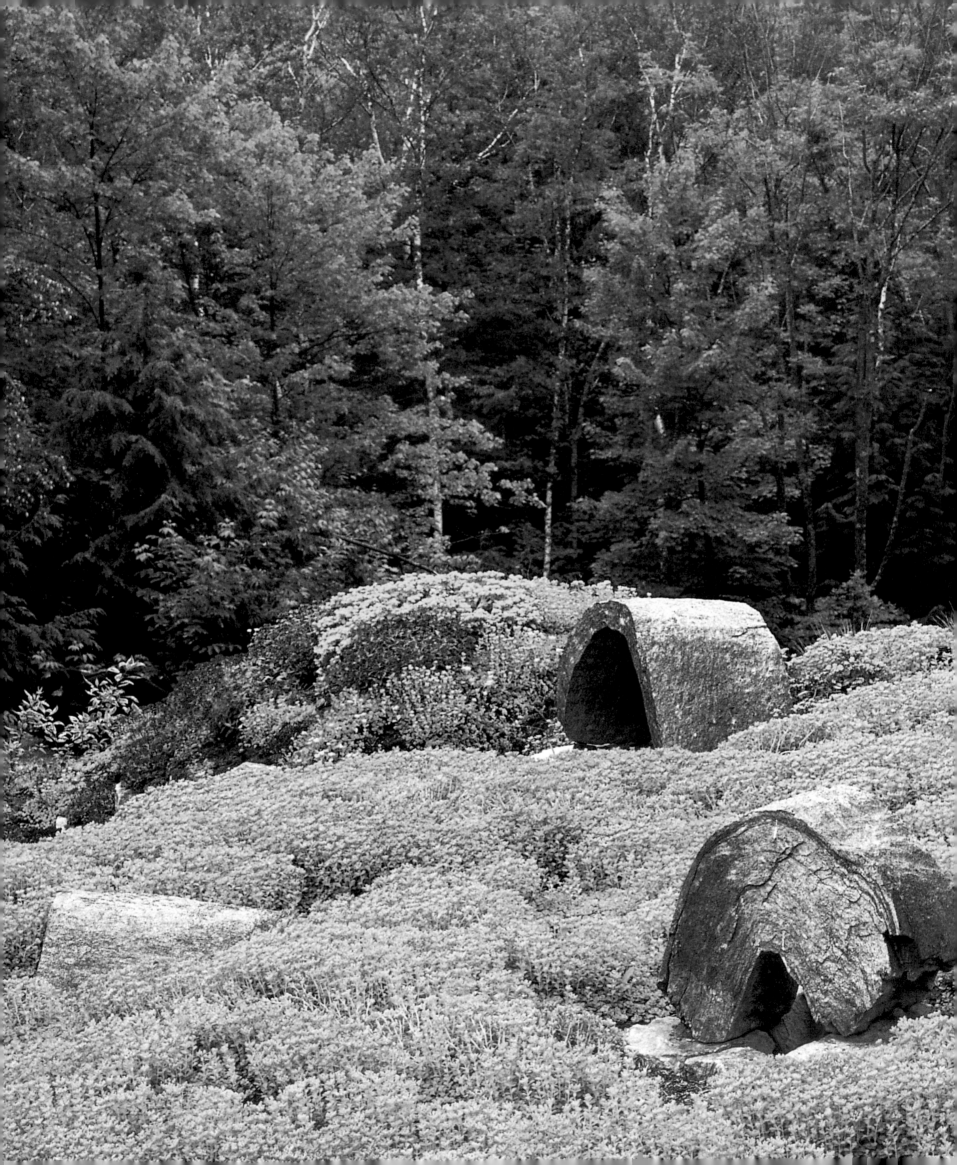

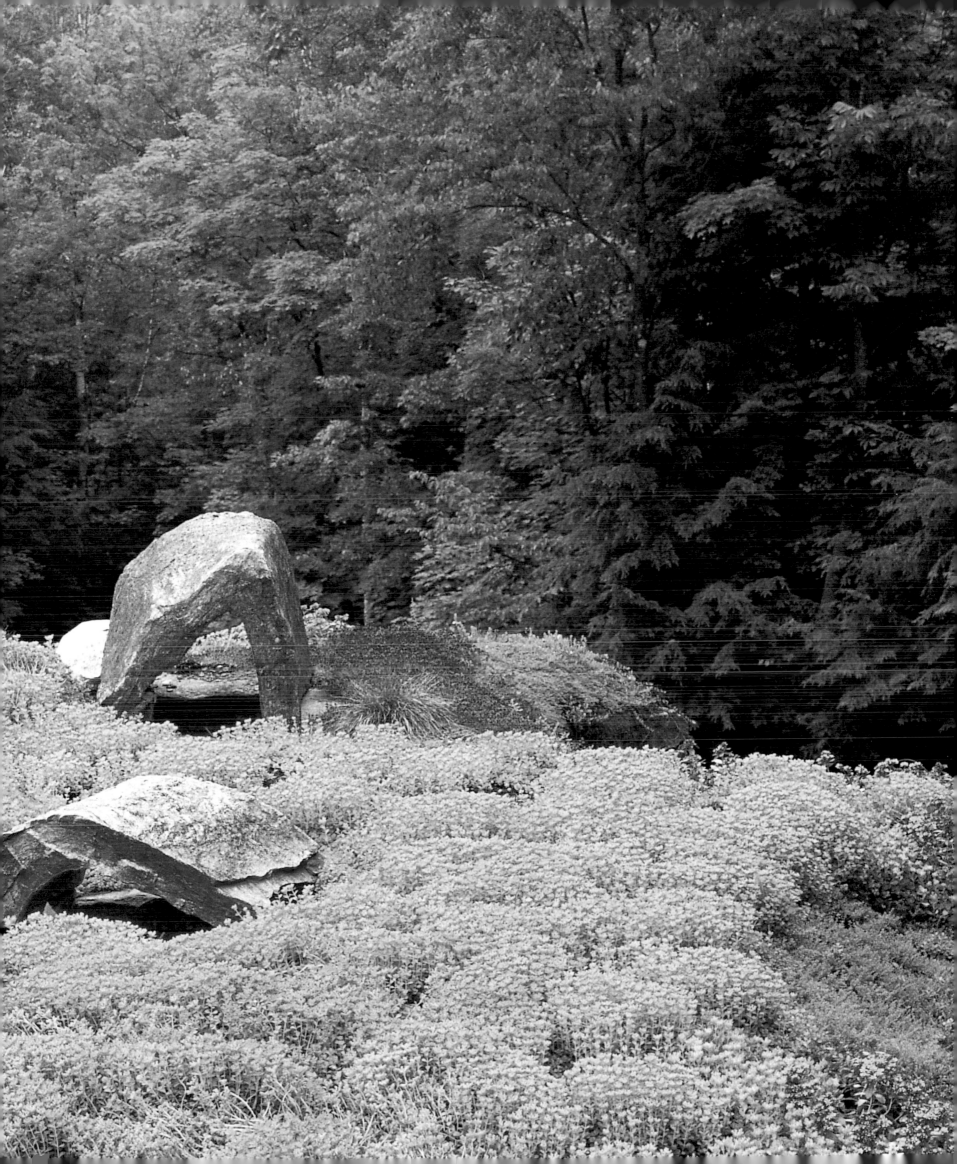

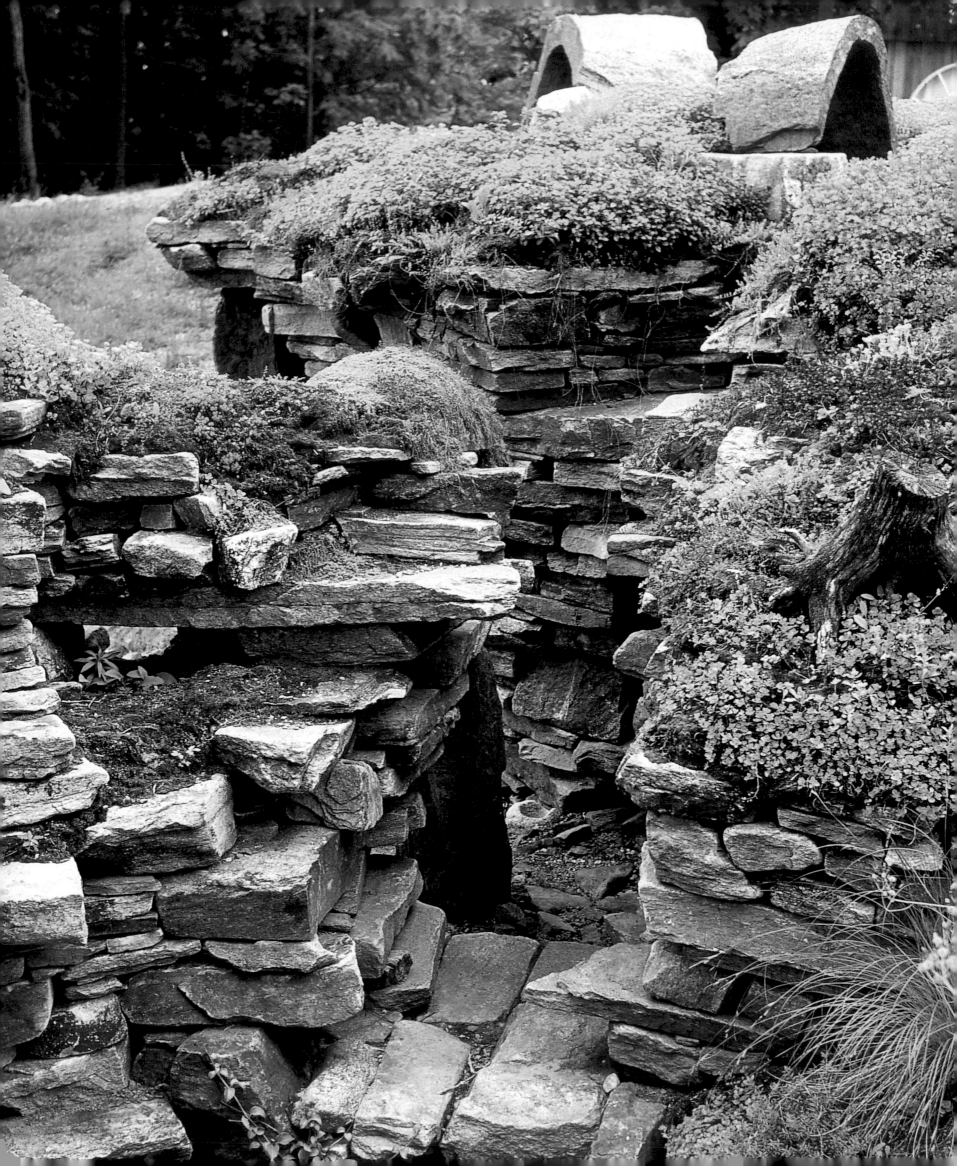

Not all stone collected in earlier centuries was put into walls.

Stone that offended the plow was dumped over banks and heaped into piles wherever it was convenient and where it was out of the way. In my search for building stone, I've discovered that what may at first appear to be just a few loose stones under a thicket of blackberry briers often turns out to be a deep scree of stone discarded at the edge of a pasture.

Another favorite place where earlier generations cast off unwanted stone was atop a knob of exposed ledge in the middle of a field. Because grass couldn't grow there anyway, it was a natural spot to deposit picked stone. What might look to you and me like an arbitrary mound of fieldstone can, when the stone is removed, reveal the logic in its location: a blister of bedrock.

One underutilized source of wall stone is the commercial gravel pit. Stones that are too large for screening are set aside for crushing. Referred to as "pit tailings," these six-inch-plus stones are an excellent source of clean walling stone.

The greatest treasure trove of loose stone I've stumbled upon was a "block field." Usually located on steep terrain at the base of a sheer vertical ledge, this is the ancient crumblings off the ledge face. Over time, exposure to weather extremes create conditions that loosen the friable ledge and slabs break off and collect on the lower slope. Such fields can be spread over hundreds of yards and for people like me offer an excellent selection of shapes and sizes of loose stone. However, their rugged topography is apt to be a serious challenge for any gatherer.

In a landscape rich in loose stone, stone quarried specifically for drystone walling seems an unnecessary extravagance. Sometimes, though, a commercial quarry is the best choice.

Wherever it is found, stone belongs to someone and can be gathered only with permission. If the owner refuses, I just keep looking; the right circumstances present themselves in time. Exploring backcountry, talking with people about their areas, discovering artifacts of drystone construction are all part of the adventure in searching for a source of walling stone.

PAGES 22–23: The soft coat of color covering its back is a contrast to the grotto's rough edges, appearing like an eroded rift in the earth's flanks.

OPPOSITE: These warped creations were found objects, unaltered by me in any way. It was they that changed me, that challenged me to create a setting for them deserving of their fantastic nature. The subterranean grotto that lurks beneath them contains walling techniques I had not attempted before. Stonecrop (*Sedum spurium 'John Creech'*) carpets the grotto's roof.

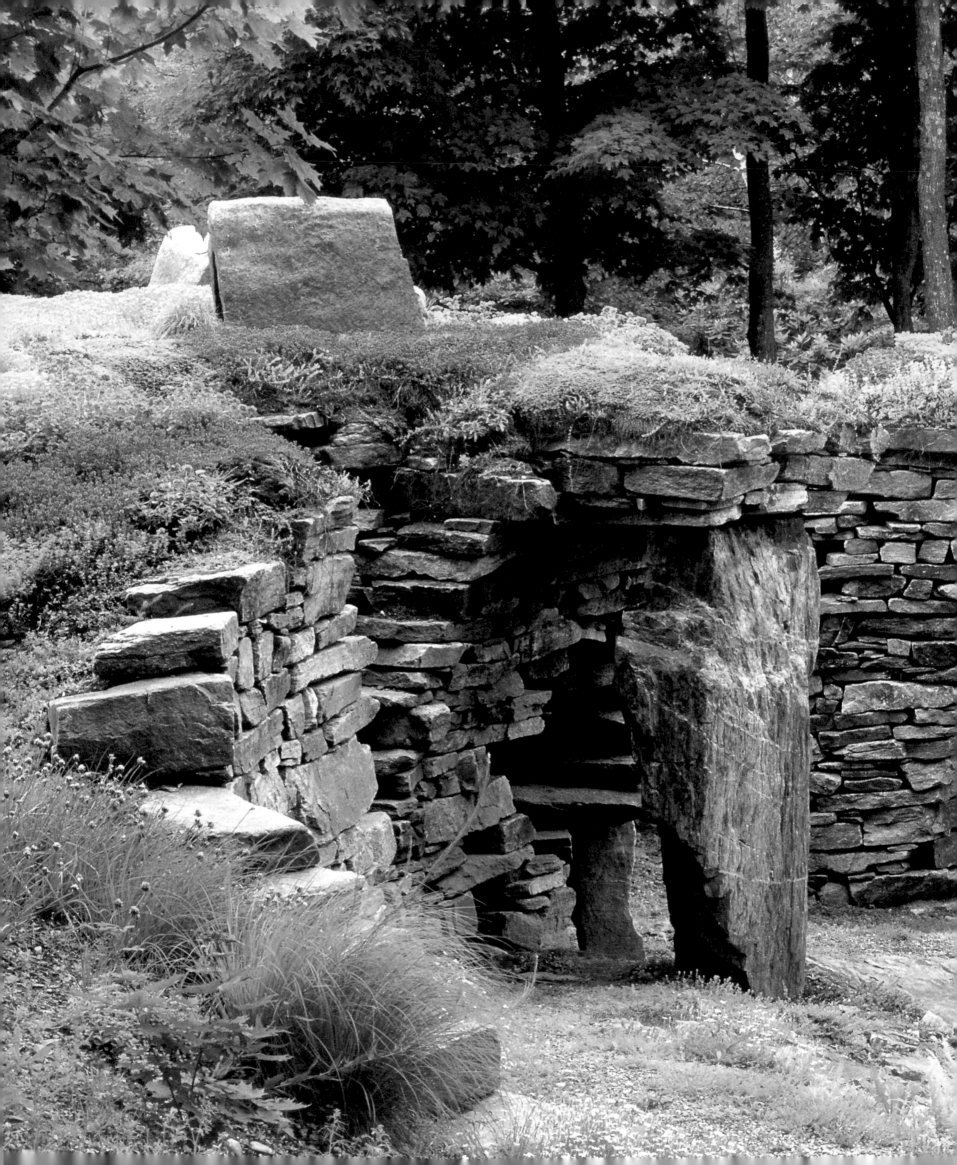

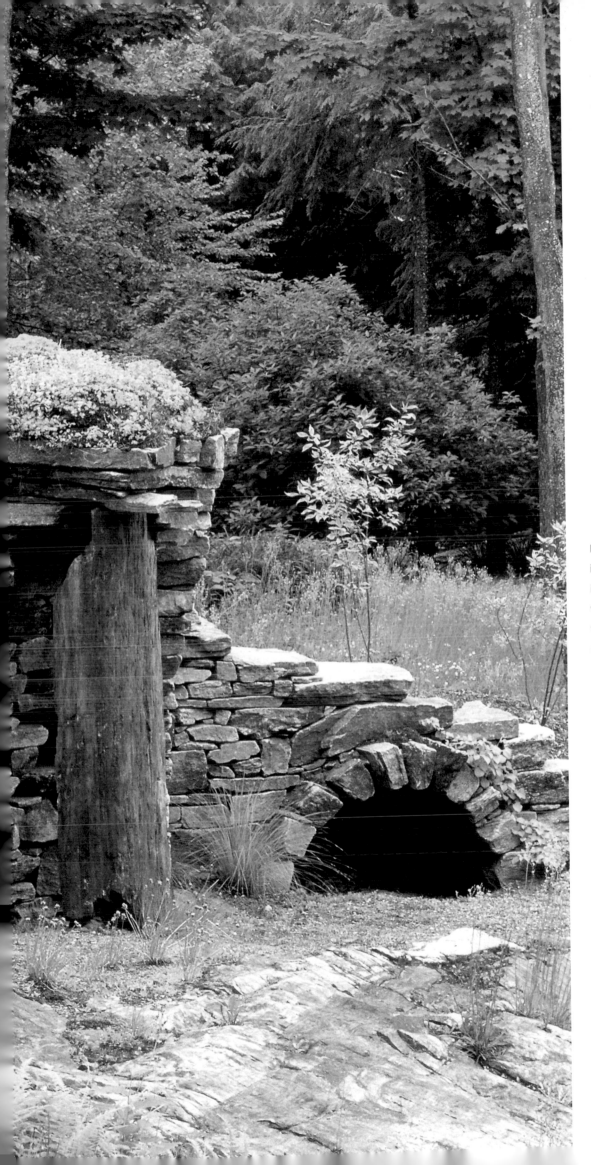

Perhaps having gone beyond bold with the implementation of this grotto design, I wonder if I've taken the craft past its limits. Filled with dozens of waterlines that allow it to weep from its very pores, this ledge-topping extravaganza defies the code of restraint inherent in the drystone craft. Walking around it is fun in a scary sort of way, like exploring an old mine shaft. The top is planted with a deep carpet of sedum punctuated by the four insanely twisted stones. They act as covers for the light wells that illuminate the underlying grotto interior. After the soil was removed to expose the ledge surface, twin spires broken from the ledge face were set on end, temporarily supported with wood cribbing. Working gingerly around them over the course of one winter, I brought the grotto walls up and out over the standing stones until they were heavily weighted with stone and topsoil. The cribbing came away and there they stood, squeezed between earth and sky.

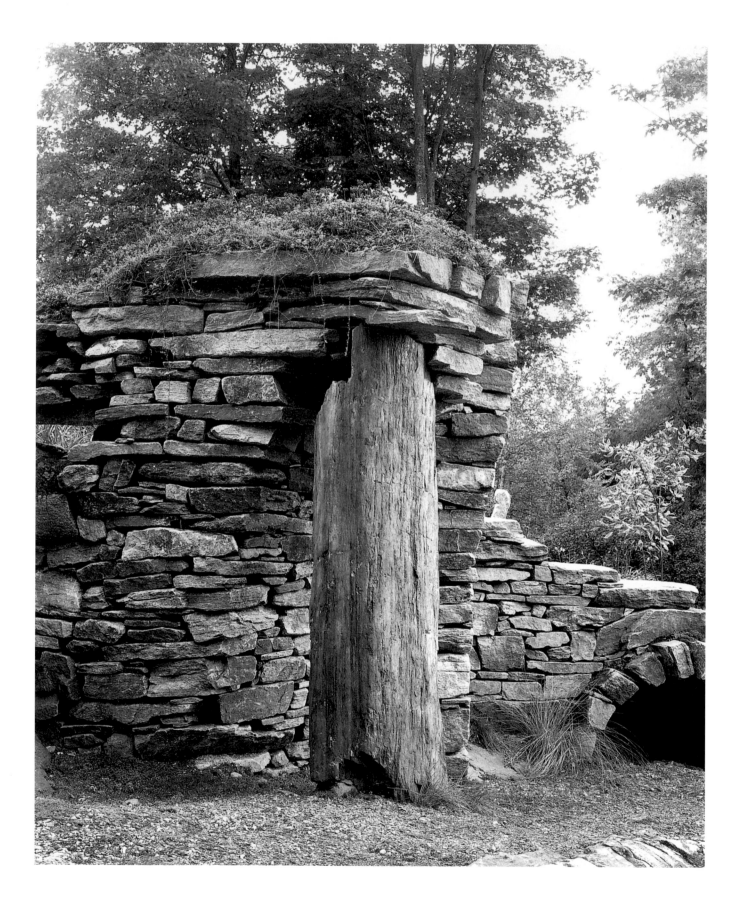

When I start building, I don't set out to make a beautiful wall. My intention is a lasting structure. Throughout the day, I apply my efforts to the basic principles of drystone construction. If I follow them successfully, I'm likely to leave behind a pretty good-looking wall.

There is no standard delivery system when it comes to getting stone to a building site. Sometimes the stones must practically be made members of the family before they finally get into a wall. Gathered from difficult locations, individual ones may have to be taken "by the hand" and led one at a time over rough terrain. How badly the stone is desired, and how much tenacity the gatherer has, determines whether hard-to-reach stone is collected, or left where it's found. I take advantage of mechanical assistance at every opportunity. But it is not always practical or possible to take heavy equipment to the source of stone, so I bring my tenacity to it.

Whoever said that familiarity breeds contempt probably handled the same stone one too many times. After my back has been stretched again and again over the same stone, my fondness for it is greatly diminished. The fewer times an individual stone is handled, the more enthusiasm I keep for it. To "discover" a stone is to see it and move it for the first time, to learn its shape and weight. It really needs to be discovered only once. Just as it is lifted and placed in the wall is the most opportune time, in my back's opinion.

A single stone is slung from the loader arms by a chain lassoed around it. Shuttled to the construction site, it will be suspended above the wall and lowered into place.

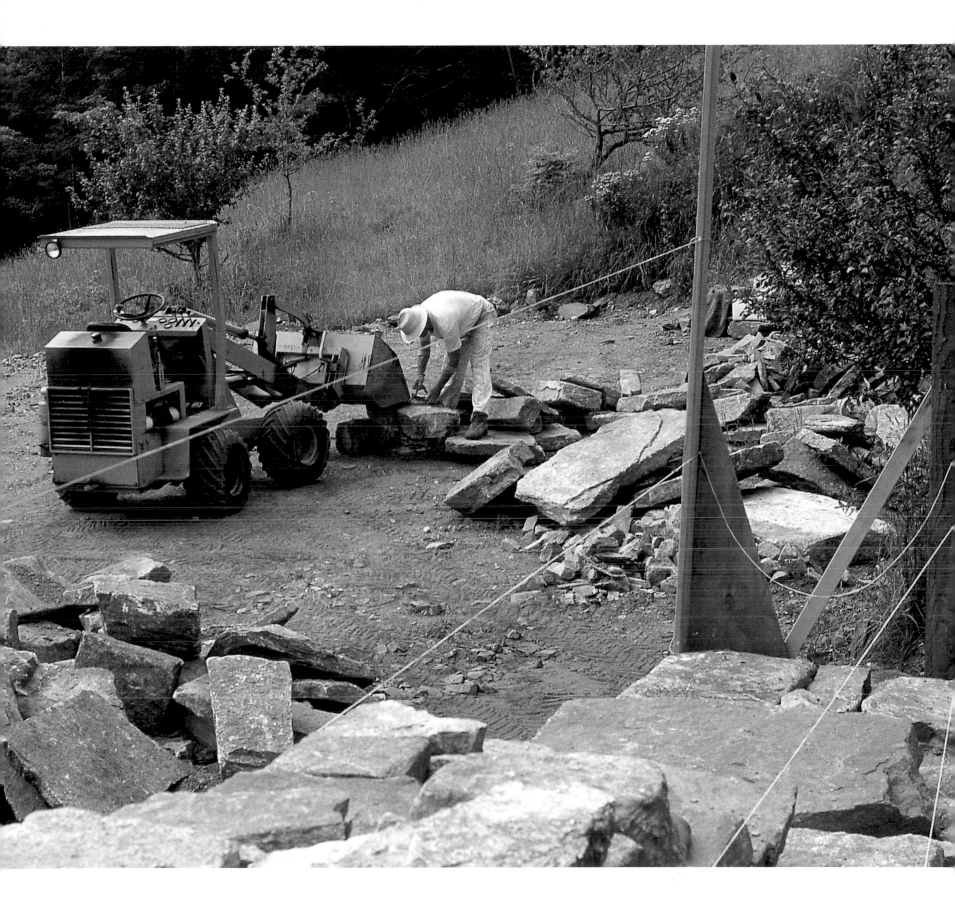

A waller may feel overwhelmed by the sight of many stones to choose from, but it is far better to have too many choices than not enough.

The skill one wishes to have is the ability to cast a gaze across a stockpile and immediately reduce the number of possible picks to one. Knowing why one stone and not another is needed is the result of understanding four principles:

1. "End in, end out." Run the longest dimension of each stone into the wall. In that way the wall's weight presses on the greatest surface area of each stone.

2. Cross the joints. Stones are set on the wall "one over two and two over one." Mutual gripping occurs when each stone touches two above it, two below it, and two beside it. Each stone touches as many other stones as possible.

3. Keep the middle full. In order to prevent slippage or settling because of internal hollows, keep the wall firmly and fully stuffed. Fillings are not thrown or shoveled in. The two wall faces are built up, keeping pace with each other, and "hearting" is added caerfully and consistently. Some wallers refer to this as "keeping my heart up."

4. Taper as you go up. As the wall increases in height, the waller decreases its width by setting the external faces of each course slightly more toward the center. "Batter" directs pressure inward and centralizes the weight of the wall.

OPPOSITE AND PAGES 34–35: In a collection of stone, can you find the germination of a wall's design? There is something bladelike about this wall, as though it sliced its way up out of the ground. The material is naturally cleft "drift" stone collected from a steep slope at the base of a sharp-faced ledge. The individual shapes are cousins to the overall shape of the wall. A Norway Spruce (*Picea abies*) shoots skyward from a lawn behind the wall.

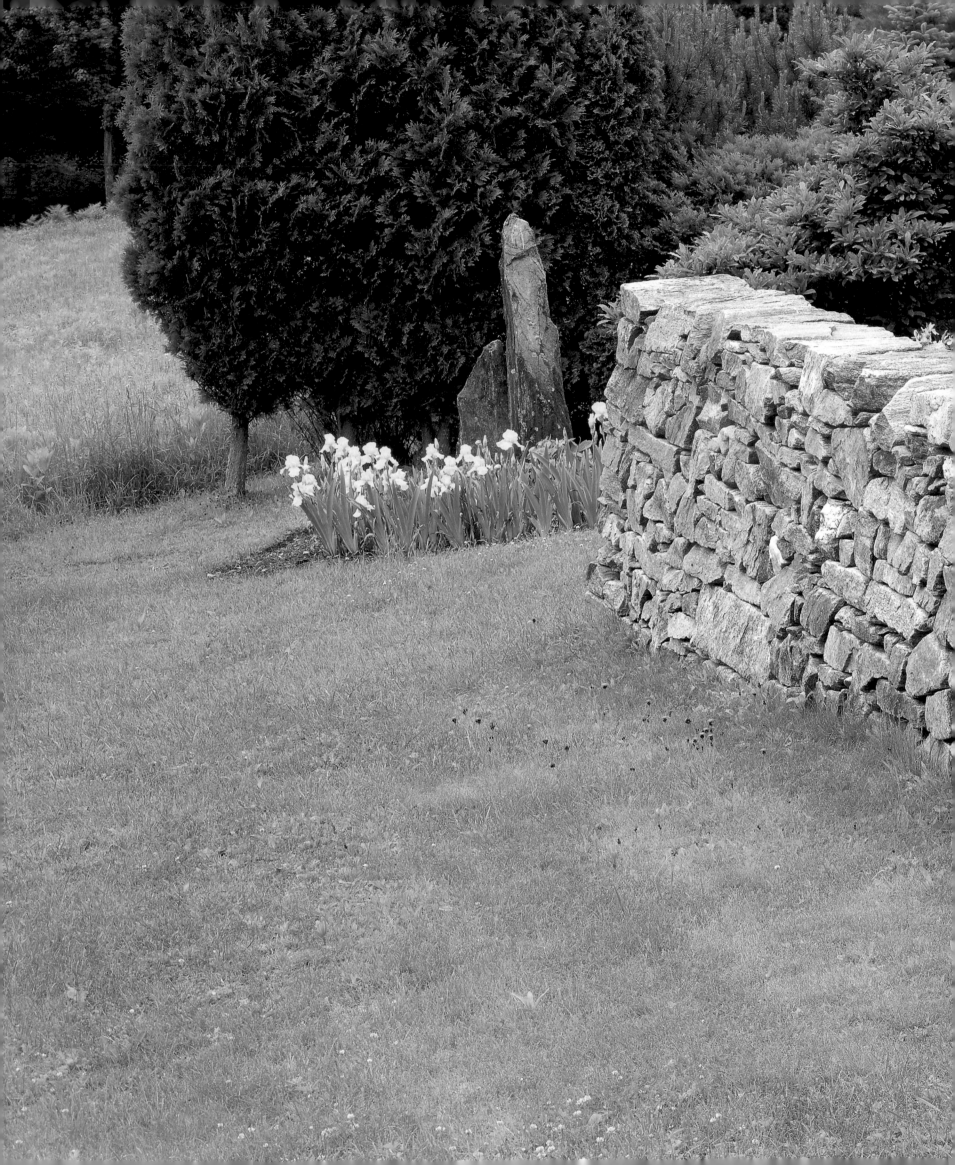

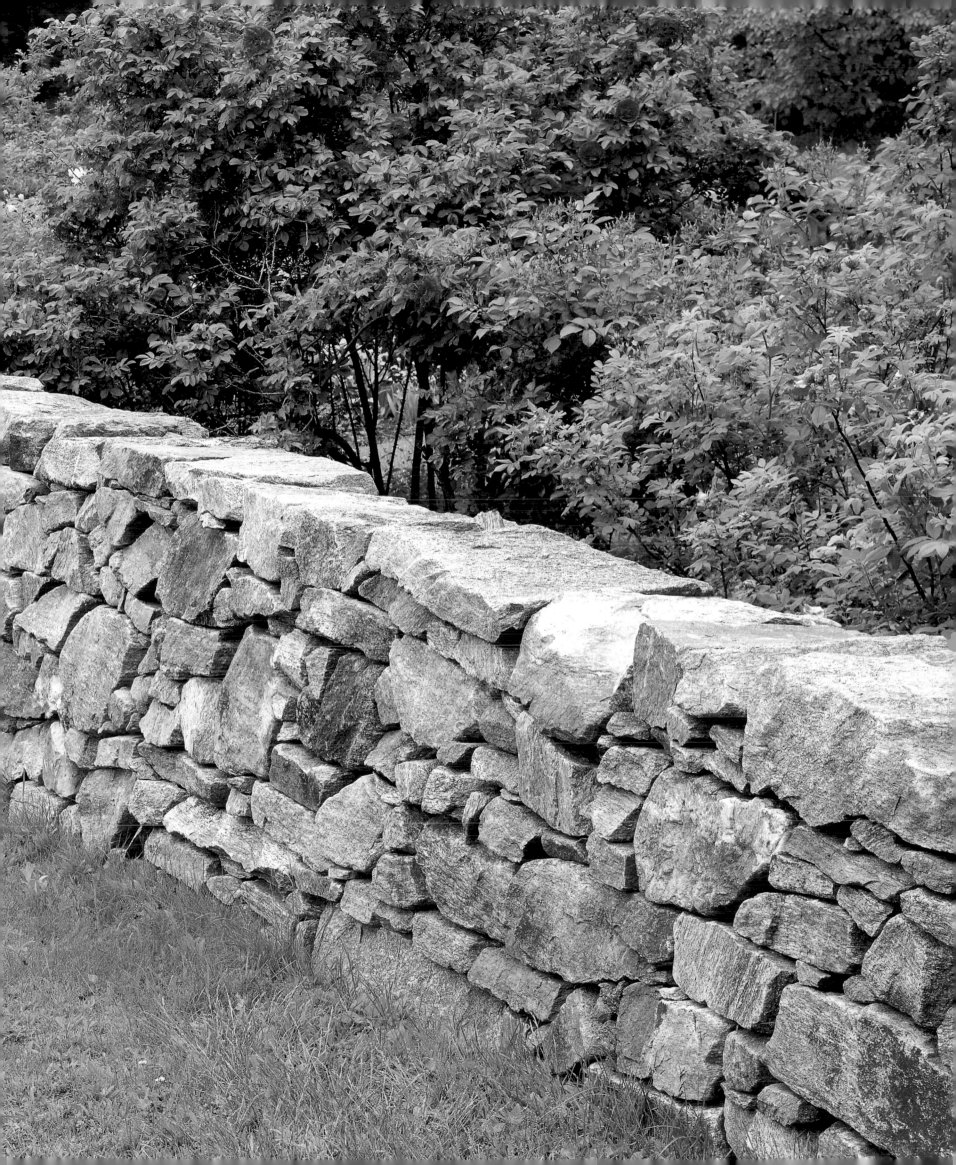

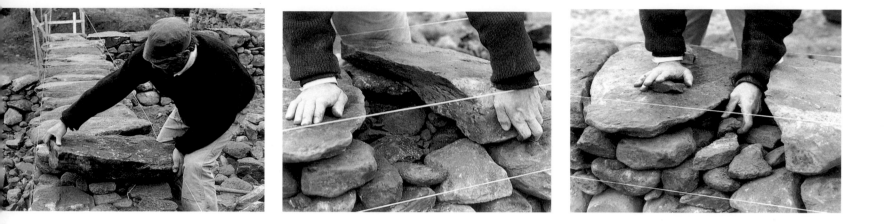

In the brief time I've stood on this land, I've watched saplings grow into trees and a new forest spread across fields left fallow. Adjusting my gaze backward, I catch a glimmer of two worlds now gone. Hints of the primal scene are detectable in wide-angle views of smoothly worn hilltops and scalloped valleys. In the middle ground of time and view are snatches of sheep-shorn fields looped by necklaces of lichen-mottled stone walls. A third world, my world, emerges from details in the foreground. There, lessons from the past meet the hopes for the future.

Stones and the place where they are ultimately going to rest are my tools for creating a new view. Until there is a collection of stones, in a variety of shapes and sizes just ready to use, designing is just theoretical. Dreaming of possibilities for a wall is good exercise for the imagination, but realizing it requires two things: a known supply of stone and a building site. The closer the supply of stone is to being ready to use, the clearer are the possibilities.

Design begins by seeking out the limitations of the stone and the site. I must find a balance in using each stone. If too much is asked of an individual stone in terms of its function in the wall, I could waste time making it conform to the idea of what I want it to do instead of using it where it is useful as it is. The landscape is forgiving and demanding; by appreciating the first and respecting the latter, a workable vision develops. When I identify the restrictions to creation, the strongest design emerges.

It is said that the best fertilizer for a garden is the footprint of the gardener. The same could be said for a wall. Walking the ground of a site enriches my imaginings: feeling the rise and fall of a slope underfoot, gazing at the close surroundings and the distant vistas, even lying on the ground and getting a worm's eye view of things. Far from looking for a confrontation with the place, I'm seeking a connection.

When I begin designing, I try to intrude as little as possible on the space. A ball of string and some wooden stakes are enough to allow me to begin sketching a shape on the landscape. Defining the form by the string, where it touches the ground, where it rises up, and where it tops out, I create the ghost of an image, then stand back and view it from all sides. This is a quick study that can be easily changed, and can be changed a number of times as I try out different possibilities. I leave my string outlines up for a while to see how they feel over time.

At this point, my design is a general layout with details to come later—a number of unknowns remain. As my knowledge of my stockpile of stone develops, how it all can be put to best use becomes clear. The shape and size of certain stones suggest their own possibilities. A design that completes itself as a result of the construction process creates an organic consciousness, a vibrancy, that stays with the wall for the rest of its life.

Before the string and stakes come down and the "sketch" is erased, reference markers are placed outside the building area and powdered lime-stone is dropped along the edges of the area to be excavated. After trenches are dug and filled with crushed stone to establish the wall foundations, a wooden framework is erected from which string lines are stretched. To outline a curved plan, small pieces of bright marker tape are skewered on long nails that are then pounded into the ground every few feet along the curve.

Accurate guides that remain true throughout the building process are an asset. When carefully followed, they help keep the finish of the wall consistent.

A design is only as good as its implementation. Some of the constructions pictured on these pages were accomplished in a day or two, while others developed over the course of weeks or months. Seashells fascinate me because they are created moment by moment through the lifetime of the animal. The full measure of the animal's life is recorded in its shell. These walls are the evidence of many creative moments in my life. Good designs reflect good days I've had walling.

To fit a capstone, I must take care to see that its underside rests as fully on the heart of the wall as it does on the face stones.

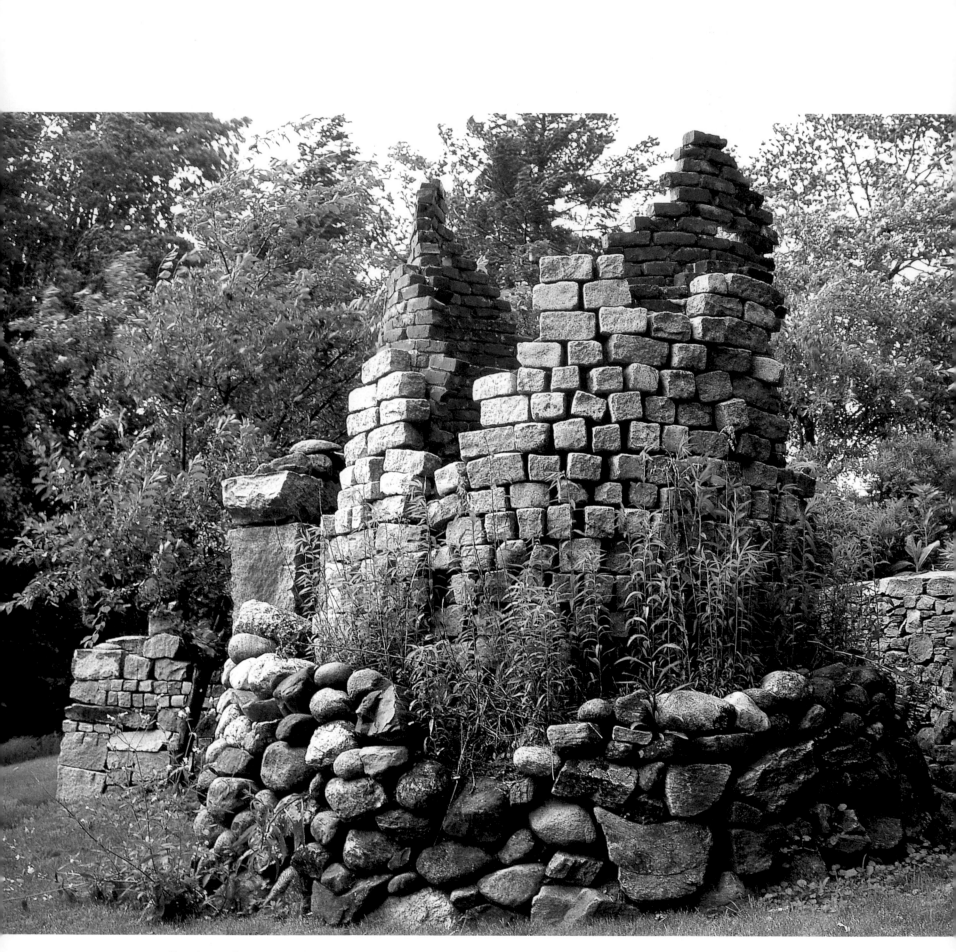

Three layers of masonry are exposed in the decaying silo folly. Drystone construction rings the base of a hollow core composed of cemented cobblestone and brick. Bracketed by a crabapple tree on the left and lilacs (*Syringa vulgaris*) on the right, the silo itself has taken in stray seedlings from the indigenous flora and given them a home.

diligence

Whenever the subject of masonry came up, it was never long before John Regan's name was mentioned. From an early age, I had been hearing stories of the man's accomplishments from my father and his friends, so as a young man, I was surprised to find that he was still alive and working at his trade.

My first impression of him was of a man with a torso the size, shape, and density of an eighty-pound sack of cement. He wore thick glasses, but he could see just fine, a fact I later discovered when I worked as his tender. None of my mistakes escaped his sight.

He kept a pack of cigarettes in the breast pocket of his overalls and he smoked with dutiful regularity. Years of working on all fours had stiffened his joints, and he walked with a shuffle from the pain in his knees. His thick fingered hands were powerful and quick, always ready to "pick and dip"—pick a brick up with his left hand and dip into the mortar with the trowel in his right.

John grew up in a family of Leominster, Massachusetts, masons. His father and uncles worked together crafting entire buildings. John's first job for his father, at the end of the First World War, was to lead a horse in a circle around the bull wheel of the winch that lifted brick and mortar up to the mason tenders working on the scaffolding. In time he became a tender himself, keeping the masons supplied with needed brick and mortar.

John told me a story from his apprentice days about the first time he stockpiled brick. The repetitious handling of the rough brick all day long in the rain had softened his hands and severely abraded his fingers. One evening at the supper table, he complained of the pain. His father's response was a swift rebuke. "The old man looked into my eyes without looking at the raw fingertips I was holding up to show him, and said, 'You're holdin' on to 'em too long.' He meant that if I'd worked faster, it wouldn't have happened! 'You're holdin' on to 'em too long,' was all he said to me," John repeated with a laugh.

By the time I met John, he had been a mason all his adult life and was in semiretirement. In our town he was simply known as the best there was in the trade. As a young stonemason, I was hugely impressed by his work and pleaded with him to let me work for him. He told me to find a job with a big outfit, start at the bottom, and learn every aspect of the trade. I kept working my own jobs, but eventually he took pity on me—or he figured that since I appeared determined to do the work, he'd better see to it that I did it properly.

In the years I knew him, John was always generous with his time and expertise. As we started working together, he did the bricklaying and I did the tending and stone laying. We built a number of fireplaces and one house foundation. I remember only one time that he was short with me. After complimenting me on a job I'd done, he asked, "Wha'd it take?" Thinking he was asking how much it had cost the customer, I answered with a dollar figure. His big head snapped up and he barked, "Don't tell me how much it cost. I don't care anything about that. How many days did it take?" Quality workmanship done in a timely fashion was what mattered to him.

After John stopped working, he and I sometimes drove around the countryside, visiting places he'd worked. On winter days, we would sit at his kitchen table talking about the different trades and the people we knew in them. He saw himself as equal to all people. Only in piety to God did he place himself in a subordinate position.

Shortly before he died, he advised me, "Work for the same people again and again. They'll become some of the best friends you'll ever make." He also counseled me not to try to get rich quick off any job. "Be fair with everyone and you'll make a comfortable living for the rest of your life." All along, John had been teaching me masonry skills, but what he really wanted me to learn from my time with him was the art of living a happy and productive life.

More difficult for the artist than creating something new is creating something old. Nature defies the touchstones of the artist: planning and building. As soon as a plan is made, nature thwarts it. As soon as an object begins to be built "up," gravity pulls it in the opposite direction. Attempting to give something new the feel of great age is to work at cross-purposes with nature, but who better qualifies to create folly than the artist?

I purposely made a shambles out of this far corner of the garden. A gaggle of walls collide in this "ruin."

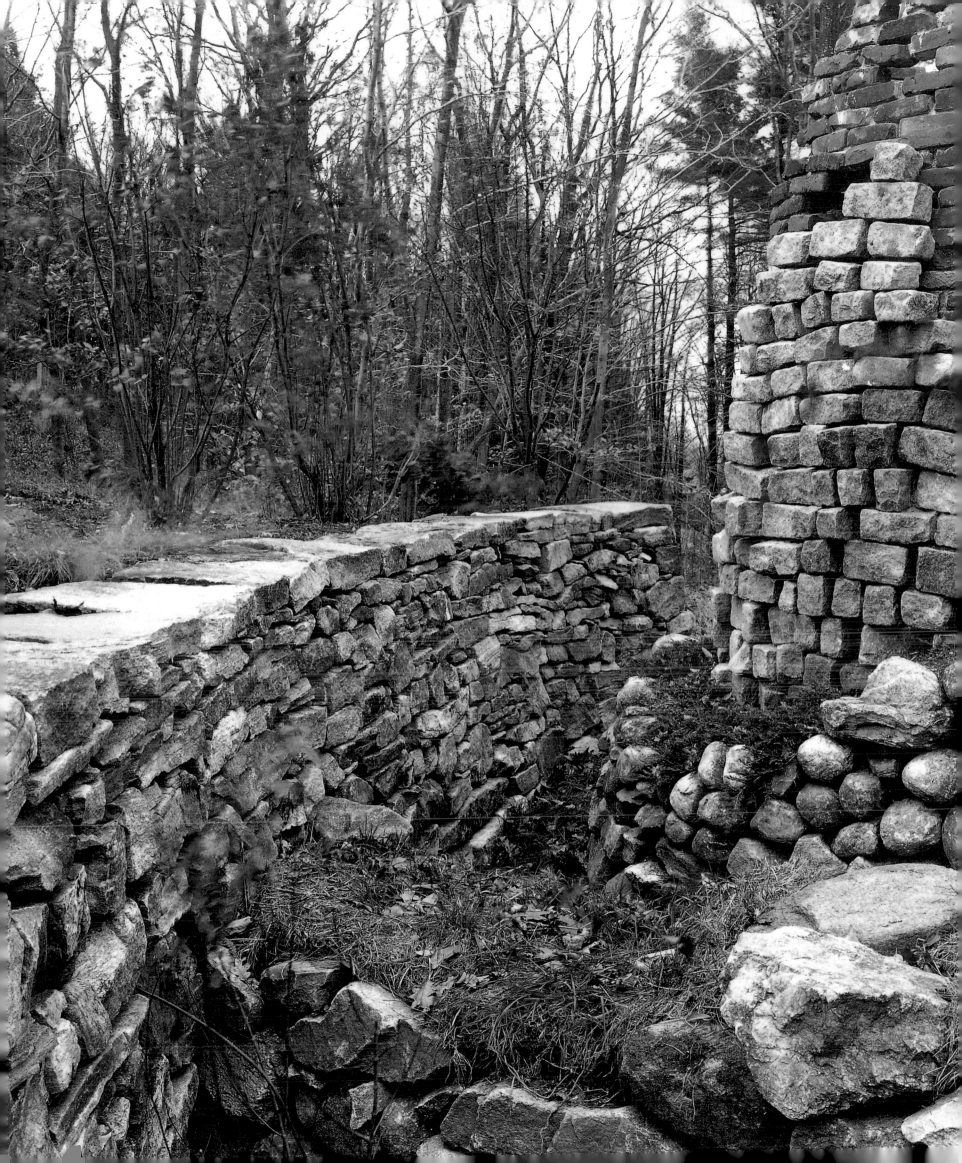

Construction begins

with one stone. Any stone will do because until there is one in place, there is nothing to inspire the selection of another. Every choice is a response to the choices that have come before it.

To begin walling is to acknowledge the power held by stone. Every stone, whatever its size, has the potential to raise the wall up or bring the waller down. It is with a thought that each stone is lifted and placed, and that thought stays with the stone for the life of the wall. I put myself in a humble position to the stone by beginning each thought from the ground. I accept the way things are and subtly change them at the same time.

Building a wall is building faith in oneself. By getting through difficulties and working to satisfaction, I build slowly on small successes. Walling is an eventless occupation: all practice without performance.

PAGES 42–43: In this haphazard of broad, flat stones piled out in a field, one slab appears to float above another. Perhaps a little unorthodox for bleachers around a tennis court, but nice enough to look at when the tennis game is over.

RIGHT: Laid in a herringbone pattern, the stone looks as though it's continuing to fall into place. Despite its chaotic appearance, this style of walling is very sturdy. The weight of each stone presses down on, and across, the wall face, wedging the stones ever more tightly together.

44

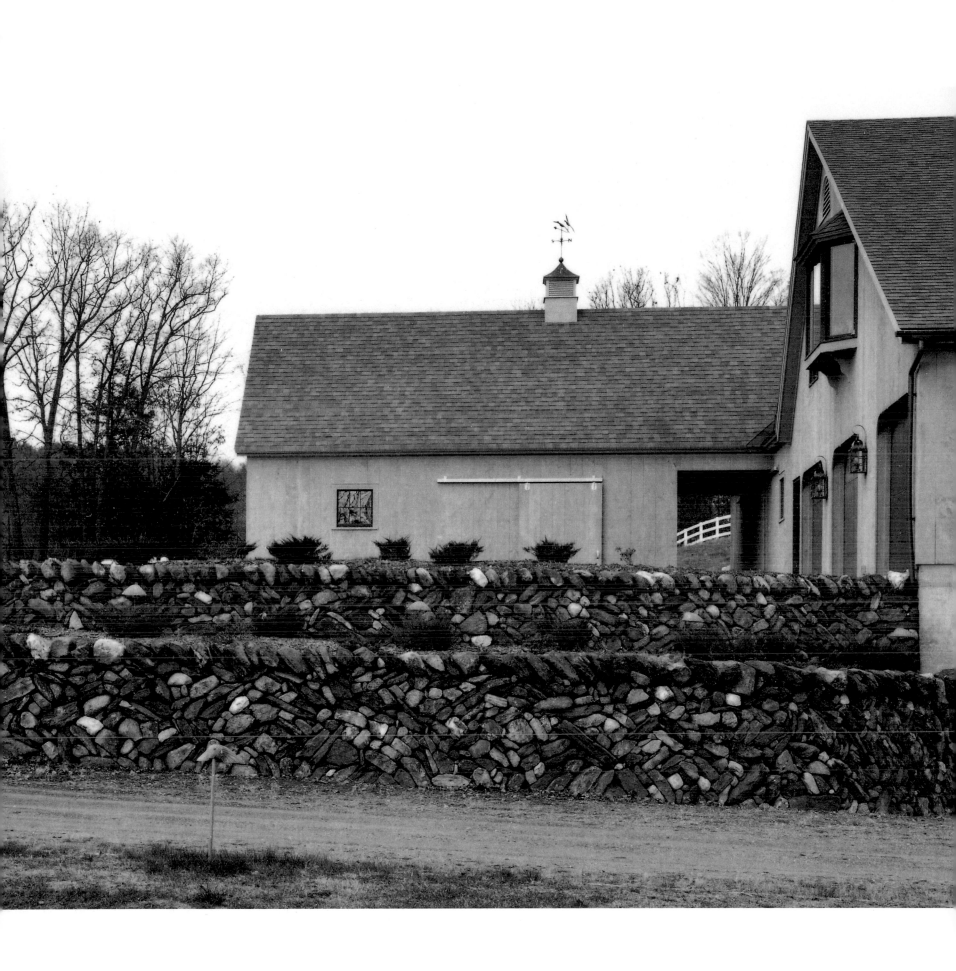

Dressing for walling is a study in protection. The waller

dresses to be protected from the natural elements and

those peculiar to walling. Pants with a double layer of

material on the front of the leg help when kneeling and

when stones are pulled up onto the thighs. Long-sleeve

shirts reduce abrasion on the forearms. Deep-lugged and

flexible-sole boots provide traction and allow the feet

to bend when the waller is in a squatting position, which is often. A broad-brimmed hat that won't blow off is protection from the sun and reduces the glare that reflects back up from the stone. Building sites sometimes have a microclimate of desertlike conditions. The stone absorbs and reflects the sun's heat, and dust fills the air. But at the other extreme, a waller may be found standing, or trying to stand, in a cold muddy ditch, wrestling with slippery stones and wearing a rain suit and rubber gloves.

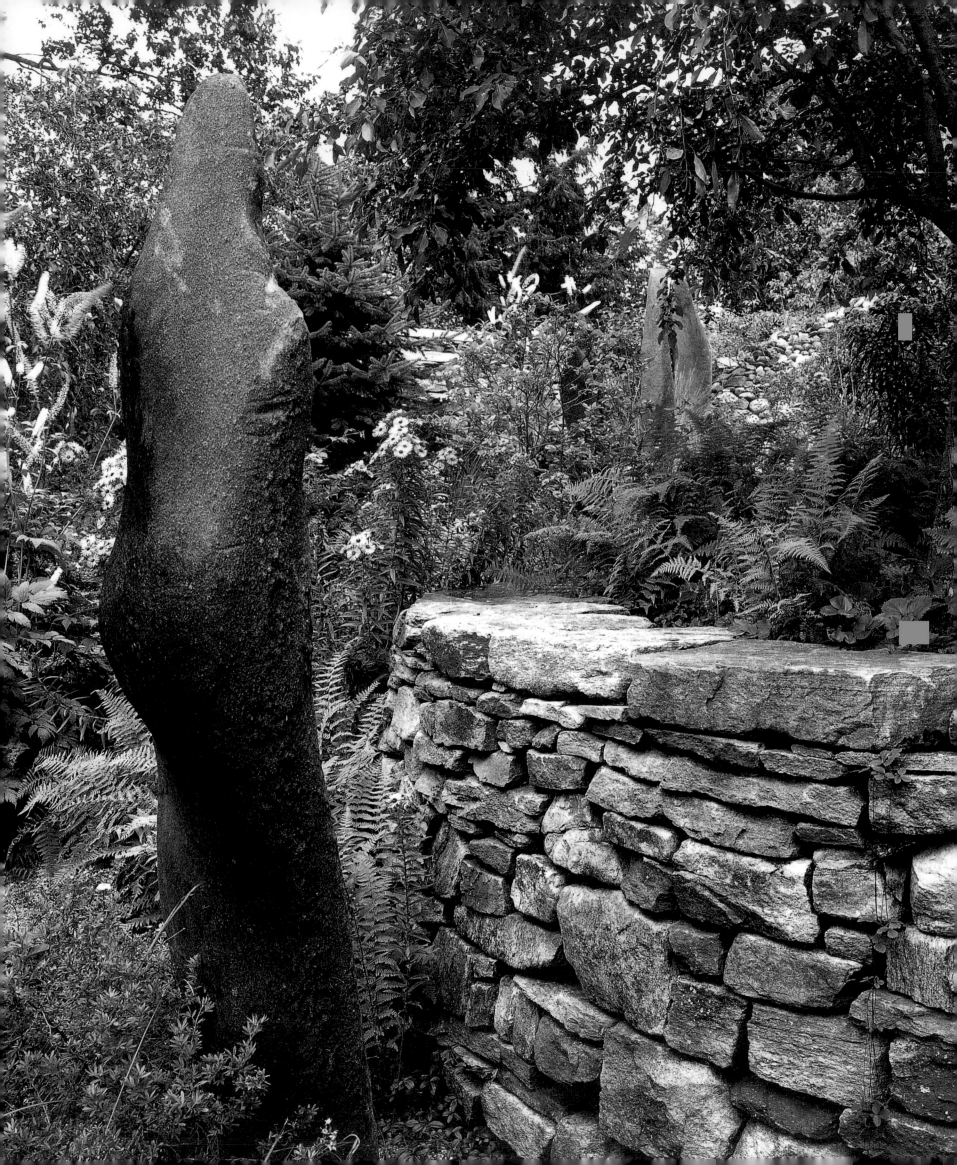

The body is the one irreplaceable tool a waller has. Hammer, pry

bar, level, and string are all important basic tools, but none is as fundamental as the body. The act of lifting stone sets in motion a wide range of muscular activity and affects the body differently according to what is being lifted. A single large stone requires concentrated energy from the arms and legs. Picking up lots of small stone draws energy slowly. Every day, my job is to gauge and monitor the stress I'm imposing on my body; my goal is to expand its limits without breaking it down.

For lifting, my back wants to be straight but not stiff. The movement begins from the top of my head, setting in motion a chain reaction. Even though it happens quickly, I'm aware of the process that's taking place within and can cancel the order to lift before any link in the chain is stressed excessively.

The highest point in the lift corresponds with the greatest lengthening of the spine. A back is a poor lifting device. It is only a way to combine the dexterity of the arms and

hands with the strength of the legs. When the torso does act as a lever, it is actually the abdominal muscles that are doing the work. If my back aches, it is probably from being used improperly

Moving small stones from stockpile to wall is more a matter of shifting than lifting. In shifting, the body's endurance is tested more than its strength. My legs become a wide A-frame structure for my upper body to swing back and forth on. My torso cantilevers out from the hips, and my flattened back is parallel to the ground. In this position, I can grab and fit one, two, or more small stones at a time into the wall because I stand on the same spot, pivoting on the balls of my feet, until it's time to move to a new position.

Because there is such a strong direction of "going to earth" in the construction and in the waiting stockpiles of stone, it is vital that I keep an attitude of "up." Amid the inertia of tons of stone, it is easy to be seduced into adopting an identical outlook. My path lies between being grounded

in balance and stability and being detached for safety and creativity.

In walling I seek a continually expanding sphere of influence over my outer and inner worlds. Potential for growth is on all sides. Hands work together in reaching for, balancing, and controlling stone. Because nothing separates me from the stone and because my entire body is employed in the movement and control of it, I achieve clarity of action. The more open-minded I can become, the easier the building. If there is an obstacle, it's likely to be under my own hat.

OPPOSITE AND PAGES 50–51: Hay-scented Fern (*Dennstaedtia punctilobula*), New England Aster (*Aster novae-angliae 'Alma Potschke'*), and Purple-leaved Snakeroot (*Cimicifuga ramosa 'Atropurpurea'*) accompany the figurative standing stones that decorate the barn foundation ruin. The unique shapes were carefully collected many years ago by someone clearing a field, but they were never used for anything. As it turned out, I was the lucky one to erect them.

49

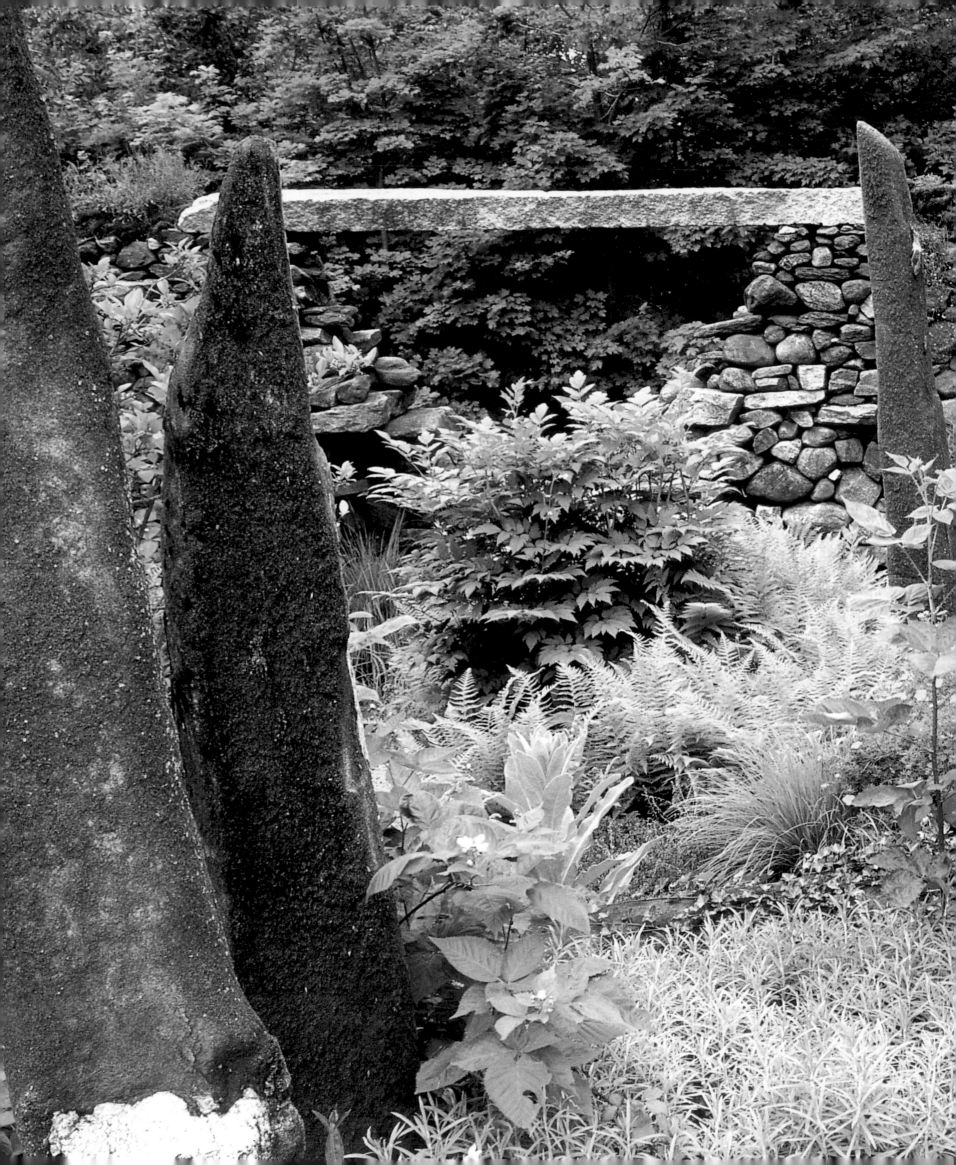

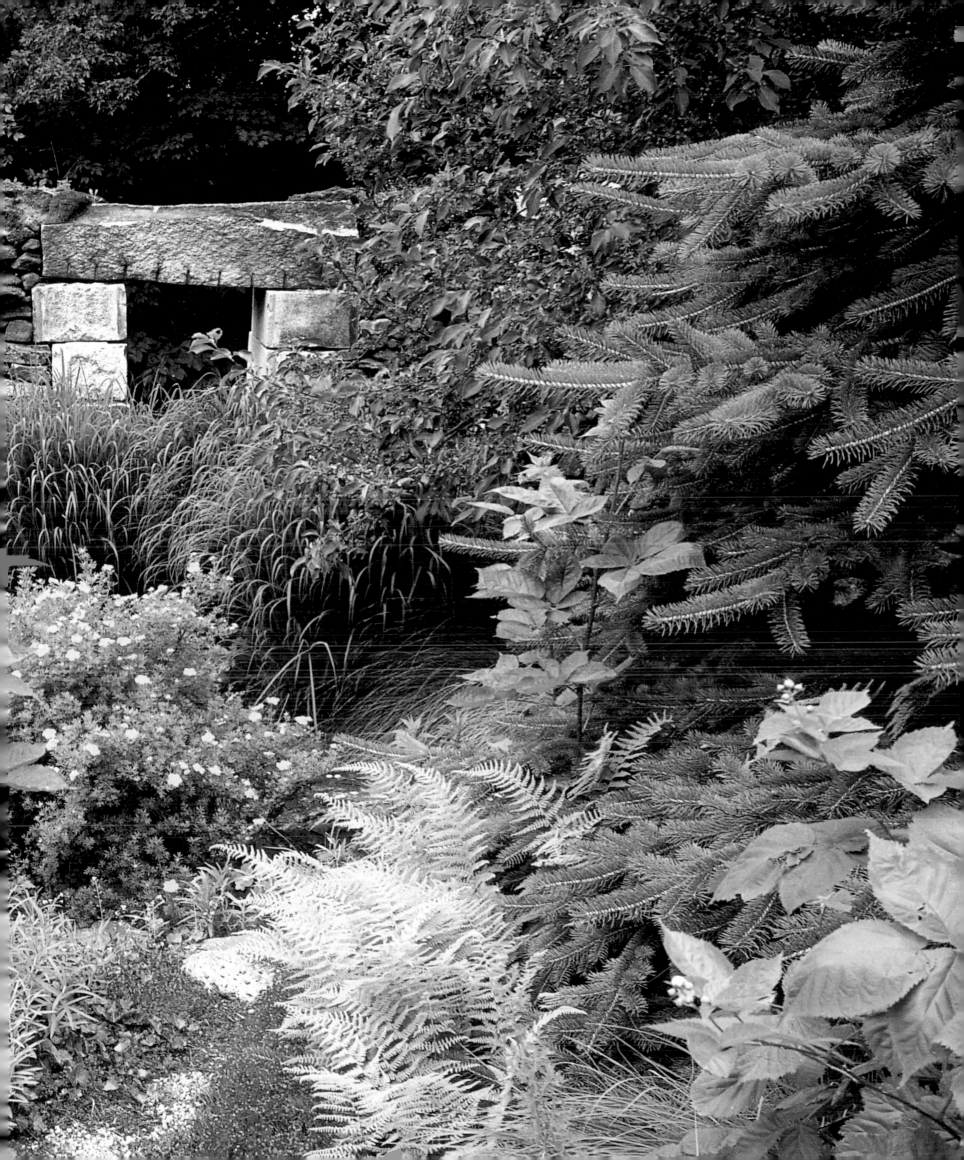

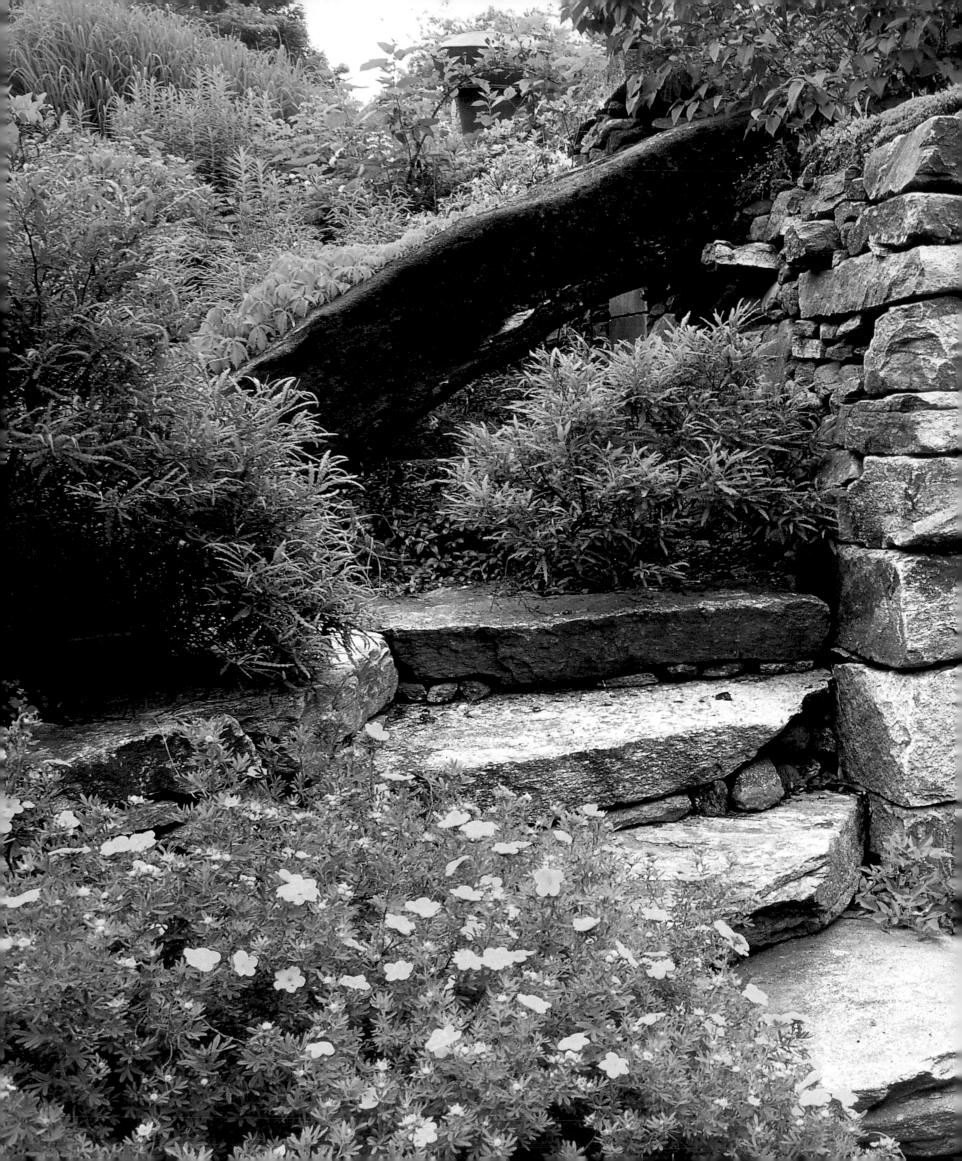

Drystone walls are old forms full of new ideas.

I find fresh possibilities for solving age-old questions in every stockpile of stone. Over the years not much has changed in the working mode of wallers. The formula for a wall built in A.D. 2001 is recognizable in a wall built in 2001 B.C. But in those two walls, and in all the miles of walls built in the time between them, no two collections of stone were handled in quite the same way, or appear in exactly the same relationships. But all these stones of infinitely varied shapes, put together in endlessly different combinations, have produced walls that look not that very different from one another. The whole, it turns out, is simpler than the sum of its parts.

To further the sense of passing time in the barn foundation ruin, a standing stone was allowed to fall across the path at the top of the stairs. By barring passage to a place that once upon a time might have been commonly traveled, a feeling of mystery is born. Shrubby Cinquefoil (*Pontentilla fruticosa*) blooms in the lower left-hand corner of the photograph, and Sweet Fern (*Comptonia peregrina*) flourishes under the fallen menhir.

To gain a sense of a large stone's mass, something close to an embrace is required. I squat over the shape with my arms stretched out against the insides of my bent legs, my hands spread out under the lower edges of the stone, my torso pressed against its upper surface. I never said this wasn't a dirty job. As my legs push off from the balls of my feet, my body is forced against the stone, tightening the bond between us and rolling us forward and upward.

Instantly the stone's center is intimated. My arms hang stretched from my shoulders with the weight of the stone beginning to roll away from my rising chest and head. To hold the embrace would be to topple over with the stone, so I go up while the stone turns over. My hands stay with the moving stone, monitoring the progress of the freewheeling mass.

There, at its apogee, the quick burst of energy that began the stone's journey is spent. Left on its own, the stone will plunge swiftly to an unplanned destiny. If I am successful at handling its falling speed, it is instead transformed into a directed, powerful force.

To accomplish this, I pit my leveraged weight against that of the stone. With heels braced on solid footing and spine arched away from the intended line of travel, my hands grasp the upper extent of the stone and direct the action. A twist here, a pull there, a few minor adjustments to

the stone's fall lengthens the distance it travels, increases the height it climbs, or orients its face to fall at the front of the wall. Perhaps it does all three.

The moment of impact is the signal to return my attention fully to my own person. All body parts are out from under the load. To hear my hands "slap" the top surface of the stone and the "clack" of the stone landing on the wall at the same time is music to my ears. It's a signal that all fingers are safely above the load as the stone hits the wall and that my body continues its motion upward.

Mac McAuslan, a friend and retired rigger, gave me some advice on the safe lifting of heavy objects: "Stay out from under the load." His simple words return to me whenever I'm faced with a potentially dangerous lifting situation. I've taken his advice and made it my rule. His simple words quickly dispel any of my problem-solving ideas that might sacrifice safety.

If the corbeled entryway arch isn't enough to signal the beginning of an unusual experience, immediately upon passing under it one must navigate a stream that trickles across the path that leads farther into the ruin. The stairway is flanked by Pearly Everlasting (*Anaphalis margaritacea*), artemisia, and roses. Along the stream grow Butterbur (*Petasites japonicus*) and Yellow Flag Iris (*Iris pseudacorus*).

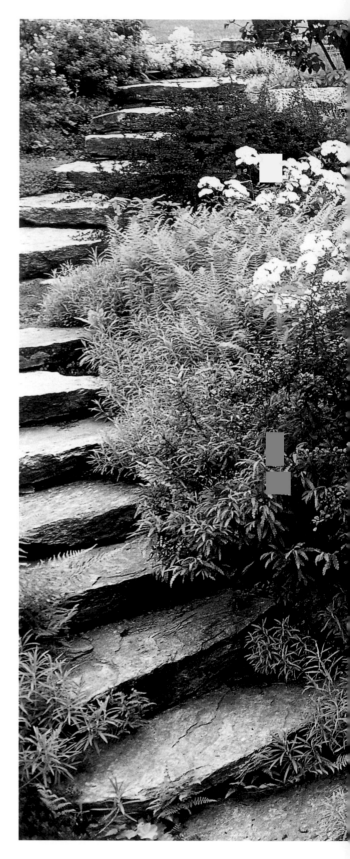

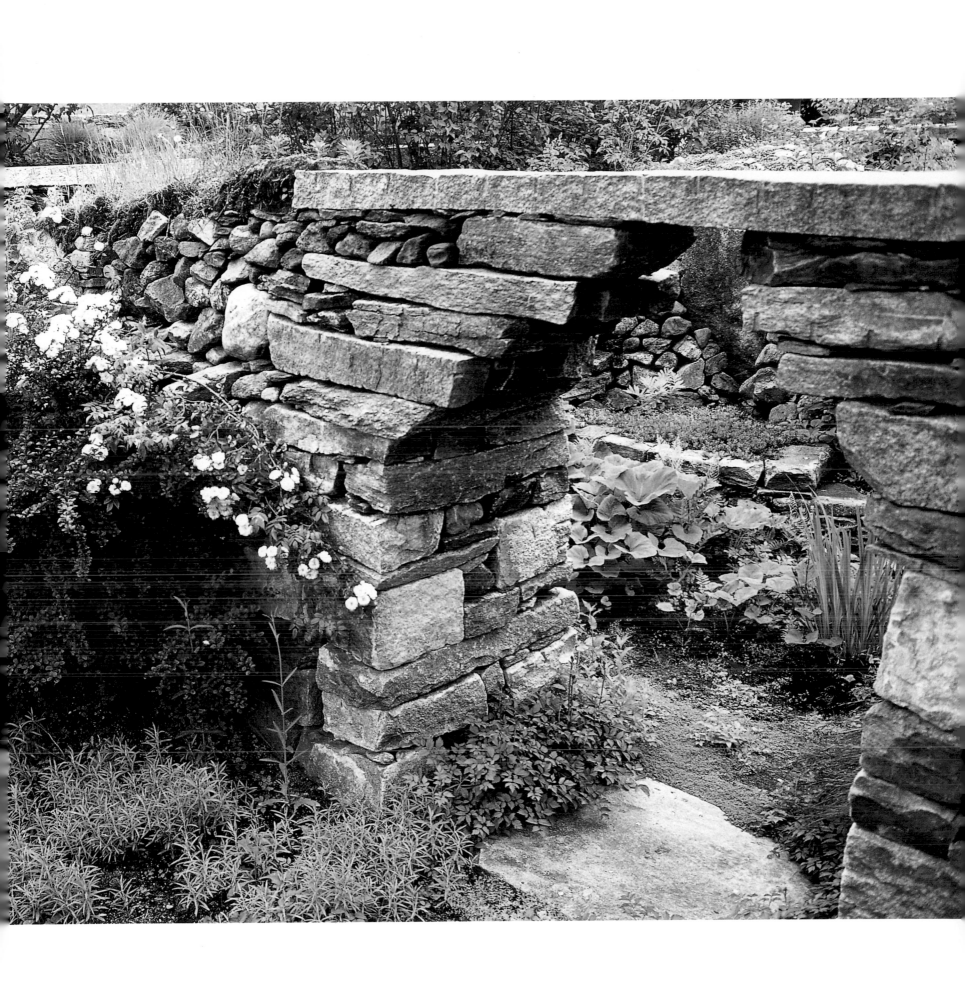

My friends and neighbors ask me to build them things out of dry stone. People have unique knowledge of their property and land. The more I know of what they understand or dream about their place, the better a tailor I can be. I want to make walls that hang well off the shoulders of the earth or tuck neatly into its waistband.

Euonymus (*Euonymus fortunei 'Kewensis'*) finds a good foothold on the granulated surface of a vertical granite slab.

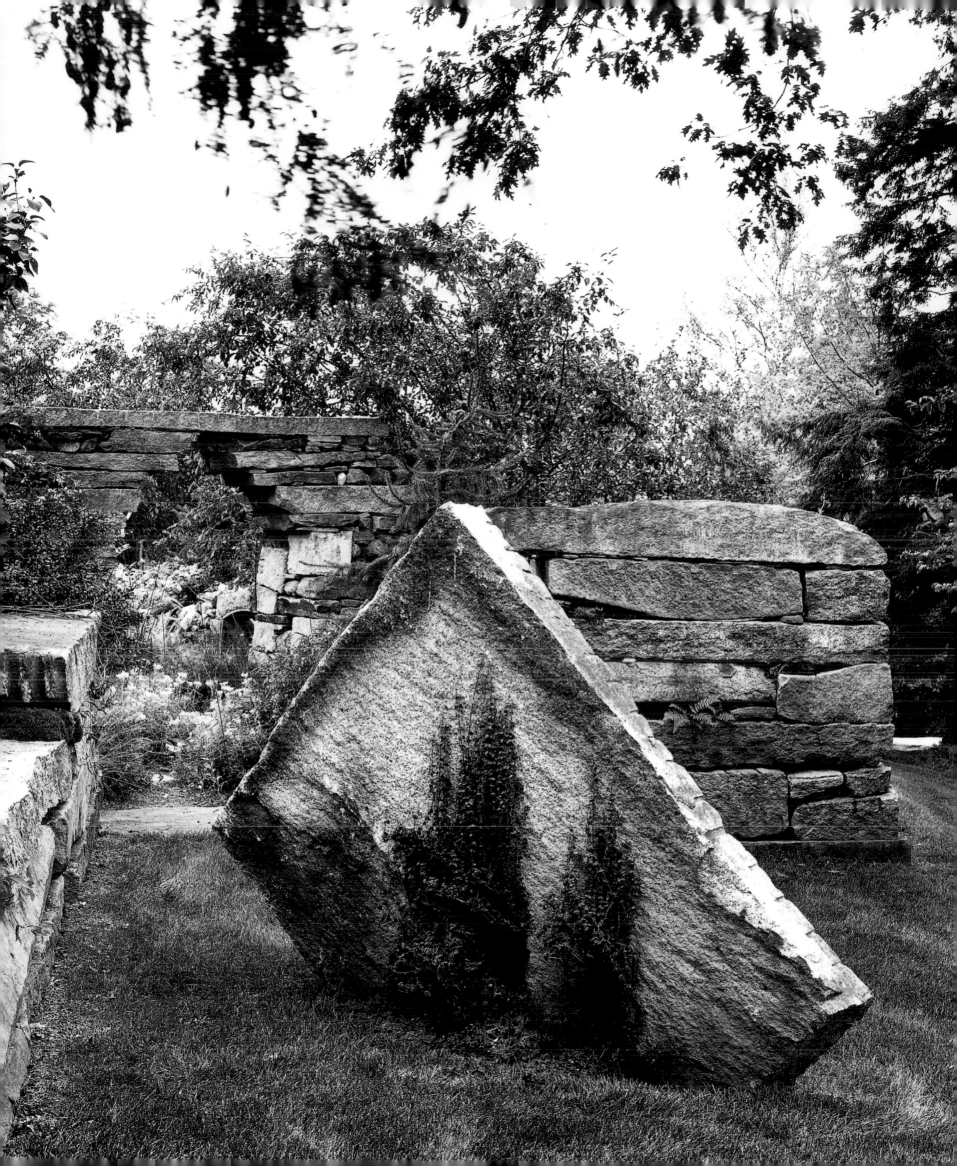

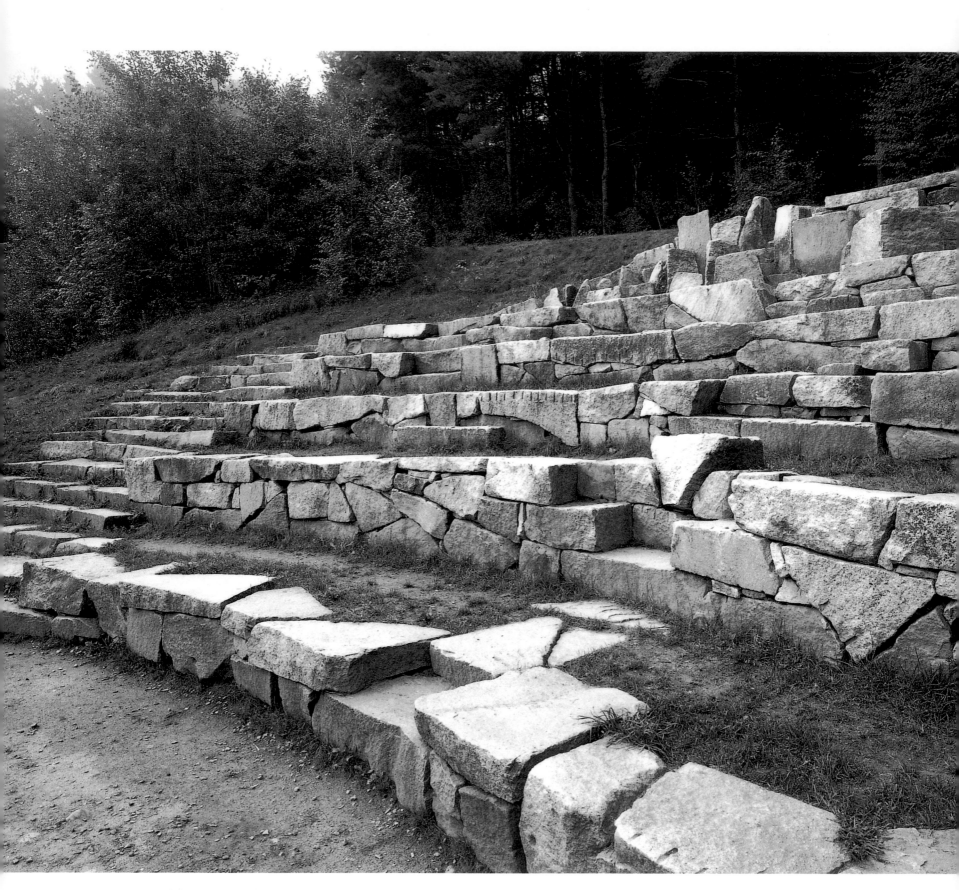

In this amphitheater, built in the spirit of the ancient Greeks but used as a grandstand for the town softball field, audiences are more likely to hear the crack of a bat than the cry of a thespian.

Humans have been drawn to flat, level stone surfaces from our very beginnings. Flat stones are like reference points in an ever-changing world, a place to gather around that remains steady.

PAGES 60–61: Before the table and chairs were added for outdoor dining, this egg-shaped patio sparkled like a pool of light under the dark-leaved branches of an oak tree on the edge of a clearing. Thin sheets of workable stone made hammer-trimming these shapes to fit closely an easy job.

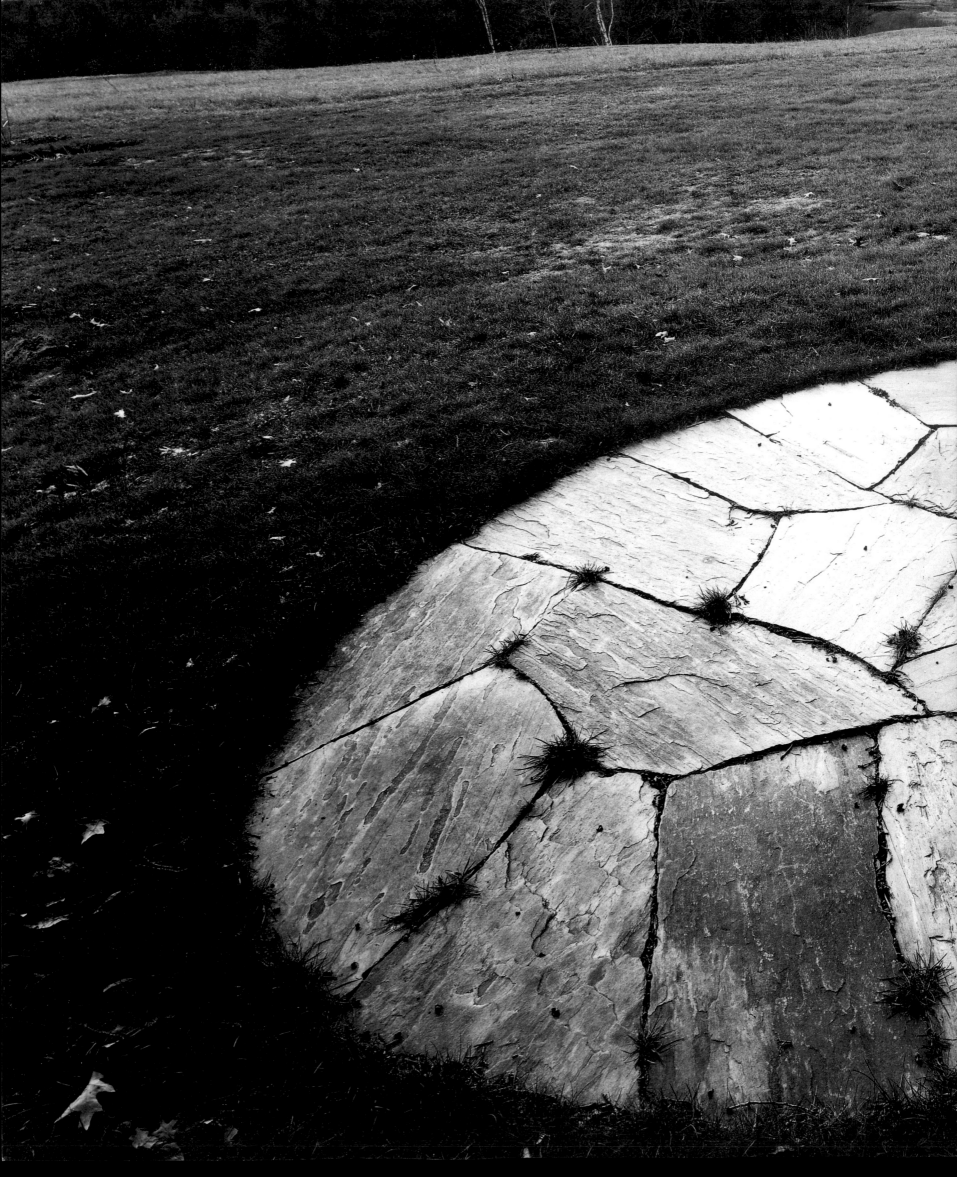

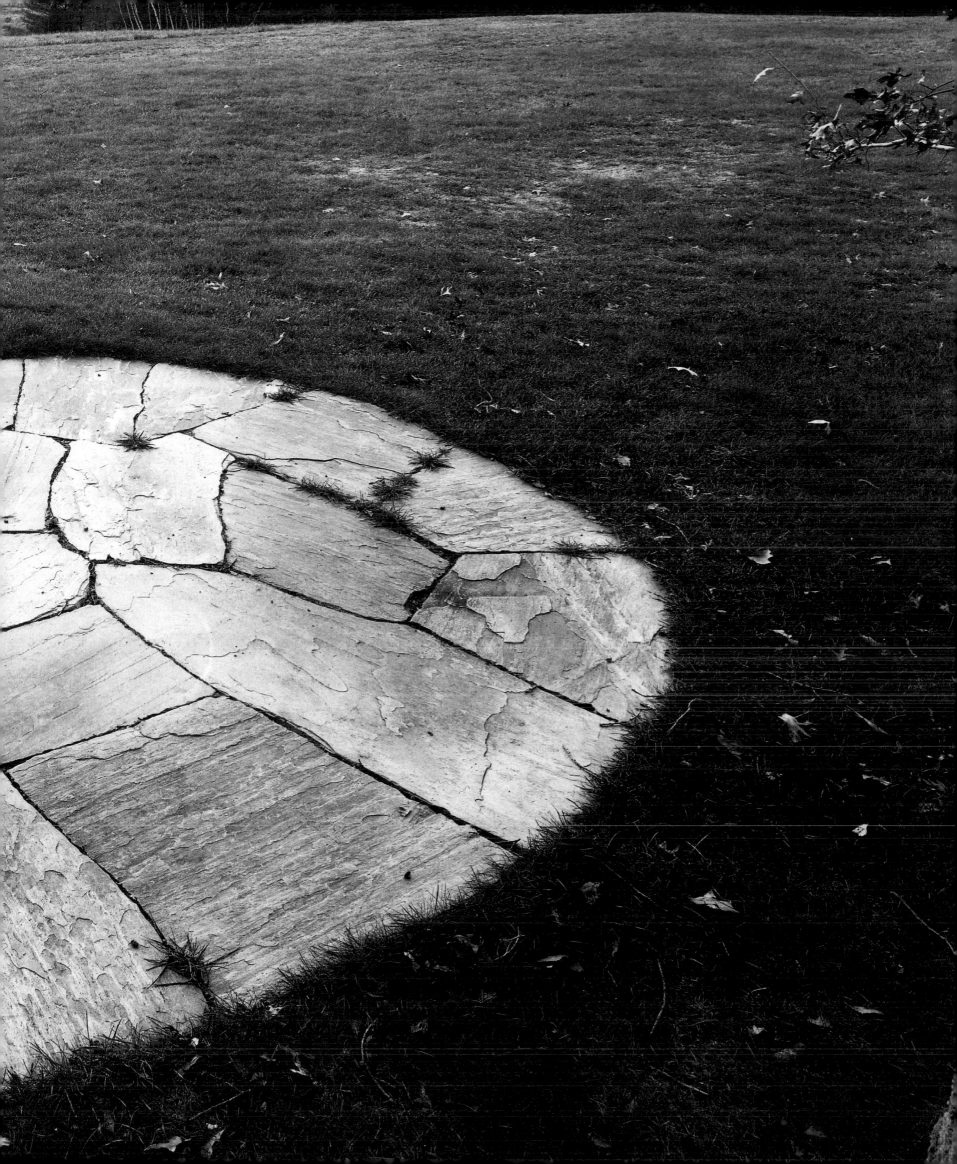

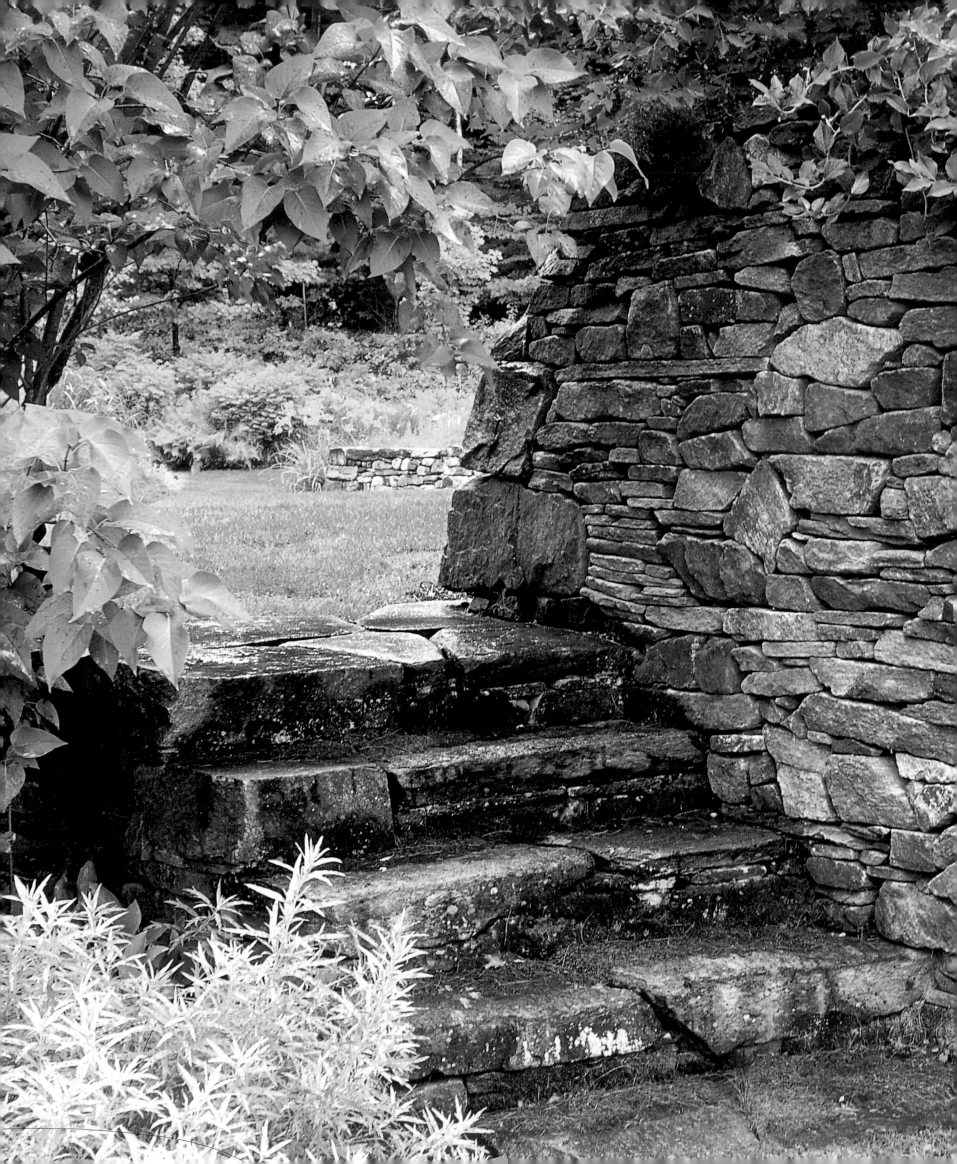

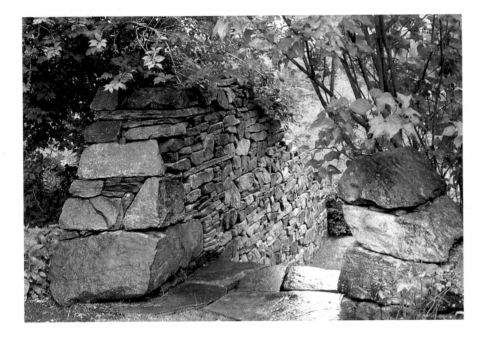

Soon after human beings picked up the first stones, they probably

hurled them to the ground in an attempt to break them open. The desire to see what was inside would have been too tempting not to. I flatter myself by thinking that my own effort to break stone issues from some loftier calling. Of course, the professional reason I break stone is quite practical: I attempt to modify its shape to make it fit more snugly next to its neighbor or to create a more ready surface for the upcoming courses. But that's not to say that I don't, in fact, look to see what I've exposed every time I strike and break a stone with a hammer.

A lot of energy is spent hitting a stone—double that of lifting it. Unless the type of stone being used can't be shaped because of its hardness or fragility, hammering is often an unavoidable part of my day.

A hammer with both a blunt and wedge-shaped end performs two functions. The blunt end is used for

spalling and pulverizing, the wedge end for chipping and splitting. How the stone is readied, or "banked," for shaping, the degree of force, and the number and placement of blows are all variables in a process that only experience teaches. An accurate break with the fewest hits is the goal.

Stone speaks out as it is struck. Its words may indicate agreement with the hammer's demands, or declare its solidarity. Trimming stone is like giving a haircut to a youngster: If you catch him in the right mood, the job is easy and quick. Stone is put in the mood to be broken by its bottom being given a comfortable seat. The edge that is to be trimmed is made uncomfortable by being laid over a hard spot. A hail of hammer blows is directed toward the edge cantilevered out over the hard spot. Stressed and looking for relief, it fractures. It yelps, and a shard jumps off.

The long note that is sounded when a seam is split grows deeper as a seam is pried apart. Yawning deeply, stone vocalizes from way down in its old throat. It buckles apart, becoming two stones with two new voices.

Before lifting a hammer, I protect my eyes. I was convinced of the importance of safety glasses for myself after talking with a quarry worker who snickered about a fellow quarrier who was wearing a protector. "He lost an eye splitting stone, and now he has to wear those things." Realizing that I would like to keep both of my eyes, I immediately began wearing safety glasses.

OPPOSITE: Artemisia (*Artemisia ludoviciana*) edges the moss-coated steps.
ABOVE: Hooded in forsythia and lilac (*Syringa vulgaris*), two rakish wall ends invite exploration down into a sunken garden.

ingenuity

Michelle and David Holzapfel are workers in wood. Or perhaps it would be more accurate to say tree-parts artists. Under their guidance, roots, twisted limbs, hollow trunks of trees, and burls are brought out of the woods to become sculptures and furniture. Like me, they take what they find and see what it has to offer before beginning a design. Relying on uncertain—and unexpected—sources for our art can sometimes make for tenuous times.

One day, David asked if I would be interested in trading art with them. "Art for art," he said. "We'd love to have one of your walls. Take a look at all this stone!" Two years earlier, the highway department had drilled and blasted a hump of ledge on the edge of their property, removing it to improve visibility on a curve in the road. The outcrop, originally the size of a school bus, was relocated, in many pieces, to another spot on their property. This was the stone they had in mind. It had been shocked, shattered, and ripped from the earth; broken strands of colored

blasting wire sprouted ominously out of the weed-choked heaps of rock and dirt.

Most days I would have turned my nose up at the thought of using such a ratty-looking collection of jagged stone. But after many days of rain, the trail I'd been traveling to get out stone for my current job had become impassable and I was out of materials. So on that day I was happy to have any supply that was accessible. David and Michelle's piles were on high firm ground, and I agreed to start right away.

Two years before the solid ledge had been turned into loose stone and moved forty yards. Now I moved it another forty yards and turned it into a solid wall.

When the wall was finished, Michelle was delighted that I'd used up so much of the stone, especially because it had seemed unusable. "It's like walking into someone's kitchen, looking in the refrigerator, and making whatever ingredients you find into a great meal!" she said.

Early in the process I had dis-

covered what positive attributes the supply did possess and used them to my advantage. By respecting the limitations of the supply and designing a wall to suit them, I realized that the final results looked and felt appropriate in every way.

The animal I most closely associate with drystone walls is the chipmunk. How wonderful it must be to know a wall from its inside out! For chipmunks, a wall is protection from predators, cozy sleeping quarters, and a safe place to store food. High points on the wall are their lookout stations; a wall's length is like a highway through the forest. Voids within the wall are their dining rooms. I've found the remains of a pinecone, pulled apart by a nimble-clawed chipmunk to get at the seeds. Perhaps most unusual, I once lifted a stone off an old retaining wall, exposing a tunnel out of which came rolling, single file, dozens of tiny cherry stones, the remains of a feast at a black cherry tree. I was so struck by the sight that I collected the shiny pits that had fallen there at my feet, drilled small holes in them, and strung them together to make a necklace.

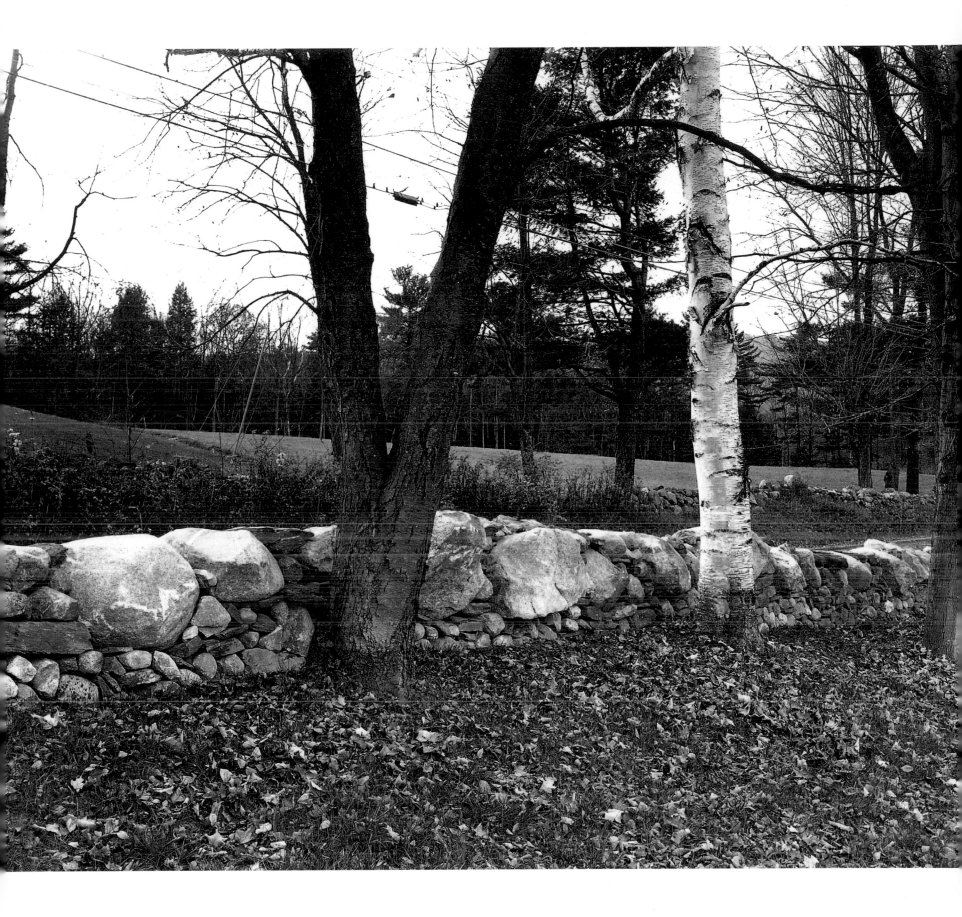

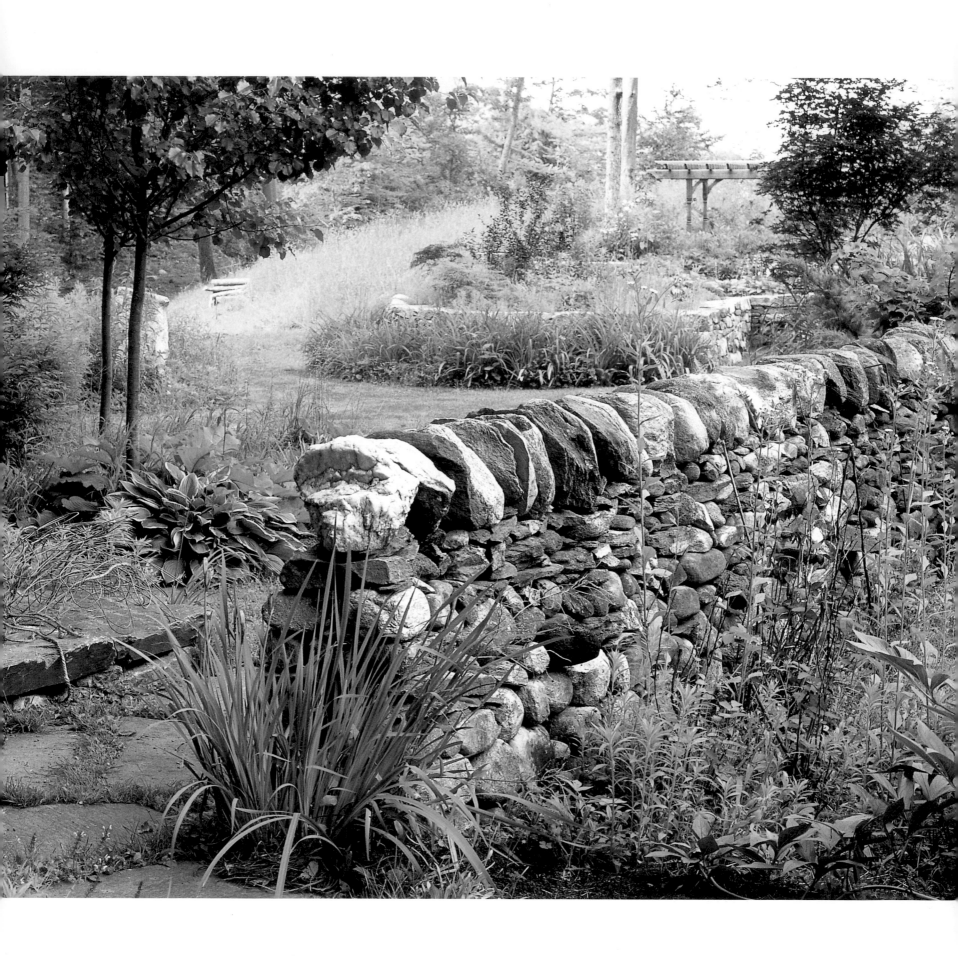

"Mute as a stone," the old saying goes. I suppose that's true if the stone is in repose. Strike it, though, and it will begin to jabber. Flip it across a stockpile

and it will talk to every stone it meets along the way. It will rattle and clatter against small ones, grind and rumble over large ones. Stones already in a wall talk back.

I overhear stones in conversation; the clacks and clucks keep me apprised of what's going on under my hands but out of my sight. Sometimes I put in my own two cents' worth, but mostly I just listen in, and what I hear helps me raise the wall. I can catch and correct an unseen space lurking under a freshly set stone when I hear a hollow sound as the stone goes down. I know a stone is secure if it seats itself with the sound of a dead bolt lock being thrown.

Walling is like being a tour guide for a group of people who speak a language I don't. I may not understand their conversation, but by their tones I can tell if I'm leading them where they want to go.

A silent sentry is posted at the garden entrance, its distinguished white-quartz head standing out from among a soldier-straight line of cope stones.

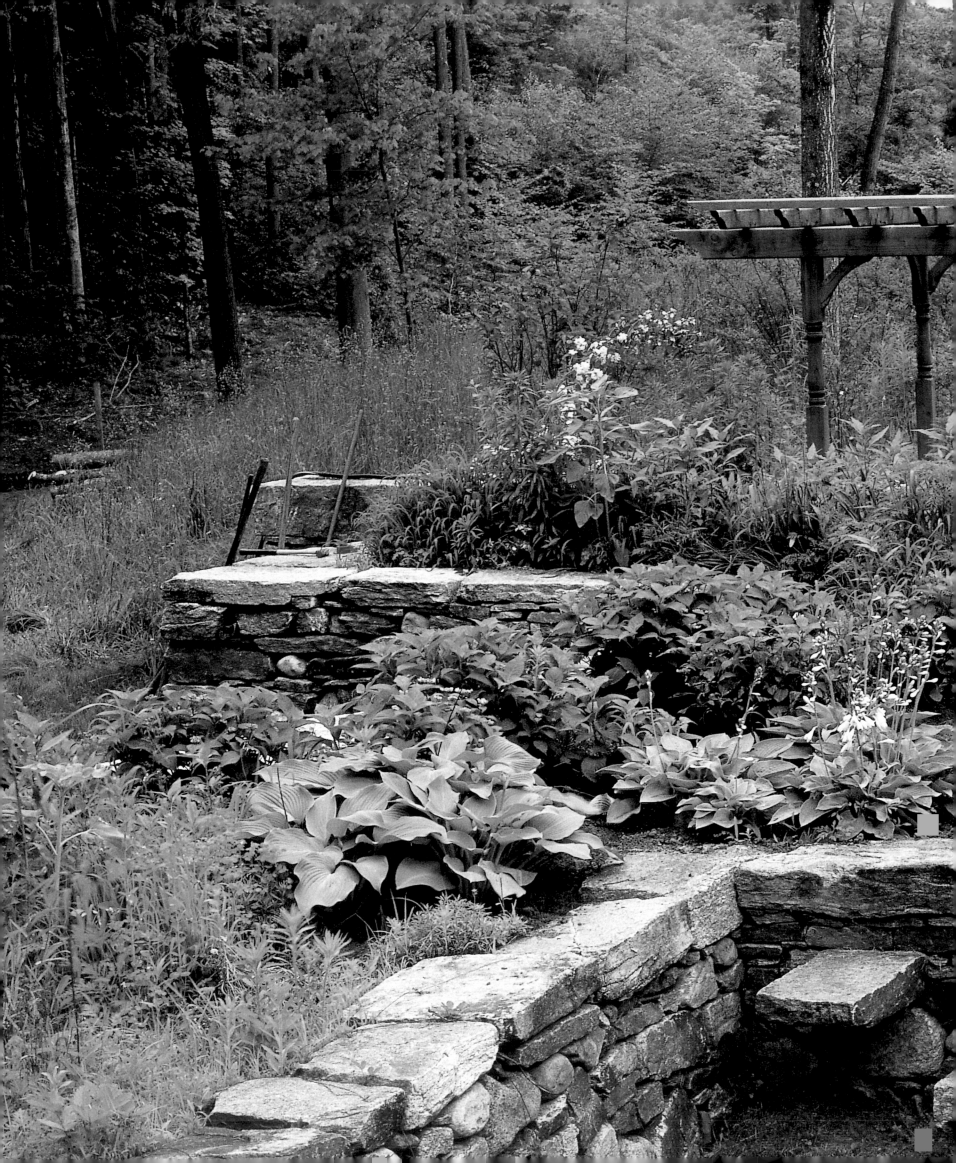

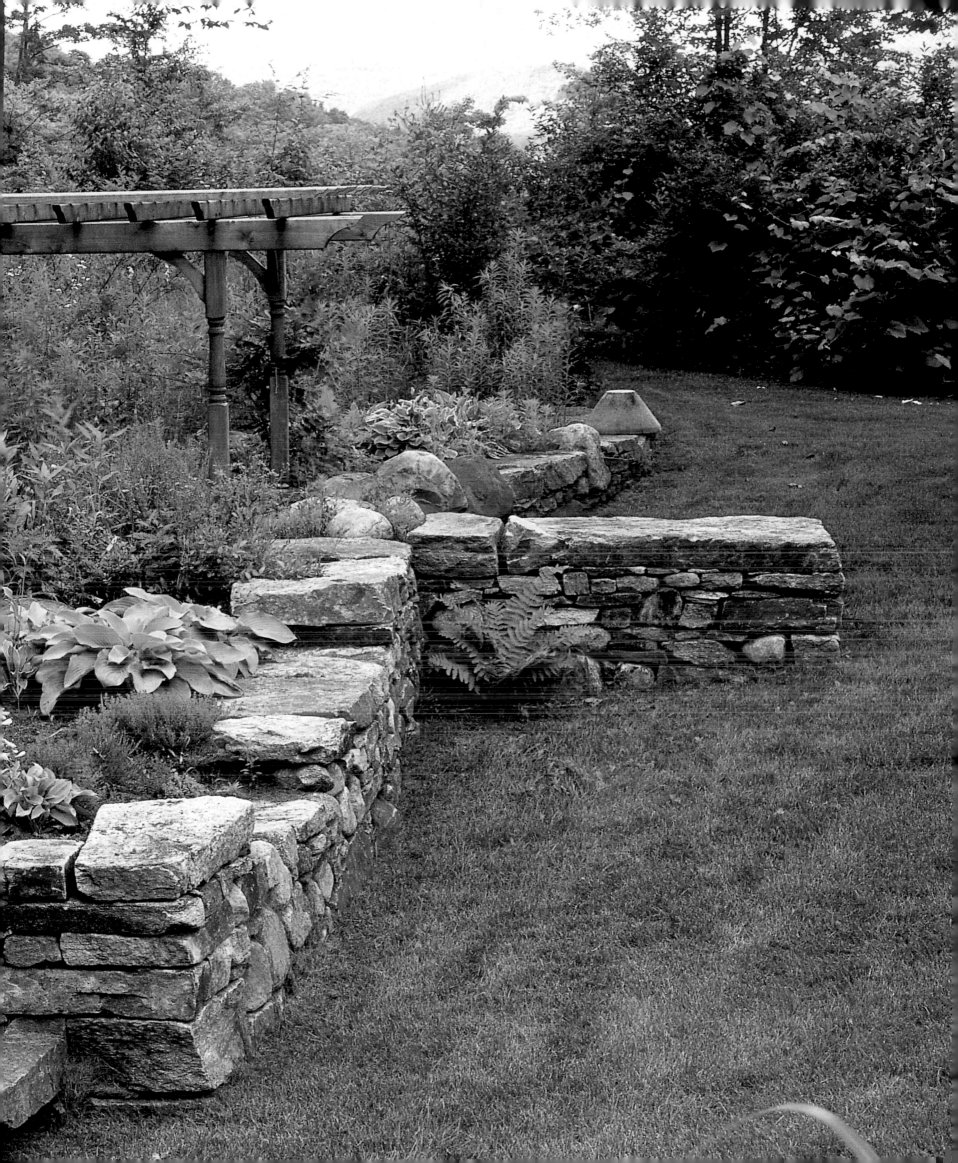

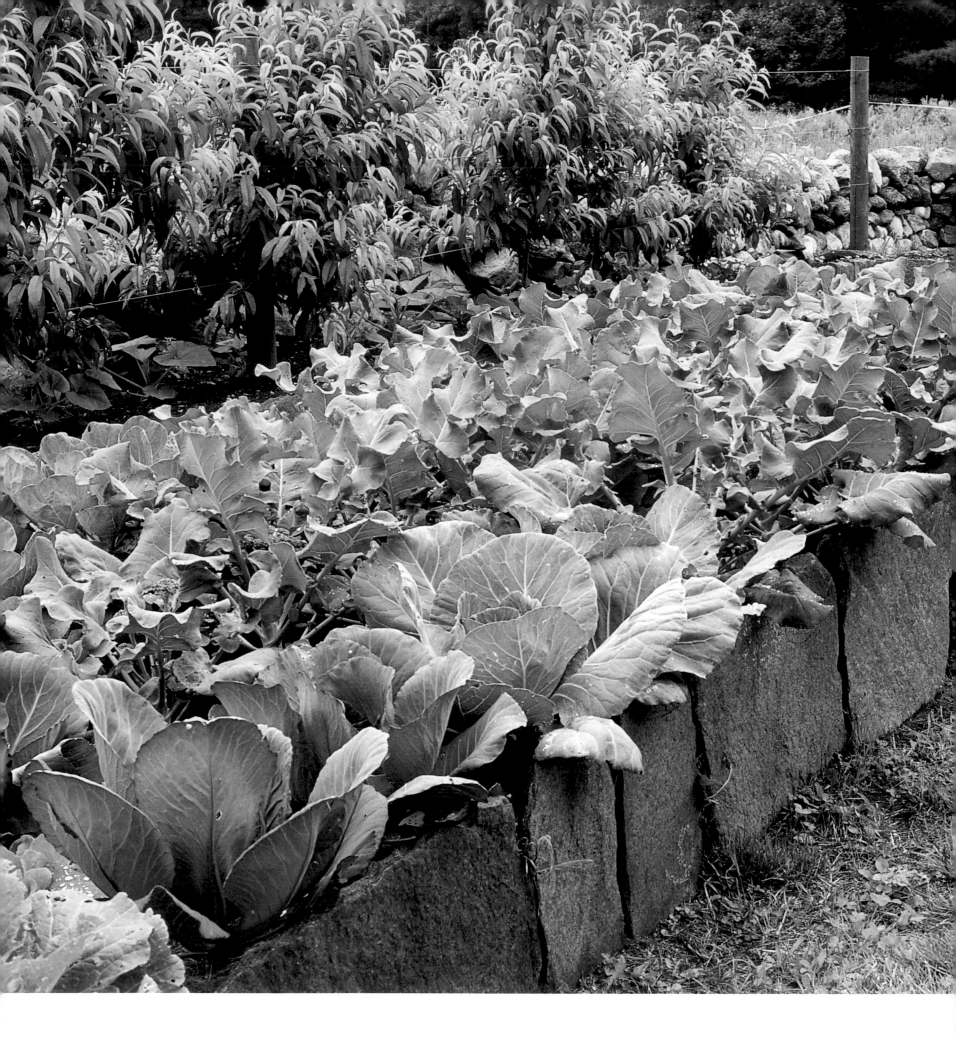

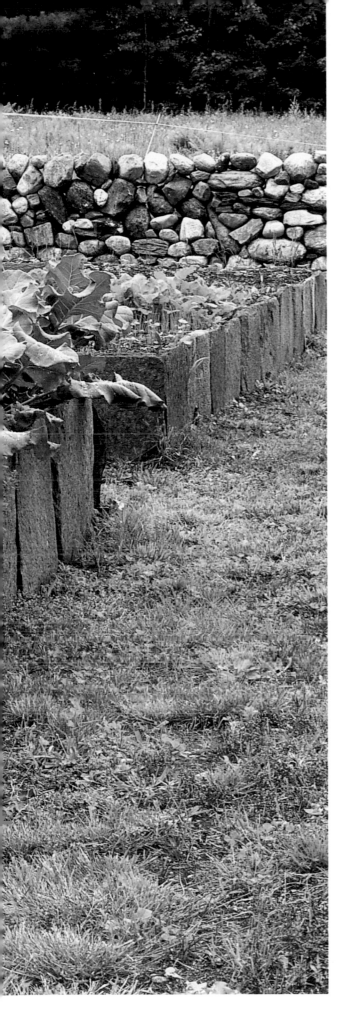

Some stone is layered and formed in the manner of a book. It can be cleaved between its pages. I throw the wedge end of the hammerhead against a seam running along the edge in an attempt to split it in two.

PAGES 68–69: While the arbor frame awaits the growth of climbing vines that will someday cover it, the raised bed plantings have flourished in less than two seasons' growth.

LEFT: To support the weight of soil in these raised beds, the quarry stone slabs had the lower half of their height buried below the grade of the path. A fieldstone fence lines the edge of the vegetable garden.

Traveling around New England, I've noticed
that the most carefully constructed and well-
maintained drystone walls are around old
cemeteries. Respect for those who have died
is reflected in the quality of the stone craft
found in and around these resting places.
I was pleased to be asked by stewards of
this countryside cemetery to build a stone
fence to replace a worn-out metal one.

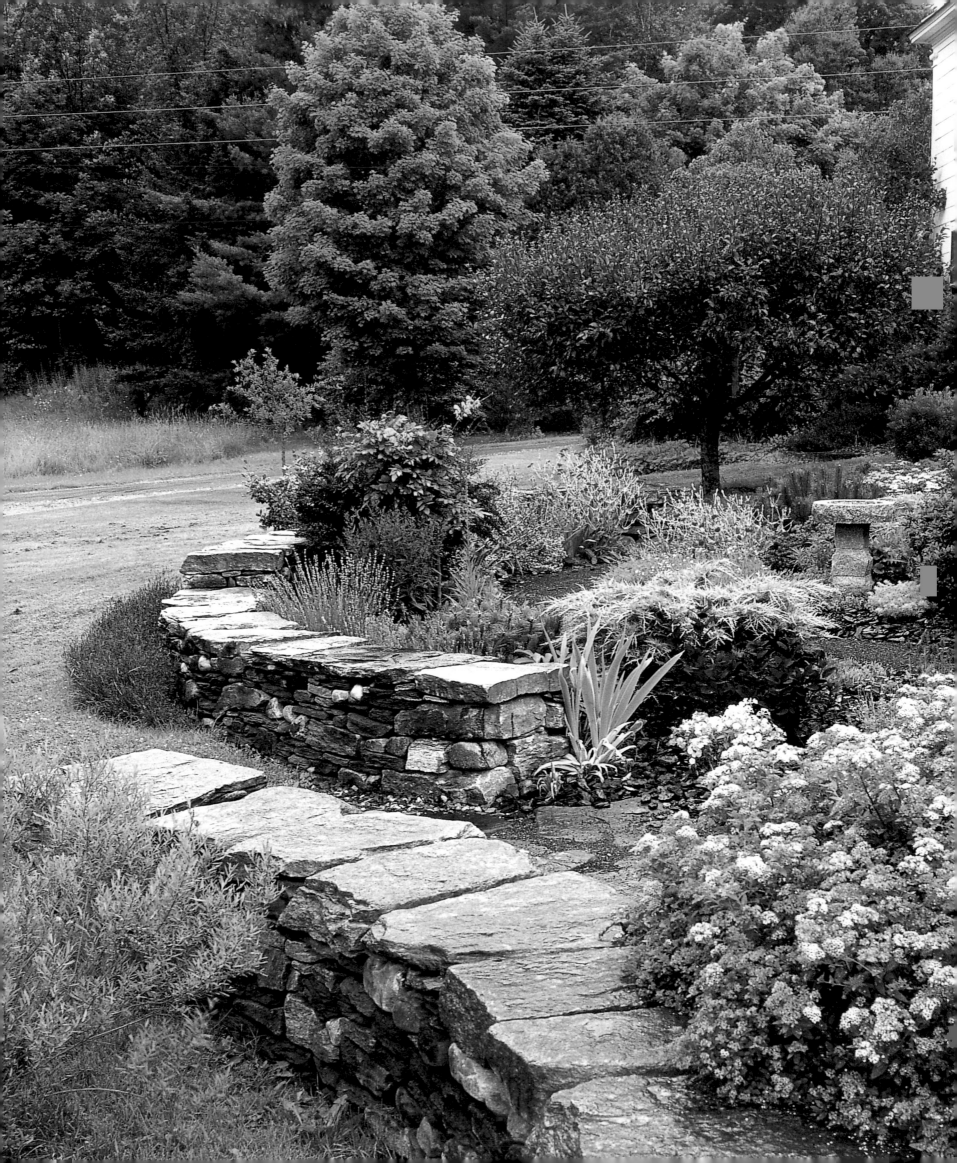

Walls are "never to be opened" boxes of stone.

They are carefully crafted containers that are always full and cannot be emptied.

Stone from three sources was used to assemble this pair of walls: small flat pieces of quarried stone for leveling the courses, medium-size rounded gravel-pit tailings for faces and hearting, and large slabs of natural block field material for corners and tops. Spirea (*Spirea x Bumalda*), dwarf conifers, and barberry are interplanted with bearded iris, lavender, dianthus, and campion (*Lychnis coronaria 'Atrosanguinea'*) to form a border garden.

readiness

Hugh and Emery Evans were brothers, and Harry Evans was Hugh's son. The Evans's farm milked forty Holsteins, sugared maple, and custom-sawed lumber. For a young fellow like myself, it was the perfect place to learn how to do a lot of different things. It was also where I learned that most of the business of accomplishing something was preparation. Helping out with farmwork gave me a broader view of the laboring life. I developed an appreciation for the flow between chores as much as for the chores themselves.

In between barn chores, the Evanses often headed into the woods to harvest trees. They hitched an open-sided wagon to the tractor and loaded on chain saws and logging tools. Harry pointed the skidder toward the woods and Hugh followed with the tractor. Across the slow-running waters of the brook, chain-clad tires crunched their way toward a logging trail that climbed the northwest slope of East Mountain. Emery and I would ride the wagon standing

up. Emery took a wide stance, fixed his eyes on some distant point, and bounced up and down on the wagon bed as erect and sturdy as could be. I just couldn't get the knack of standing on a bouncing platform, especially when it was moving uphill. The second time my legs went out from under me and landed me on my backside, I slid myself off the edge of the moving wagon and walked behind it. If I couldn't stand, I wasn't going to sit. It was less humiliating just to walk.

At the top of the trail, I watched to see how I could help. Without discussion, the men spread themselves out around the forest floor. Emery took the power saw to the base of a large hemlock, started the saw, and motioned for me to join him. "You're the chopper; where are you going to drop it?" Suddenly, I was the leader, and my heart raced at the excitement of the challenge.

I pointed in the direction I thought it should fall, and Emery asked me what to do first. I shrugged.

"Find your escape route," he explained. "You want to have an escape route ready if things don't go the way you plan."

I figured which way to run if I had to get away in a hurry from the falling tree and cut the path.

A lifetime of working on the land had taught Emery that things sometimes go wrong, and that anything less than preparation for any eventuality was an invitation to trouble. I managed to bring that tree down without incident. Since then, I've not always been as lucky. I've had to use my escape routes, and I've been mighty glad they were there.

These lumpy stones are typical of those often found discarded in a heap at the edge of an old farm field. I thought it would be fun to lay them up in their common context but in an uncommon shape. Although I don't know what the actual ratio of mass is from bottom to top, I was surprised and impressed by how much more stone was required to build the bottom half of this pyramid than the top half.

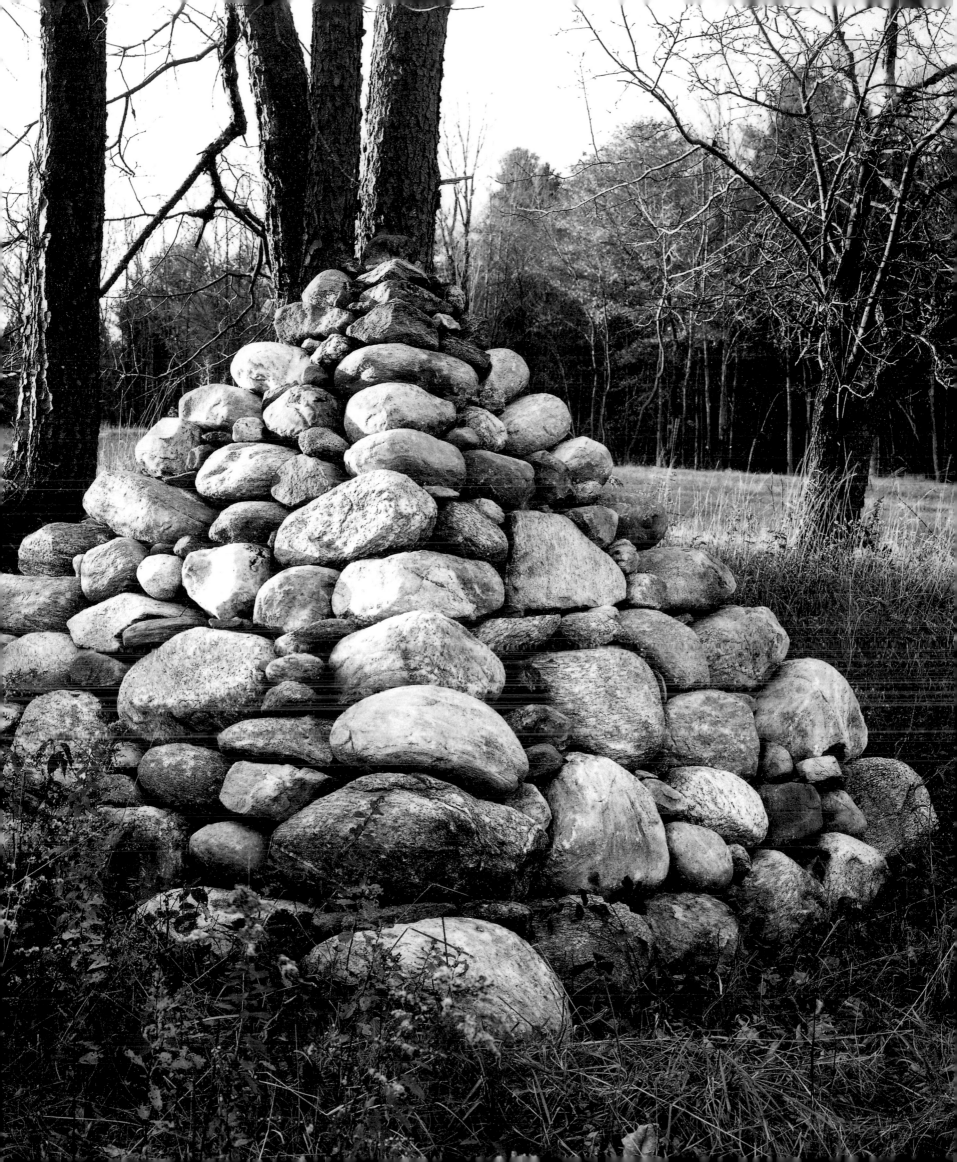

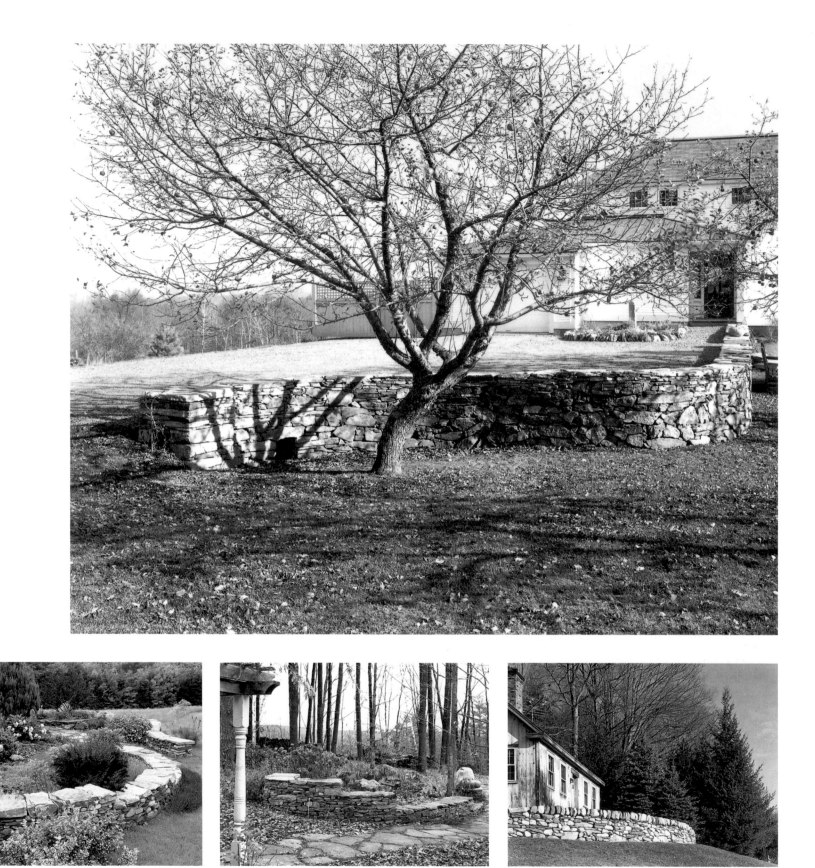

An individual stone is a solid object. Together, stones become a liquid medium and naturally flow into curved walls.

TOP: In bowing around a venerable apple tree, a wall's line imitates the bend of the tree's branches.

BOTTOM: Left, a low freestanding wall snakes its way through the garden. Center, a stepped-topped wall embraces a rock garden along the step stone path. Right, the arc of a cope-topped wall connects the slope of the field to the straight lines of the cape.

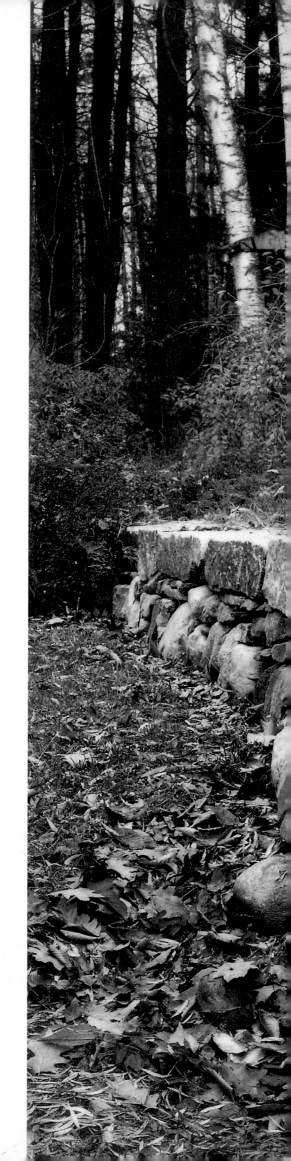

Spaces are really the stuff that walls

are made of. When the waller releases the stone, it is transformed from a stone into a piece of a wall. Only its having been let go at that time, in that place, distinguishes it from all other stone.

During construction, every stone is set in the interest of what will follow it. Stabilizing each by adding shims, or knocking off protrusions, is done to create firm surfaces, ready spaces for more stone. To watch me, you might think I'm building a wall of stone, but my focus actually is on building negative spaces. If I can create spaces that absorb loose stone into the shape of a wall, then when there are no more spaces left, the wall will be finished. Spaces are really the stuff that walls are made of.

Two distinct sources of stone were combined in the creation of these walls: angular block field slabs and rounded boulders selected from gravel-pit tailings. A small stream exits the arched opening.

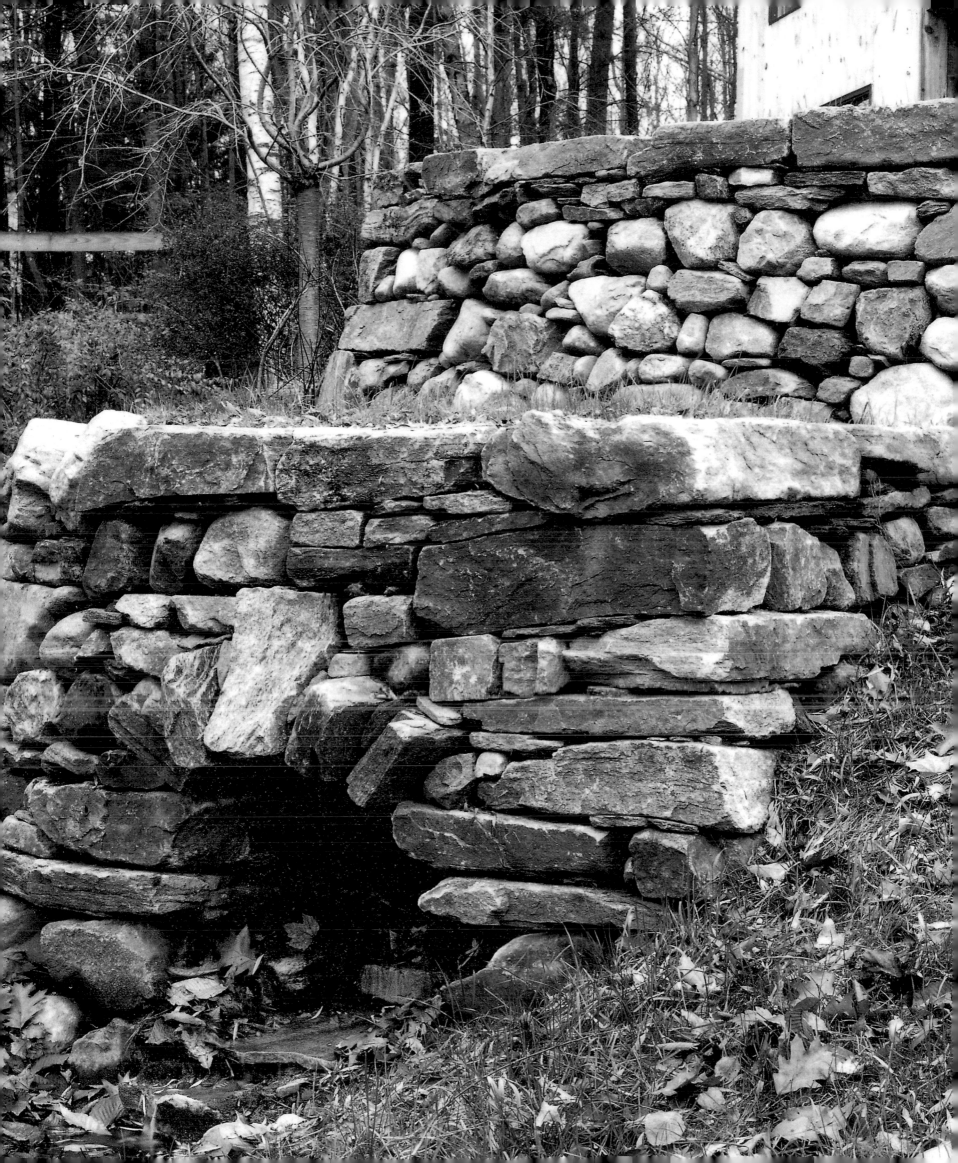

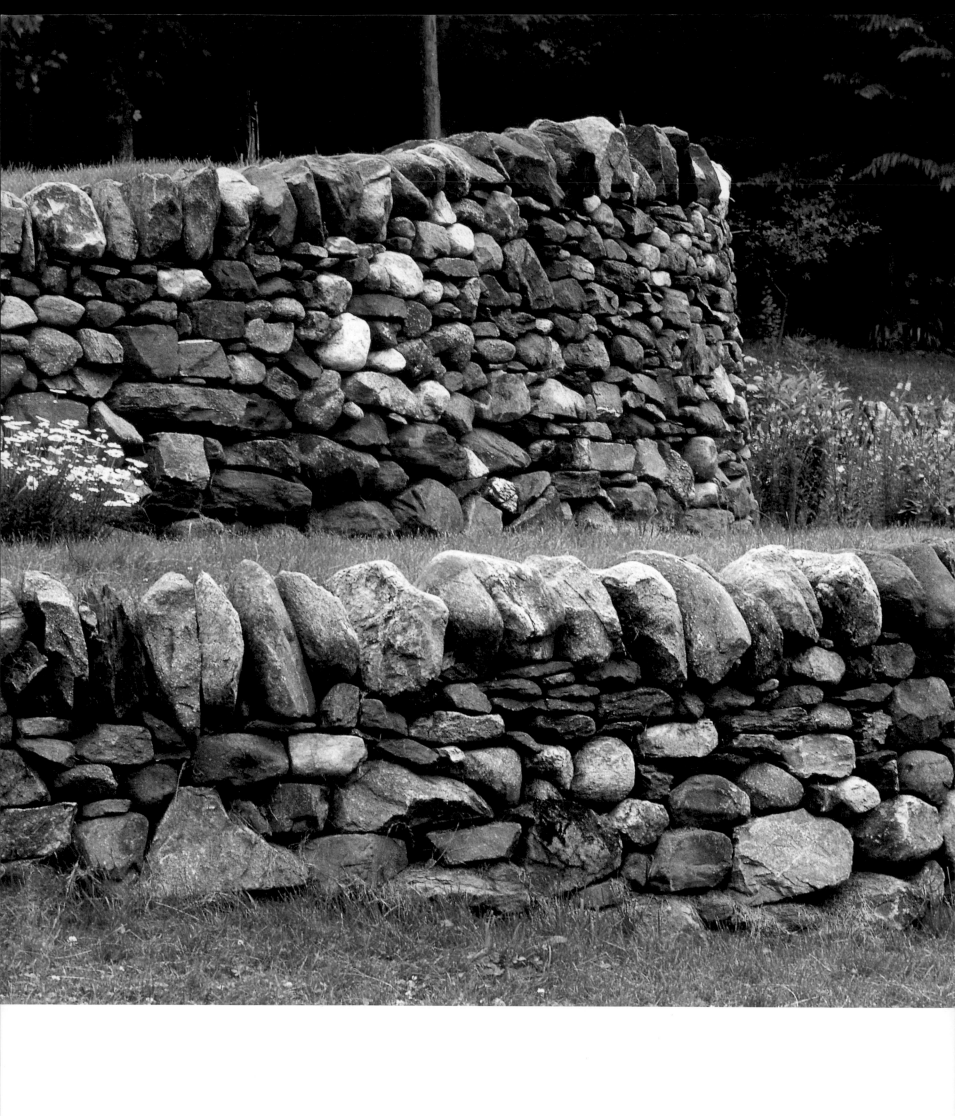

Over the course of a day of walling, I choose

from a full variety of stone shapes, some easily usable and others less so. Using up all of the most desirable early in the construction process is tempting, but I will ultimately regret it. Although some stones are just hard to find a home for, every difficult shape taken from the stockpile and set into the wall increases the ratio of easy stone waiting to be utilized. By maintaining a consistent mixture throughout the job, my finished wall will have a uniform appearance from top to bottom and end to end. And my workday will also have a steady rhythm of accomplishment.

I have two choices when walling: finding a stone to fit a space, or finding a space to fit a stone. Both are ongoing options. Either way, the choice is immediate, and I don't dwell on its results. Stone is dropped, slid, rolled, or pried into position and then forgotten as I move on to the next decision I have to make. Walls grow most easily and quickly when they emerge from the present. Acting on each decision without looking back helps me stay even with the moment.

The skill of walling is in the taming of randomness, the bringing together of disparate shapes into a unified form. While still in a stockpile, stones can be assigned different degrees of usefulness, but after I put them in the wall, they share equal importance. The wall teems with interdependent individual stones, and its beauty comes from the stones' combined character.

While I was putting this wall together, I had a visitor who hadn't seen a coped wall before and expressed some incredulity that the round stones wouldn't roll off the top over time. I convinced him to try to lift any one of the copes out of the lineup. Although he hesitated, not wanting to wreck my work, he soon began tugging and shoving himself up against the bottom edge of a cope for all he was worth, without budging it. Many copes must be loosened at the same time for any one to move. A single cope borrows the weight of many through their shared friction. Decorating these walls is a cottage garden of perennials including daisies, roses, bee balm, daylilies, and phlox.

Stone is picked and placed: no exchanges, no returns, and no regrets. Giving each stone a second chance to find its home doubles the building time. Three chances make a job take three times as long as it needs to. The first stone you decide to use may not be the best of three, if three were allowed, but as long as it is structurally acceptable, it stays. The place to make improvements over a potential mistake is with the next stone. Progress is made by recognizing faults and using the knowledge of them to make the next choice a better one.

Under a Littleleaf Linden (*Tilia cordata*), the rock-strewn ground is covered by a yellow flowering Stonecrop (*Sedum acre*), a Dwarf Red-leaved Barberry (*Berberis thunbergii 'Atropurpurea' 'Crimson Pymy'*), and a Tam Juniper (*Juniperus sabina 'Tamariscifolia'*). Evergreens include Dwarf Scotch Pine (*Pinus sylvestris 'Nana'*) and Bird's Nest Spruce (*Picea abies 'Nidiformis'*).

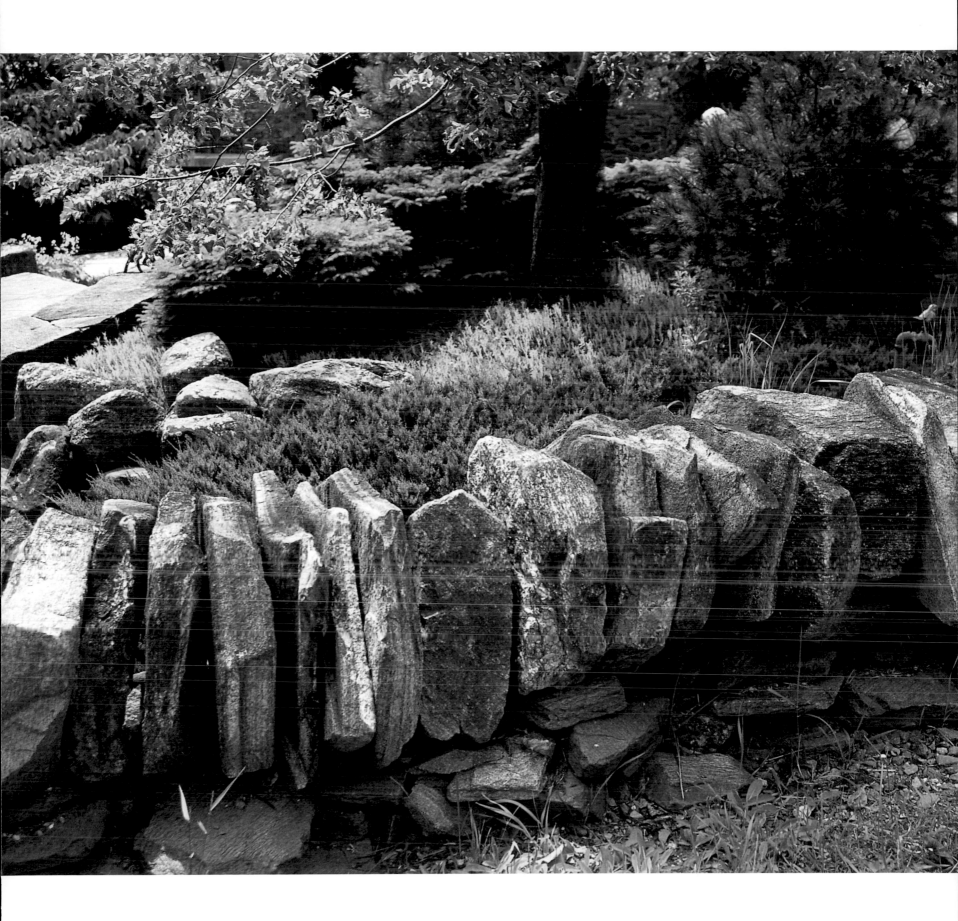

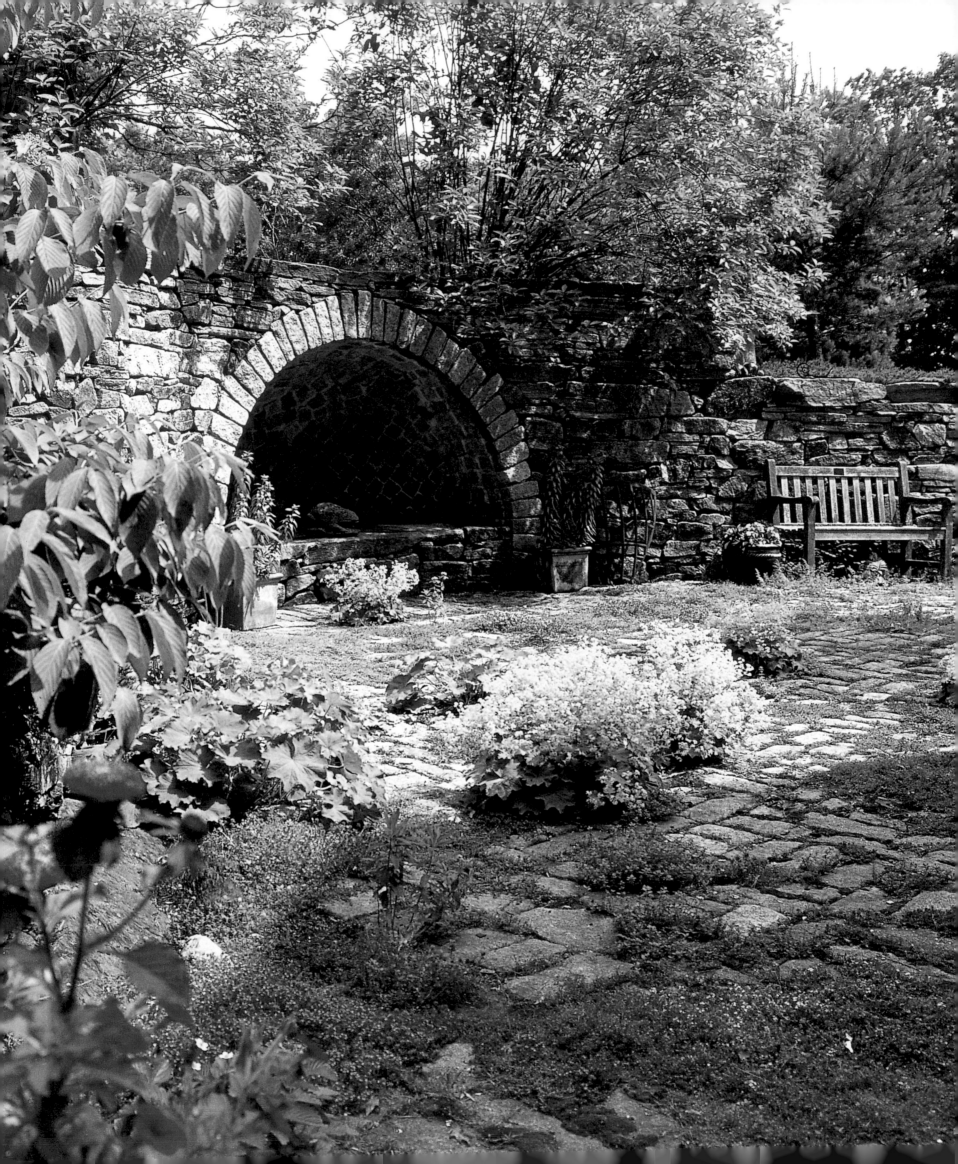

precision

The summer I turned sixteen, I took a job trimming grass along state roads for the Vermont State Department of Highways. I was assigned to a crew led by a year-round employee, Ralph Canedy, whose job during the summer months was to keep nine teenage boys working and safe from their own ignorance. His winter months on the road were spent in solitary reverie salting, sanding, and plowing the four lanes of the interstate between Bellows Falls and the Massachusetts state line.

Ralph wore a tan cap, its brim dipped to one side from the twisting he gave it while scratching his head. A pipe in his mouth and a shirt pocket full of tobacco, Ralph would hitch up his trousers to just under his rib cage and give us our orders for the day.

He wouldn't abide laziness. If we were out there, we were working. While the older guys, on tractors, mowed the broad expanse of median strip and flatter portions next to the breakdown lane, we in the scythe crew worked in groups of three, cutting the tall grass on the slopes behind the guardrails. Keeping a distance from one another with the fastest boy going first, a trio would set out to clear off a bank, each cutting a six-foot swath.

The scythe is a tool from times past. The twisted shape of the snath, or handle, looks at first glance like a bent tree limb. The blade, although a precisely made instrument, hasn't come so far in its sophistication that its antecedents can't be conjured up. The word "scythe" has its roots in the Latin words meaning "broken piece" (of stone). To use it, the long thin steel blade bolted tightly to the snath at a slightly acute angle is drawn in a 180-degree arc, slicing the grass off in a band nearly as wide as the length of the blade.

I liked tramping along the highway with a scythe balanced on the crook of my arm. We were like a band of roving mercenaries spread out on a patrol, ready to strike down the next tuft of grass that raised its tasseled head. When we got down behind a long set of guardrails—and they were a half-mile long in some places—the three bands of grass we laid down, with narrow trails from our shuffling feet through their center, were a beautiful pastoral accent on the landscape that we alone appreciated.

No one spoke much during the day. We were spread out enough that talk had to be conducted at a high volume, and that took wind from the exertion of keeping smooth scythe strokes. Our footing was set ahead and then locked into the hillside for the time it took the blade to be brought down in a long free swipe held parallel to the tilted ground by our stiffened arms. At the bottom of the swing our arms hinged and whipped the snath back to the top of the arc. By twisting at the waist, we gained the longest circumference for each swing and consequently cut the broadest band possible. No one wanted to be accused of leaving a meager swath behind. And the evidence of one's level of expertise lay there at his feet for all to see.

As simple a task as scything looks, it isn't a quick study. One may learn the fundamental technique in a minute, but to be able to repeat it accurately throughout the day is where the skill lies.

Most days Ralph skipped around in the truck checking on the tractor work and cutting the grass on the islands at the end of the exit ramps with a gas mower. If the scythe crew was shorthanded, he would hang a blade on a snath and take a lead swath at the top of the bank. From behind, there didn't appear to us to be much action in his gate, and we didn't give much thought to what it would take

A sunny courtyard full of verdant growth can be enjoyed even more fully with the knowledge of how it has changed and developed over the years.

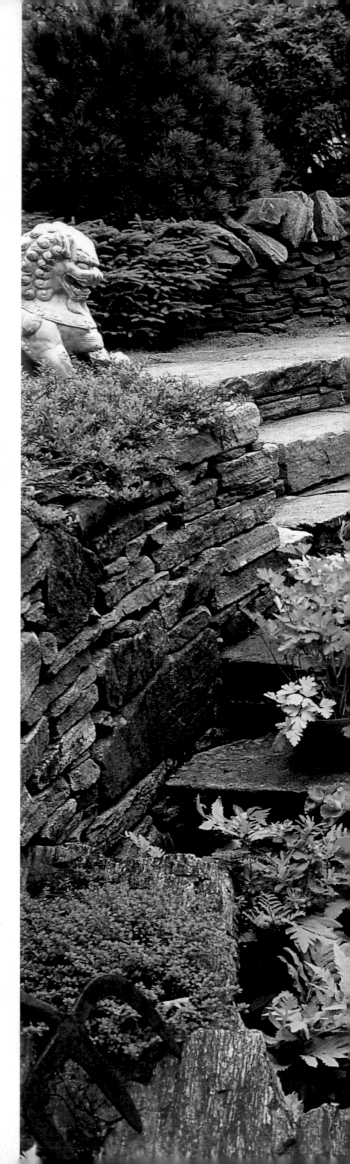

to keep up with him. After all, he was an old man, probably pushing forty! So it was a shock to us to find that while we struggled along behind, Ralph methodically pulled ahead. The grass was wet with dew and clumped up, lying heavily across our blades at the bottom of our swings. The "no-see-ums" swarmed around our heads and bit the tender flesh at the base of our eyelids, causing them to burn and itch unmercifully. We stopped to clean the matted grass from our blades and scratch our itches. Farther ahead Ralph's torso leaned into his work, the momentum of each swing pulling him forward. A puff of blue smoke periodically rose in a veil around his head from the stem end of the pipe clamped between his teeth and chased away those bothersome flies.

By the time the sun had topped the wooded ridgeline to our east and had begun to steam away the dew from the high grass, Ralph was nowhere to be seen. But ahead of us for the next two hundred yards, all the way to where it merged with the tractor-mown grade, was

a perfectly shorn strip of ground, the long stems of grass plaited together in glossy ribbons. Then, from behind us we heard the sound of the truck. It was Ralph; he had finished his stint, crossed the road, and returned to the truck by walking along the verge of the passing lane, scything around the base of the reflector posts as he went. He held up a water jug signaling us to climb the bank for a break, a break we hardly felt we deserved.

There is nothing flashy about the display of mastery in a handcraft. It's uneventful. It's carried out while the observer is waiting for something special to happen. There was nothing exaggerated in Ralph's movements; nothing about his progress drew attention. His skill had removed all unnecessary actions until only the effective ones remained.

This staircase combines the safety of conformity with the pleasure of variety. There is precision in the regularity of tread and riser sizes even though the overall feel is casual.

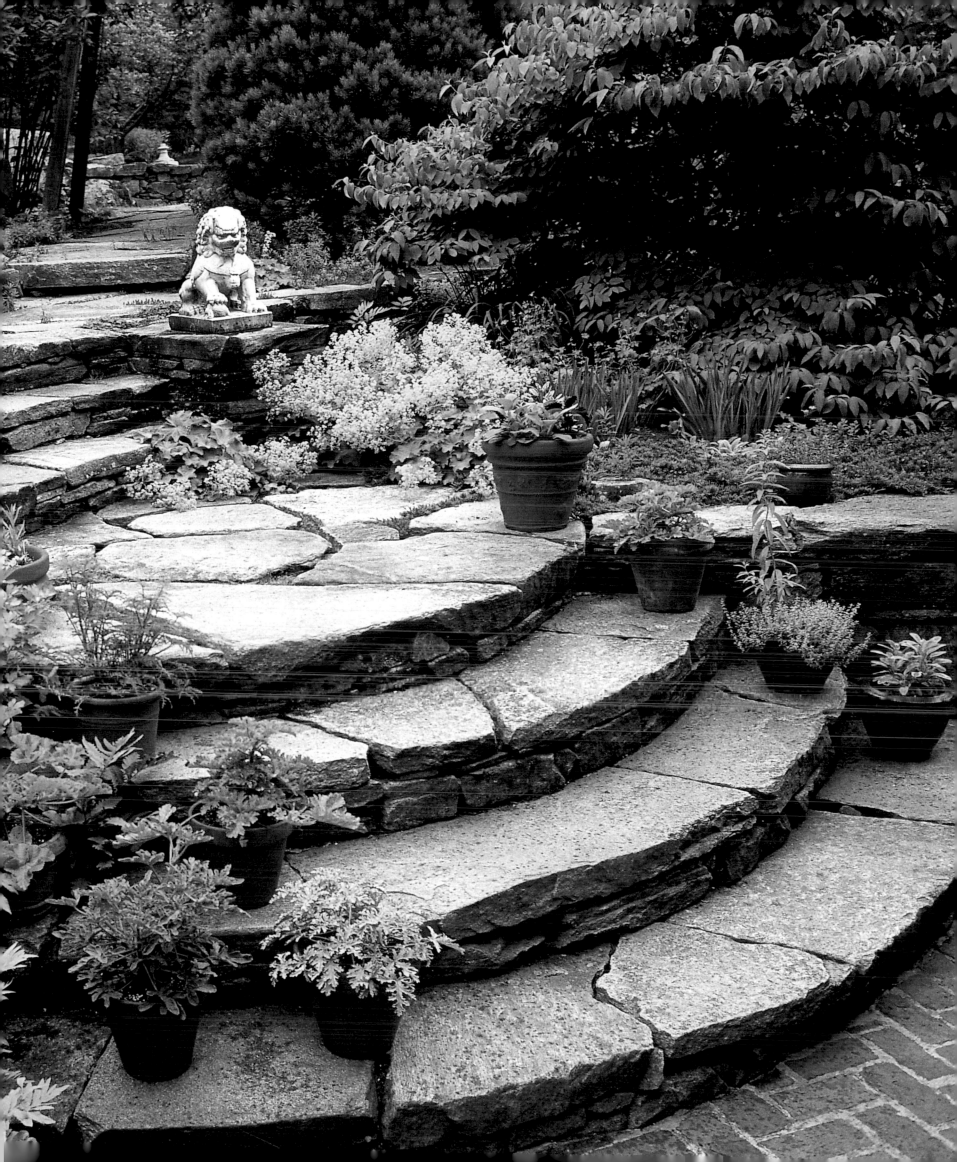

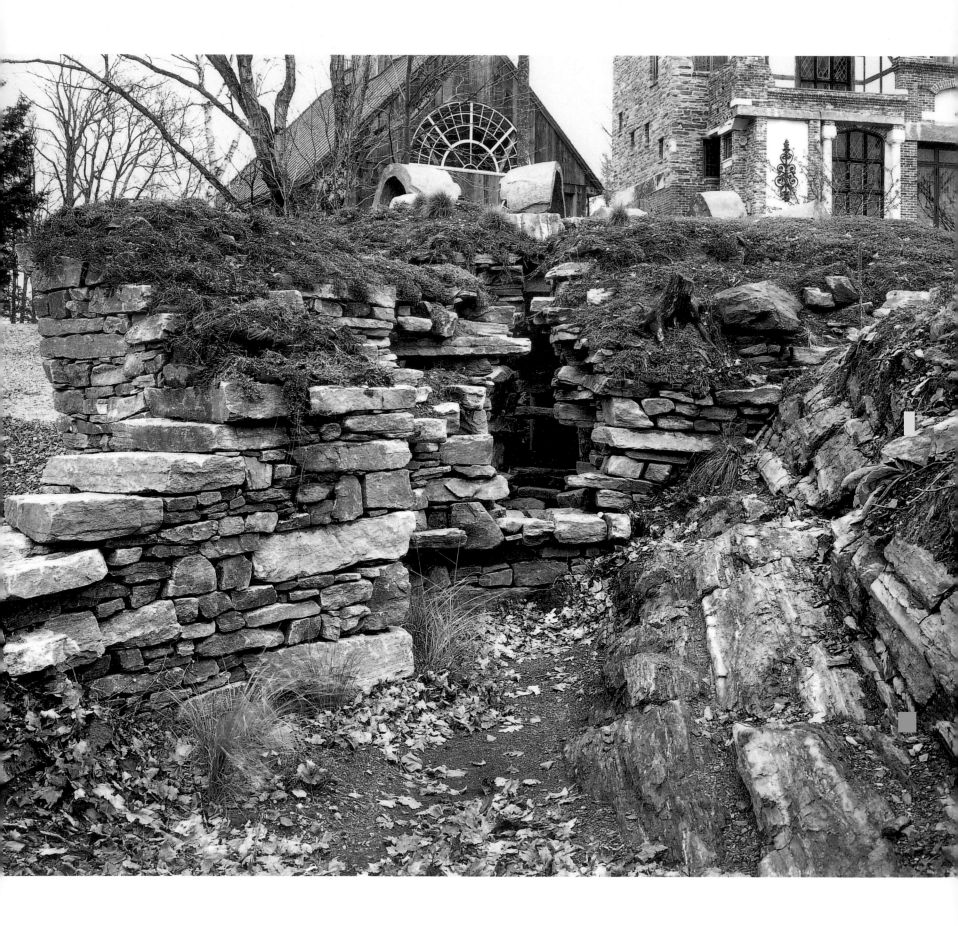

Stones seem to want to congregate.
In a stream they remain together
when all else is washed away.
On a mountaintop they endure
when everything else is blown
away. Every piece finds its right
relationship to every other.

A tree stump "planted" on the roof of the grotto further authenticates the aged feeling that was developed by building the grotto against an exposed chunk of natural ledge. The photograph was taken less than a year after construction and before very much vegetation had moved in. From this angle the view into the depths of the grotto is through a succession of broken-edged openings, adding intrigue to the space.

solidarity

Whenever we team up, I like to work close enough to Sonam Lama to learn more about his growing up in Tibet. His parents sent him, at the age of thirteen, to a Buddhist monastery to begin his religious studies. As a monk, he, unlike his siblings at home, would be assured of food to eat every day. However, because most of the monastery's buildings had been destroyed by Chinese artillery fire fifteen years earlier, as a young monk he slept in tents and his daily work was rebuilding the monastery's sacred stone buildings. He studied and worked for ten years, only to be placed under house arrest by the Chinese government for engaging in political activity. Realizing that he'd spend the rest of his life confined in the monastery, he made the only choice he felt he had.

One night he started walking and walked every night for two months until he got to the Indian border. Once safely across, exhausted from his trek, he took off the blue cotton hat he'd been required to wear under Communist rule, laid it on a river stone, and hammered it repeatedly. Finally free of Communist authority, he watched the pieces of cloth disappear down the river.

In Tibetan, Sonam's name means "lucky," and he believes he was aptly named. He emigrated to the United States and continued practicing the stone craft he learned in Tibet.

One Friday afternoon we watched the sky threatening a thunderstorm and agreed that if and when it came, we would head home rather than wait around for it to stop. So when the sky did open up and the rain poured down on us, I was ready to go. I grabbed my tools and ran for the truck, expecting Sonam to be right behind me. But he wasn't. Through the sheets of rain pelting down on the windshield, I could just make out his hunched body, moving steadily in the rhythm of walling, right where I'd left him.

A long, wet five minutes later, he threw himself into the passenger seat beside me. "I had a row of face stones that needed backing before I could go," he said.

Amazed at his dedication, I had to ask, "Was it really worth getting soaked for? We've got a long ride home and you're drenched to the skin!"

"Oh, yes, I had to do it or I wouldn't have gotten a good night's sleep this weekend."

In Tibet, he had been taught that if stonework was left unsecured at the end of the day, the waller would not be able to sleep well that night. And if he should die leaving behind unbacked work, he would not rest well for eternity.

I realized that without knowing it, I'd also been practicing that same Buddhist belief. On an early spring day three years earlier, I had been asked by someone to look at a wall on his property that had been started the previous year. An unexpected snowfall had buried it in November and postponed its completion until spring. Unfortunately, the waller had died during the winter, so the home owner needed someone else to finish the job.

Before me was a three-foot-high retaining wall, nicely built and backed except for five face stones loosely lined up on top of the last finished course, with no backing to secure them. At the time he set them there, the waller probably had no doubt that he would return the next day and fix them into the wall. But another workday on that site never came for him, and the five stones still lay there, four months later, as a small monument to his presumption.

Looking at those stones, I realized how uncertain all of our lives really were and how I could no longer take mine for granted. Those five stones taught me a lesson very similar to the one Sonam learned. From that day on, I began to leave each day's work as complete within itself as it could be, and I hoped, by extension, that I would become more complete within myself as well.

Granite sill stones recycled from an old house foundation and cobblestones saved from the excavations under a local town street were combined with freshly quarried stone. One small leaded window completed the setting. Hay-scented Fern (*Dennstaedtia punctilobula*) and Virginia Creeper (*Parthenocissus quinquefolia*) flourish here.

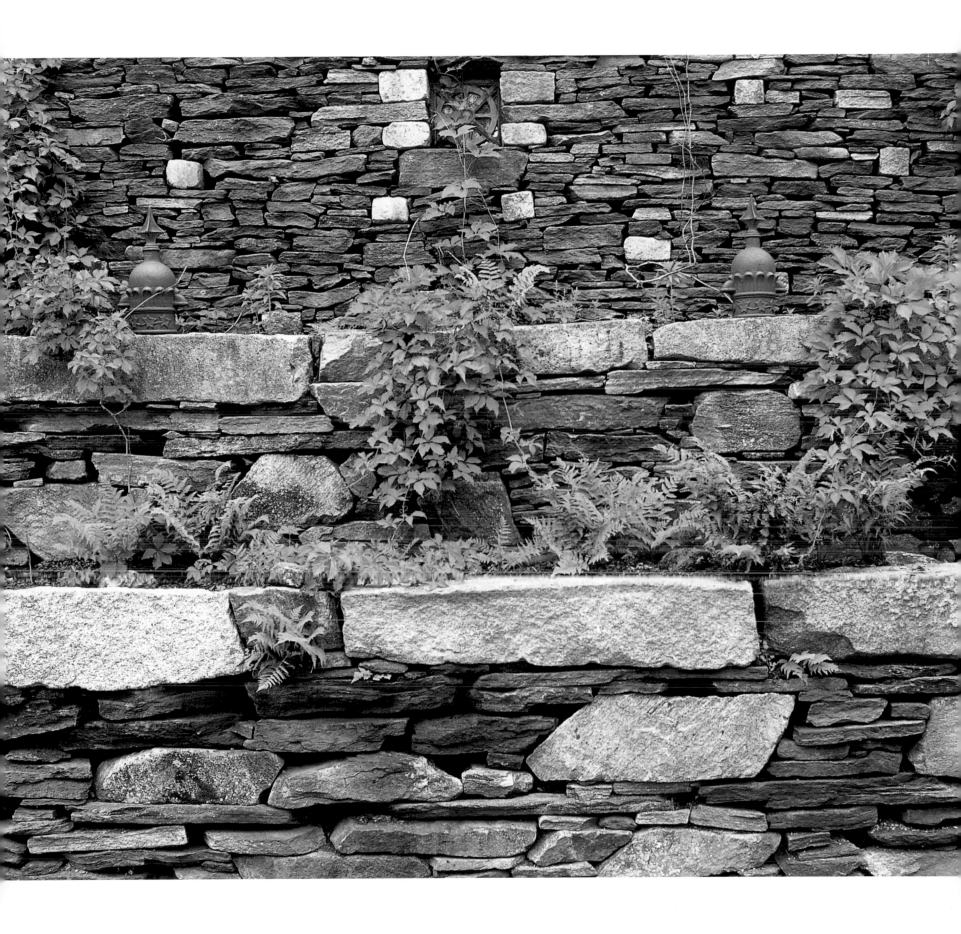

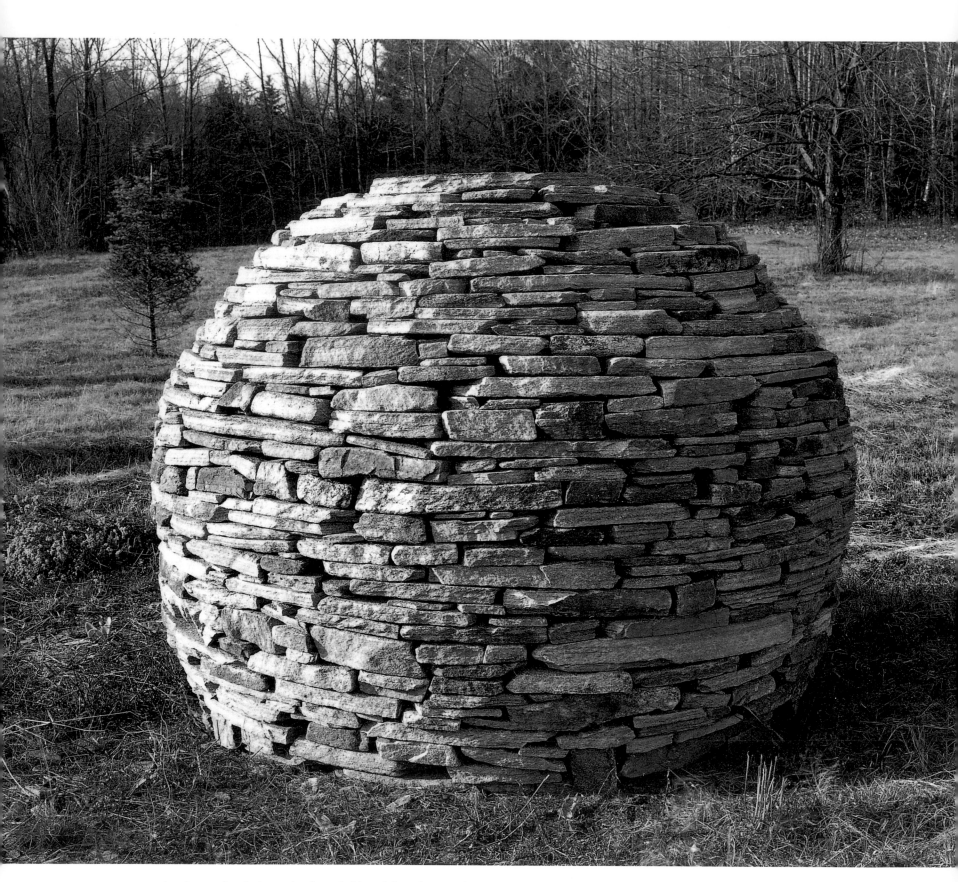

I made a crude spinning contraption out of two sticks and some string as a guide in designing the spherical plan. Inside is a central, hollow core capped with a single stone. The craft of drystone walling is characterized by its pragmatic utility; we expect it to be used for something or to have once had a use. If not, we wonder why it is. Sometimes it's just for fun.

While not exactly lighthearted, stone is playful; it hides its bumptious nature well. Within the volume of each stone is an immutable center, and from that point radiate all forces of movement. My attention is drawn to that spot; the truth of where the stone is headed is held there.

Touch is the sense that informs me most generally about stone. My eyes urge on my hands, but the touching and gripping is the handshake of agreement for us to begin working together.

Stone has a strong predisposition to fall. Just a little tipping, spinning, or rolling on my part activates its restless soul. Once I've set the stone in motion, my efforts must quickly change to slowing, controlling, and directing its independent spirit.

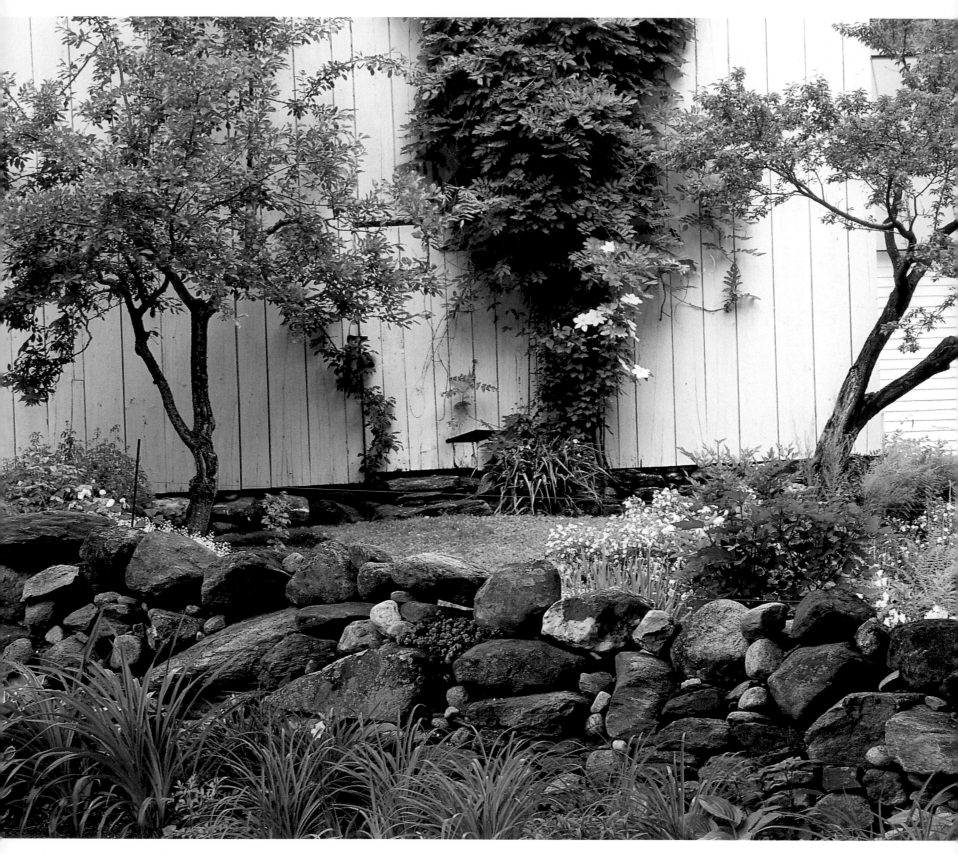

This trail of stone has been followed by a riotous parade of plantings. All bring fresh life to an old barnyard.

There is something incongruous in a scene that pairs tender life forms with a seemingly intransigent environment. At first glance, broad surfaces of bare rock appear to be the antithesis of a protective medium for plants. But stone's mass can be a climate modulator by deflecting strong winds, slowing the evaporation of moisture, holding solar heat after the sun has set, and capturing soil in erosion-proof pockets.

I'm always excited to build steps because they remind me of what's to come. They will take the footfalls of friends and, later on, others who will know me only by where these steps lead them.

TOP: Left, stairs can be a destination themselves when combined with a landing, broad railings, and a raised plaza. Center, the orientation of the staircase gives a person the feeling he's climbing onto the wall's shoulders. Right, a wide set of steps may be traversed from corner to corner, thereby lengthening the treads and easing one's descent.

BOTTOM: A single stairway breaking through a retaining wall is an invitation to move. The wall is breached both physically and psychologically, creating the freedom to explore.

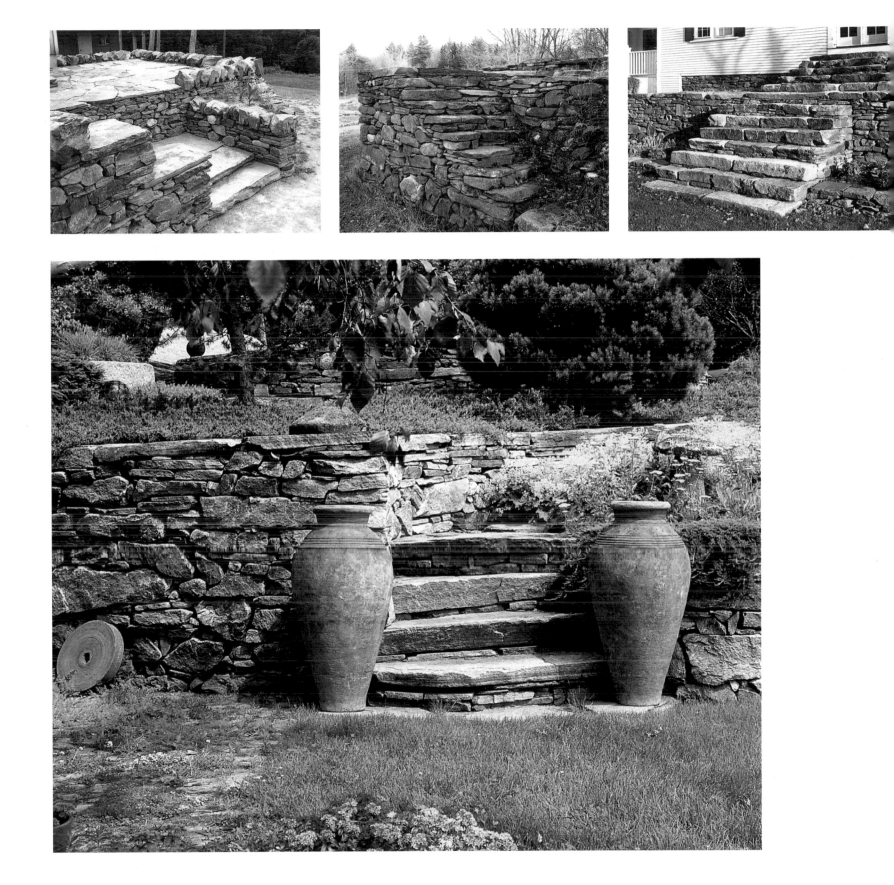

Every wall can tell a story about its maker once we understand the language that stone speaks. Every stone is visible proof of the builder's degree of contentment. A stone that looks satisfied with its position reflects the sense of ease the waller felt when placing it there. I began this book intending to tell a story about my walls. The truth is, these walls tell a story about me.

The zigzag path design separates the wall levels into a dramatic set of switchbacks. The path cuts through wall faces of parallelogram-patterned stone.

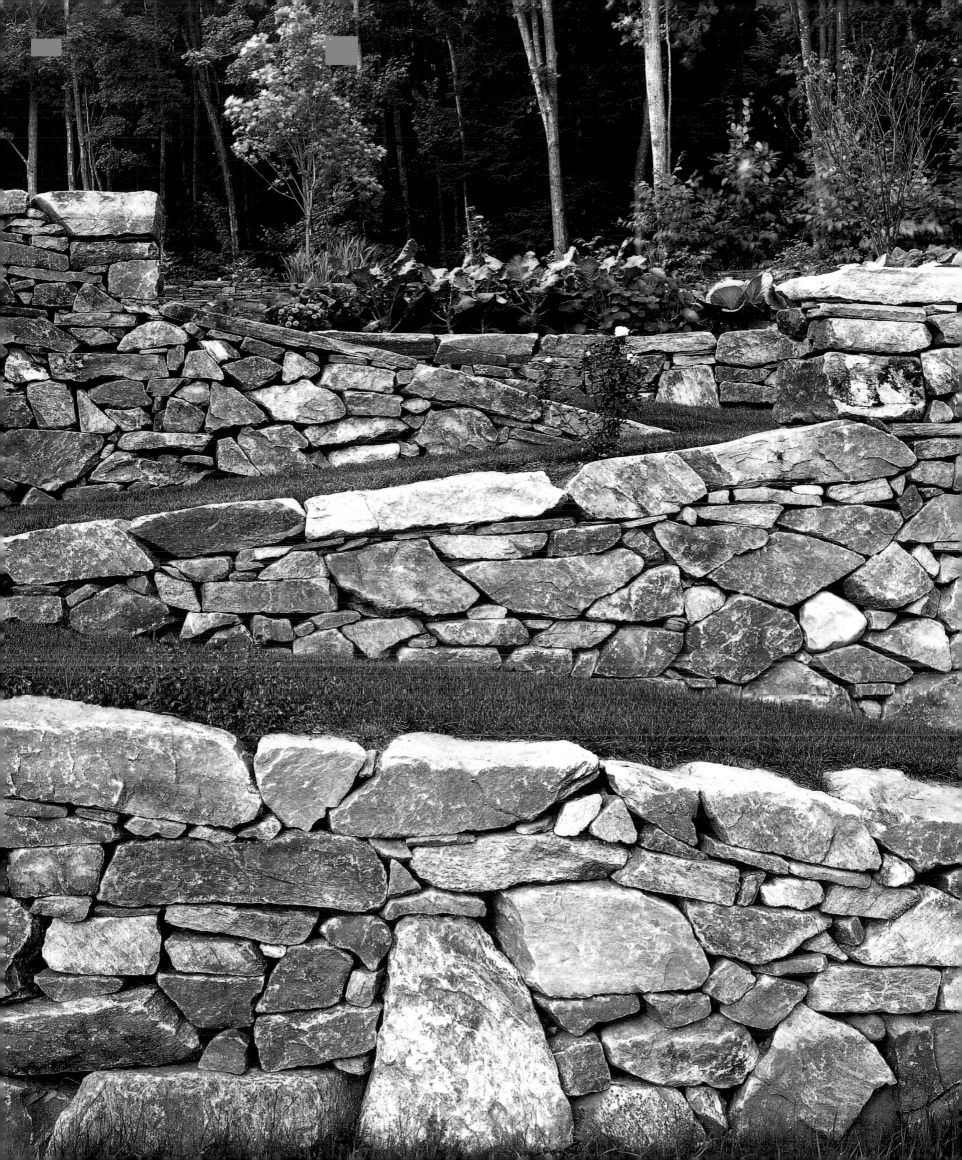

the gallery

RETAINING AND FREESTANDING WALL WITH STAIRWAY

Location: West Dummerston, VT, 1980
Dimensions: 80 feet x 4 feet
Description: Built on a 2-foot-deep base of 1½-inch crushed stone
Origin of stone: Stone gathered from derelict walls on the property
Time to complete: 16 days

I had been told that the old farmhouse, turned seasonal home, would be unoccupied while I was working on the property. Bright and early the first morning of construction, heavy equipment rumbled noisily across the backyard. A middle-aged woman dressed only in her nightgown came rushing out of the house and across the lawn, screaming hysterically at the equipment operators to shut off their machines. No one had informed the family friend that the serenity of her two-day visit would be so rudely shattered. She ordered us to go away as though we were undesirable characters in a nightmare she was having and then turned and raced barefoot back into the house. We were momentarily stupefied, as though an apparition had shocked us awake as well.

After taking a short coffee break, we went back to digging up the yard and dumping stone. The irate houseguest never materialized again.

Pages ii–iii

PICNIC TABLE AND FOUR BENCHES

Location: Dummerston, VT, Property A, 1998
Dimensions: 4 feet x 5 feet x 2 feet
Description: Built on subsoil
Origin of stone: Imported block-field stone
Time to complete: 1 day

The inspiration to build a stone picnic table must have come from my youth. The forest in my neighborhood had a great many ledge outcroppings on its floor. My friends and I named one area full of nooks and crannies "the kitchen." A flat ledge with a hummock at one end, like a pillow, was called "the bed." We spent countless hours playing "in our house."

Page v

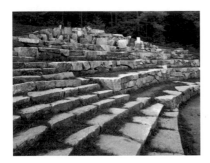

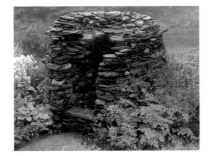

SOFTBALL FIELD BLEACHERS

Location: Brattleboro, VT, 1983

Dimensions: 80 feet x 30 feet x 15 feet

Description: Built on a shale ledge

Origin of stone: Grout piles at a no-longer-worked granite quarry seven miles north

Time to complete: 35 days

Even though this was a public setting, few people were aware I was building it because softball season was over and the site was not visible from the street. After toiling away on my own for a month I was treated to a visit by a kindergarten class. The children swarmed over the unfinished structure and expressed nothing but sheer delight in this newly discovered playground. Any concerns I was having about how it might be received when it was finished quickly dissolved. The sight of twenty kids climbing and jumping around on the hillside of granite buoyed my confidence and spurred me on to complete it.

This was before I owned heavy equipment, so I had to innovate. This construction was assembled with the aid of a guyed derrick that I fabricated out of scrap steel, freshly cut spruce trees, and an antique winch salvaged off the back of an old wrecker truck. The winch was hand-powered; my arms and shoulders got a wicked workout turning the crank handle every day for the two months it took me to build the bleachers.

Pages vi–vii, 58

GARDEN HOUSE

Location: Marlboro, VT, 1994

Dimensions: 11 feet in diameter x 11 feet

Description: Built on a 2-foot-deep base of 1½-inch crushed stone

Origin of stone: Stone gathered from old walls on a neighboring property

Time to complete: 16 days

Great Britain's landscape is a veritable glossary of wall-building styles and techniques. A three-month working vacation in Wales, England, and Scotland inspired me to build this roofed enclosure. A month after returning from that trip, I was asked to build something as a focal point for an expanding perennial garden. At night it is illuminated from within by candlelight. During the day, when the garden sprinkler sweeps back and forth across the backside, water seeps through the walls and countless falling droplets enliven the interior.

When the garden house was turned into a folly by removing its top, I uncovered two mouse nests, two snake skins, a wasp's nest, and one sleepy brown bat that reluctantly flew from its disrupted roost into the nearby forest. I was surprised at how quickly the cleit had become home for such an assortment of creatures.

Pages ix, 1, 2, 3

WATER WALL AND REFLECTING POOL

Location: West Dummerston, VT, Property A, 1999

Dimensions: 8 feet x 12 feet x 2 feet

Description: Built on a 2-foot-deep base of 1½-inch crushed stone

Origin of stone: Block-field stone imported from two towns north

Time to complete: 15 days

Did the first composers of string music hear a sound in their minds and then invent the guitar in order to hear that same sound through their ears? I had to ask that question after building this structure for a musician friend. He said he wanted to hear the sound of a curtain of water falling into a pool. The object it fell from needed to be just so long and just so high, and shouldn't it be made out of stone, he wondered.

Not having heard what he was hearing in his mind, I couldn't disagree, so I built him a stone wall from where the water would fall and a shallow pool onto which the water would splash. When it was finished and the water did fall, the sound it made was intoxicating. My ears drew me as close as I could get to the liquid music without falling into the pool myself. "Was this the sound you wanted?" I asked. "This is exactly the sound," he said.

Pages 4–5, 6–7

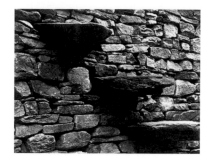

WATER WALL (THE OTHER SIDE)

Location: West Dummerston, VT,
Property A, 1999

Dimensions: 8 feet x 12 feet x 2 feet

Description: Built on a 2-foot-deep base of
1½-inch crushed stone

Origin of stone: Block-field stone imported
from two towns north and ginger stone from
the property

Time to complete: 15 days

It occurred to me moments before
starting to build the "wall of water"
that the backside of the wall would be
a great place for a stile. A stile is a set
of cantilevered steps that juts out from
the face of a wall. The total surface
area of each step piece is more than
twice what is exposed for the step
surface. The steps are secured for safe
climbing by the weight of the wall
stone above them. The top of the wall
is a fun place to perch to enjoy the
sound of the waterfall.

Pages 4–5, 6–7

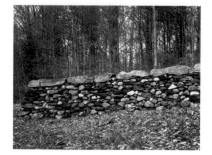

RETAINING WALL AND
EIGHT STEPS

Location: Dummerston, VT, c1993

Dimensions: 20 feet x 4 feet retaining wall
and 8 steps

Description: Built on subsoil

Origin of stone: Block-field stone and
fieldstone gathered from redundant wall on
the property

Time to complete: 5 days

One of the basic principles in drystone
wall construction is the covering of
vertical joints. Stones set along the
length of a course must cover the
places where the sides of stones join
in the course below. Vertical joints
that run for more than two courses
are potential areas of weakness. In the
same way that a small rip in the fabric
of a shirt will grow into a large hole,
a long vertical seam in a wall face will
open wider over time.

 The placement of the stones in this
wall may look indiscriminate at first
glance. On closer inspection, it can
be seen that almost every stone covers
a joint in the course immediately
below it.

Pages 10–11

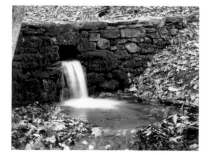

CEMENT-CORED DAM

Location: West Dummerston, VT, 1978

Dimensions: 20 feet x 3 feet

Description: Built on a ledge

Origin of stone: Stone gathered from
the property

Time to complete: 5 days

Down in a swale on a neighbor's
property runs a small stream. So that
they might cool themselves off on
hot summer days, they wanted to
impound the stream and create a little
dunking pool. From the ruins of an
old building foundation, on the steep
hill above the stream, I took the stone,
one wheelbarrow load at a time, down
to the stream and bridged the gap.

Page 12

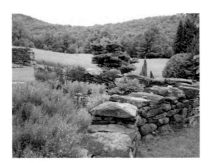

ROUGH-TOPPED HERB GARDEN WALL

Location: Newfane, VT, Property K, 1981

Dimensions: 110 feet x 3 feet

Description: Built on a 4-foot-deep fieldstone foundation

Origin of stone: Stone recycled from redundant field wall one town north

Time to complete: 15 days

When I began walling, I asked people in the trade about wall footings and foundations. It seemed that everyone had a different opinion. Some said build deep and wide foundations, while others said to simply remove the sod and foot the wall on the soil. I started looking carefully at old walls and came away with the general impression that the more mass a wall has, the better are the chances for its survival. I dug trenches and started laying stone two, three, even four feet underground. I was intent on providing a stable base for the above-grade constructions. This herb garden wall has as much fieldstone below grade as above. As this method uses up so much good stone underground, I started looking for alternative ways to adequately support the walls I was building. I decided that a base of crushed stone could be substituted for wall stone without forfeiting strength. I've employed different grades of crushed stone, depending on the depth of the foundation, from three quarters of an inch all the way up to eight inches.

Pages 14–15

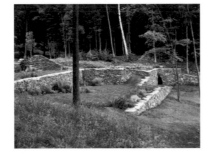

RETAINING AND FREESTANDING WALLS, STEPS, AND SACRED GROTTO

Location: West Dummerston, VT, Property A, 1987-89

Dimensions: 120 linear feet of walls, 2 feet to 8 feet high

Description: Built on a 2-foot-deep base of 1½-inch crushed stone

Origin of stone: Imported block field stone

Time to complete: A few months over a course of years

Cleon Barrows once told me stories of walking across this property as a youngster on his way to the one-room schoolhouse he attended at the bottom of the hill. It was a shortcut for him to jump the wire fence that kept the cows on the property. Until the 1920s, rugged pastureland covered the steep hillside. After a time, the forest reclaimed it and dominated for sixty years before my neighbor began clearing patches, returning it to meadow. The network of walls that has most recently been cast across the land defines it anew with walkways and orders its space unlike anything that has come before. The spirit of the place is never lost, only supplemented with our offerings.

Pages 16–17, 21, 62, 63

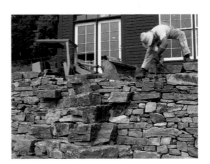

BUTTRESSED RETAINING AND FREESTANDING WALL

Location: Westminster West, VT, 1998

Dimensions: 9 feet x 8 feet

Description: Built on a 4-foot-deep base of 2- to 7-inch crushed stone

Origin of stone: Block-field stone and pit tailings imported from two towns west

Time to complete: 30 days

The three large protrusions along the face of this nine-foot-high wall help tie the construction to the landscape. Their rough shapes link the hard geometry of the building and walls to the more amorphous shapes found in the natural environment.

When conditions permit, I use pit tailings to build the back half of retaining walls to help reduce the costs. The extraction of block-field stone is an expensive enterprise compared to purchasing pit tailings from a gravel quarry. While there's no evidence now that the wall is backfilled, the face on the buried side is composed of round stone.

Walls that retain soil, the workhorses of wall types, are built in such a way that if the soil were removed from behind them they would continue to stand.

Pages 18–19, 30–31

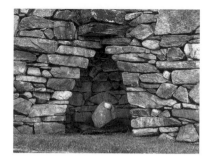

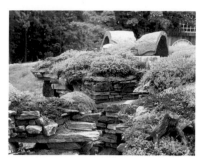

SACRED GROTTO

Location: West Dummerston, VT, Property A, 1989
Dimensions: 8 feet with a 4-foot grotto
Description: Built on a 2-foot-deep base of 1½-inch crushed stone
Origin of stone: Imported block-field stone from two towns north
Time to complete: 7 days

Caves and caverns fascinate and frighten me. This little hollow was conceived in a size that felt safe and still intriguing to me. As I look at the work I've done, I can often recognize somewhere in it the physical embodiment of some feeling or desire I've had. They were desires totally unrelated to stone or construction. Stone was simply the medium I used to bring the feelings out.

Page 21

LIGHT-WELL COVERS

Location: Walpole, NH, Property B, 1997
Dimensions: 18 inches x 18 inches
Description: Sits atop the "sacred grotto"
Origin of stone: Imported block-field stone from four towns west
Time to complete: Bent stone, millions of years in the making

The soft blanket of stonecrop growing on the top of the grotto stands in striking contrast to what is hidden beneath it. The roof of the grotto is a cribbed structure of stones, many of them over eight feet in length. They crisscross, supporting one another, and at the same time are supported by vertical standing stones rising from the floor of the grotto. The shafts of diffused light that enter the grotto from under the twisted well covers fall through the tangled roots of an old tree stump suspended from the ceiling. From the pool of water on the floor to the exposed ledge-faced back wall, the grotto interior feels deeply subterranean.

Pages 22–23, 24, 26–28, 90

NORTH-FACING GROTTO DETAIL

Location: Walpole, NH, Property B, 1997
Dimensions: 16 feet x 8 feet
Description: Built on a ledge
Origin of stone: Block-field stone imported from three towns west
Time to complete: 8 days

I may never make any landforms as perfectly as nature does, but that doesn't stop me from trying. I know that I couldn't ask for a more willing instructor. Examples of nature's handiwork are everywhere I look, and they are all exquisitely designed and executed. If I can be a careful observer and follow nature's rules when I work, there's a chance I may design and build something worthy of the setting in which I place it.

Pages 24, 90

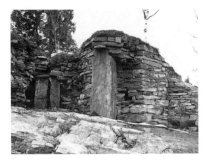

EAST-FACING GROTTO DETAIL

Location: Walpole, NH, Property B, 1997

Dimensions: 36 feet x 9 feet

Description: Built on a ledge

Origin of stone: Block-field stone imported from three towns west

Time to complete: 20 days

Building on a ledge presents advantages and challenges to the waller. On the one hand, the threat of damage to the construction from frost heaving the foundation is eliminated. On the other hand, a piece of sloped ledge may be a slippery surface on which to foot a wall.

Pages 22–23, 24, 26–28, 90

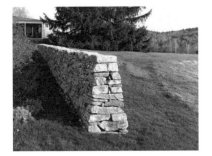

FREESTANDING WALL

Location: Newfane, VT, Property K, 1989

Dimensions: 50 feet x 3 feet

Description: Built on a 1-foot-deep base of 1½-inch crushed stone

Origin of stone: Imported block-field stone from one town north

Time to complete: 6 days

I live in an area of great natural beauty, but I don't always appreciate it fully. When I'm working, I get absorbed in the task at hand and forget to look up and admire the surroundings. Once I was working on a property similar to this one with fields and wide vistas all around. The owner of the house stepped out and motioned for me to look over my shoulder. A full-sized moose was walking away. The owner said it had been standing just behind me for quite a while watching me work. If it hadn't been brought to my attention, I would never have known that I was visited that day by that curious creature.

Pages 33–35

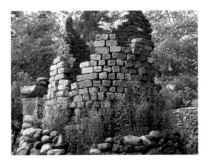

SILO FOLLY

Location: Walpole, NH, in Property B, 1994

Dimensions: 12 feet diameter x 12 feet

Description: Built on a 2-foot-deep base of 1½-inch crushed stone, cemented brick, and cobblestones

Origin of stone: Imported fieldstone and recycled granite sill stones

Time to complete: 4 days plus 12 days for masonry

A barn ruin folly could never be complete without a silo ruin. I'd never heard of any precedent for stone and brick silos in New England, but I thought a silo folly would fit in nicely with the fantastic nature of the barn ruin. Two masons did the cobblestone and brickwork from a sketch I made. I should say they were excellent masons before I set them to helping me make this curiosity. By the time they were done, bricks set level and straight with no gaps between them didn't look right to them anymore.

Pages 38, 41

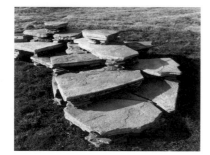

SEATING AREA

Location: Newfane, VT, Property K, 1983

Dimensions: 14 feet x 5 feet x 2 feet

Description: Built on soil

Origin of stone: Imported block-field stone

Time to complete: 1 day

The problem I assigned myself to solve here was how to fully display the shapes of these lovely stones. They had to function as seating, but the seating itself could take any form I wanted to give it. Each stone was supported in the most minimal fashion in order to expose as much surface as possible. Viewed from across the field, this looks like an outcropping of exfoliating ledge.

Pages 42–43

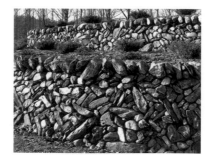

HERRINGBONE-PATTERNED RETAINING WALLS

Location: East Dummerston, VT, 1988

Dimensions: 90 feet x 4 feet

Description: Built on a 2-foot-deep base of 1½-inch crushed stone

Origin of stone: Fieldstone imported from the derelict walls on the west side of town

Time to complete: 10 days

Before I started, I didn't have a discussion with the property owner about what these walls would look like, only where they were going to go—I had never built a herringbone-patterned wall before.

What convinced me they could be a success was the way I found myself building up the back halves of previously completed retaining walls. I worked strictly from the front-face side. Setting stone in back, by way of an awkward backhand technique, I didn't fuss with them any more than absolutely necessary. I noticed that they required less shimming if I put them in on an angle. Because the back surface didn't show once the backfill covered it, I often didn't even look at that side of the wall while building. When the time did come to backfill and I got my first look at what I'd built back there, I was surprised and intrigued by the way it looked. Those blindly built back sides gave me the idea to build my next wall entirely with angled stone.

Pages 44–45

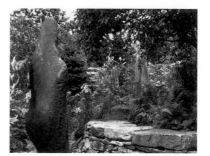

BARN RUIN FOLLY WITH STANDING FIGURE

Location: Walpole, NH, Property B, 1994

Dimensions: 7-foot standing figure

Description: Set 30 inches into crushed gravel

Origin of stone: Limestone imported from three towns south

Time to complete: A millennium of erosive sculpting

The geology of Vermont is rich in variety. Along a narrow band between the Connecticut River and the Green Mountains, running for about thirty miles north to south at an elevation around one thousand feet, is an unusual outcropping of limestone. The stone has a dark brown, granular surface and is known locally as ginger stone. The soft, round form it characteristically takes looks a lot like a loaf of gingerbread.

Pages 48–51

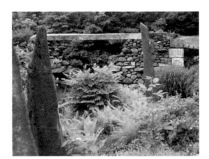

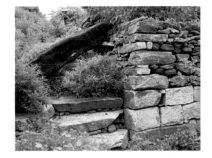

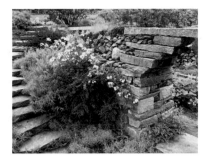

BARN RUIN FOLLY INTERIOR

Location: Walpole, NH, Property B, 1994

Dimensions: 14 feet long, 8 feet above ground

Description: Built on a ledge and 1½-inch crushed stone

Origin of stone: Recycled building stone and fieldstone

Time to complete: 12 days

There's a delicate balance between building a wall that looks broken down and building it strong enough to support a fourteen-foot length of granite eight feet above the ground. Folly construction tests the limits in the principles of drystone walling, and the daring of the drystone waller as well.

Pages 50–51

BARN RUIN FOLLY TOPPLED STONE

Location: Walpole, NH, Property B, 1994

Dimensions: 10 feet x 6 feet

Description: Built on a ledge and 1-inch crushed stone

Origin of stone: Block-field stone

Time to complete: 5 days

The fun loving nature of the "barn foundation ruin" is expressed in the fantastic shapes of standing stones, precariously perched fourteen-foot-long granite sill stone, and the exuberant cast of happy-go-lucky characters growing within its confines. The yellow flowering shrub at the center is Shrubby Cinquefoil (*Potentilla fruticosa*); ornamental grasses include Purple Reed Grass (*Miscanthus sinensis 'Purpurascens'*).

Pages 52–53

BARN RUIN FOLLY ENTRY

Location: Walpole, NH, Property B, 1994

Dimensions: 3½ feet, stairs; 5 feet x 7 feet, archway

Description: Built on a ledge and 1-inch crushed stone

Origin of stone: Recycled building stone, block-field stone, and fieldstone

Time to complete: 6 days

No wooden falsework was used to support this corbeled arch as it was constructed, nor were there any guides, other than the eyes, in developing its shape. When a known supply of material is combined with a familiar process, possibilities present themselves that can be transformed into a vision. Working toward that vision, one stone following another, I monitor my progress and gauge what's to come by the degree of success I've had in getting to that point.

The top stone locked the two sides of the arch together. I breathed a huge sigh of relief the moment it settled into place.

Pages 50–51, 54–55, 57

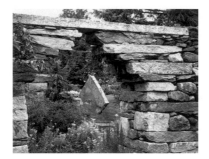

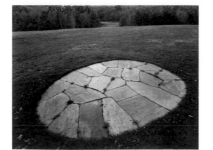

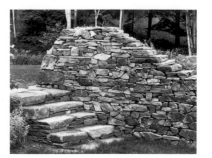

STATELY GRANITE SLAB

Location: Walpole, NH, Property B, 1994

Dimensions: 4 feet x 6 feet x 7 inches

Description: Set in soil

Origin of stone: Recycled doorstep from a church two towns west

Time to complete: 1 hour

Sometimes over the course of a construction, a stone will keep being saved because it's too good to use. That's what happened to this slab.

The handsome sheet of granite that graces the lawn just outside the barn foundation ruin is called "the Stone that Fell from the Sky." Perhaps its state of grace came with it from its former life as the front doorstep of a bygone local church.

During the three months I worked on the barn ruin folly, I knew I had to find a place for it. Eventually, it became the only stone left to lay because I had used up everything else. It gained its unique pose because I thought it was too fine a specimen to return to its former pedestrian level. I wonder if this stately slab likes its new unorthodox setting, after so many years in the service of practicality.

Page 57

OVAL PATIO

Location: Newfane, VT, Property K, 1992

Dimensions: 9 feet x 12 feet

Description: Built on a 1-foot-deep base of 1-inch crushed stone

Origin of stone: Quarry stone from one county north

Time to complete: 2 days

The constructions I make are abstract forms having their roots in geometry. Some of them have developed their own personality or borrowed one by association. I like to think of this form as a turtle slowly heading toward the wetland at the bottom of the field.

Pages 60–61

TERRACE STAIRWAY

Location: West Dummerston, VT, Property A, 1987

Dimensions: 12 feet x 6 feet

Description: Freestanding wall and four steps

Origin of stone: Block-field stone from two towns north

Time to complete: 7 days

A freestanding, free-form wall anchors a staircase between upper and lower garden terraces. Visual tension is heightened by the acute angle of wall and stairs to terrace walls.

Sometimes the object with the lowest utility rating is granted the highest volume. If the wall's only function is to be a kind of railing for the steps, then it is clearly over-designed. If it is viewed as a gentle giant ready to offer a hand to anyone using the steps, then its presence is clearly essential.

I walled through a snowstorm to complete this work.

Pages 16–17, 62, 63

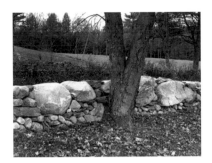

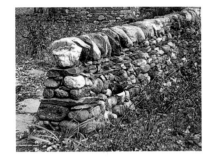

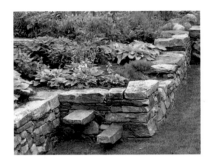

FREESTANDING BOULDER-TOPPED WALL

Location: Brattleboro, VT, 1993

Dimensions: 150 feet

Description: Built on soil

Origin of stone: Replaced fieldstone in its original wall line

Time to complete: 6 days

Walls that amble through the countryside, the line of their top stones rising and falling with the lay of the land, match the rhythm of the topography and harmonize with their surroundings.

I was skeptical that there was much I could do to rebuild this roadside wall. All that was visible when I first looked at the site was a long stretch of jumbled small stones running parallel to the town road. When I began clearing off the site, I discovered a string of boulders that had once been the base stones of a wall topped by the small ones. This arrangement probably worked well when the roads were rolled in the snowy months for sleigh travel, but it couldn't stand up to the pressure of snow being thrown at it when roads began to be plowed—and the top half was knocked apart. My solution was to reverse their order, small stone on the bottom and boulders on top. The hardest part was placing the heavy boulders on top without disrupting the lower courses of small stone. The wall hasn't been worried by plowed snow since.

Page 65

POTTING SHED WALL

Location: West Dummerston, VT, Property A, 1997

Dimensions: 16 feet x 4 feet

Description: Built on a 1-foot-deep base of 1-inch crushed stone

Origin of stone: Fieldstone from the property

Time to complete: 4 days

Very often it is the availability of stone that determines the design of a wall. Early in the spring my stone-gathering options are limited by soft wet ground in many parts of the countryside. This project was offered up at a time when the pickings were slim. My best option was a small pile of castoffs that languished over the edge of a bank on the property. It was a collection of small round stones that had frustrated some gardener's cultivation efforts many years ago. Their sizes and shapes suggested that a narrow-profiled wall could be built with them and that there were enough larger lumps to outfit the top with vertical copes. I like the idea that one gardener's nuisance castaways have now become another gardener's pleasure, in the form of a potting shed wall.

Depending on the time of the year, stone walls stand out or recede into the background of the garden.

Page 66

PLANTER

Location: West Dummerston, VT, Property A, 1998

Dimensions: 40 feet x 20 feet x 3 feet

Description: Built on subsoil

Origin of stone: Imported block-field stone and pit tailings from two towns north

Time to complete: 13 days

Weeding a perennial garden is made a little easier by elevating the beds in an oversized planter like this one. The wall top is at a comfortable sitting height, whether the gardener is weeding or pausing to take a well-deserved rest.

Pages 66, 68–69

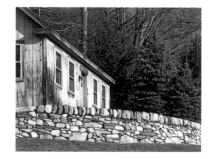

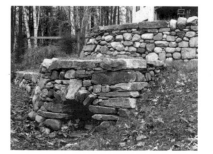

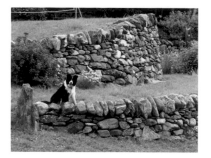

SMOOTH CURVED RETAINING WALL

Location: Guilford, VT, 1990

Dimensions: 50 feet x 3 feet

Description: Built on subsoil

Origin of stone: Imported stone from a field clearing four towns north

Time to complete: 9 days

When the ground in front of a wall is reasonably flat, I square the loader up with the face I'm building. It's a simple process to stand in front of the line of the wall and set stone along its length. When the grade in front of the wall falls away steeply, as it did on this construction, a different approach is required. A shelf was cut across the slope with the bucket of the loader. Each scoop of soil was backed out and dumped in a stockpile, away from the excavation. The shelf became the platform on which the wall would be built as well as the temporary roadway used to bring stone to where I was working. The construction began at the far end of the shelf, with one short section built to its full height before the next was started. Stone was continually laid against the open side of the wall until I had backed the construction out of the excavation.

Page 78 (bottom right)

TERRACE RETAINING WALLS

Location: Marlboro, VT, Property S, 1997

Dimensions: 30 feet x 4 feet

Description: Built on a 2-foot-deep base of 1-inch crushed stone

Origin of stone: Block-field stone from two towns north and gravel-pit tailings from one town east

Time to complete: 6 days

Negative spaces move the viewer into an awareness of the interior of a construction. Walls are more than just surfaces. A hollow in a retaining wall that exposes some of its inner workings, can stir questions in the viewer's mind about where the built world ends and the natural world begins.

　　Rounded stone has a playful look to it. Perhaps because it can roll, it lends a spirit of movement to a wall. Including round stones in a construction can lighten the sense of formality that is present in a construction of all angular stone.

Pages 80–81

FIELDSTONE RETAINING WALLS

Location: Marlboro, VT, 1996

Dimensions: 40 feet x 3 feet and 40 feet x 5 feet

Description: Built on a 3-foot-deep base of boulders and pit tailings

Origin of stone: Local field clearance stone

Time to complete: 10 days

The stone that was used to build these walls was collected the old-fashioned way. Every one was handpicked from the surface of a cultivated field. For years, a sheep farmer friend of mine made improvements to his field by picking stone. He trucked it all home and dumped it in the front yard. When he thought he had enough, he called me over to build these terrace walls. I'm usually the person who becomes most familiar with the stone in the walls I build. On this project, I have to say it's the farmer who holds that distinction.

Pages 82–83

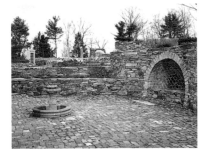

GARDEN EDGING

Location: Walpole, NH, Property B, 1990
Dimensions: 6 feet x 1 foot
Description: Vertical edging and rockery
Origin of stone: Imported block-field stone
Time to complete: 1 day

Some people would look at this photograph and see a richness of plant texture and spatial volume. I look at it and all I can see is the rough stonework that underpins the row of vertical stones. My intention was to have gravel backfill placed to a height halfway up the edgewise pieces. The roadway level was never increased after the edging went in, and as a consequence the crude foundation remains visible. I know I would be much more accepting of its appearance if it had been done by someone else. Or if it had been designed as a folly, or, better yet, was a real example of antique stonework with its earth filling eroded away. Then I wouldn't think twice about the way it looks. Such is the burden of authorship.

Page 85

CEMENTED COBBLESTONE SHELL AND CURVED WALLS

Location: Walpole, NH, Property B, 1986
Dimensions: 8 feet x 6 feet
Description: Built on a ledge
Origin of stone: Block-field stone and recycled cobblestones
Time to complete: 25 days

The first time I saw this mountaintop site, it was a barren slope in the woods. All of the trees had been cut, the stumps dug up, and the soil stripped clean, exposing a half acre of wrinkled rock ledge, its surface polished to a shine by glacial wear. Before I started the work that would eventually become this terraced garden, the site was surveyed, and from the elevations I prepared a scale model. On a molded plaster base that represented the existing ledge surface, I modeled miniature walls in clay to illustrate the proposed design. From the model I translated the wall lines onto the broad rocky face and began to build.

Page 86

CURVED STEPS

Location: Walpole, NH, Property B, 1985
Dimension: 8 feet wide
Description: Built on a ledge
Origin of stone: Imported block-field stone from three towns west
Time to complete: 6 days

Situated along the path leading to the entrance to a home, these steps have seen daily use for many years. The test of a drystone step is that it is still sturdy underfoot after long and hard service. In this construction, much of the length of each step stone is buried under the weight of the stair above it.

It's fitting that the first piece I created in the collection of mountaintop wall works would be wheel-shaped. All the work since then seems to have spun off from it. This remains a favorite place.

Pages 88–89

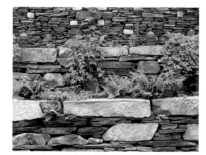

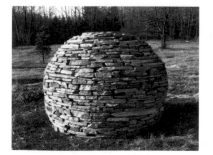

STAGGERED RETAINING AND FREESTANDING FOUNDATION FOLLY

Location: Walpole, NH, Property B, 1990
Dimensions: 24 feet x 11 feet
Description: Built on a ledge
Origin of stone: Quarry stone recycled cobblestones, and sill stones
Time to complete: 12 days

The inspiration for this shelved construction was an antique copper brewing vessel (not shown). For the unusual garden ornament to look and feel at home, the ruin of a brewery had to be simulated. The garden itself is on the opposite side of the wall. The wall was really needed only to elevate the garden area, but it took on a life of its own with the addition of the planter shelves. What might have been nothing more than a large flat surface was transformed into a hanging garden space.

Page 93

SPHERE WITH A HOLLOW CORE

Location: Newfane, VT, Property K, 1983
Dimension: 6 feet in diameter
Description: Built directly on existing soil
Origin of stone: Imported block-field stone from one town north
Time to complete: 1½ days

The finer the material the more it is able to conform to a precise plan. Thin pieces of stone are most easily trimmed, and that's important for making them fit into a tight circle. Each piece, to fit snugly next to its neighbor, has to have a slightly "slice of pie" shape to it. When it was necessary, the inside edges of the stone in this sphere were chipped with a light hammer before being set.

Page 94

BARNYARD WALL RECONSTRUCTION

Location: Newfane, VT, Property K, 1992
Dimensions: 50 feet x 3 feet
Description: Built on subsoil
Origin of stone: Existing stone and wall line
Time to complete: 4 days

Some walls stand their ground and others fall away. Old walls have a lot to teach us about building new walls that last, but there is a limit to the amount of examination one can give an old wall that remains intact. Aboveground exterior surfaces are all that show and can tell only part of the story of their longevity. The interior and below-grade sections conceal much more information.

It is left to the walls that have broken down to inform us by way of their failures. With excavation, below-grade stones may be found slipped from their original placement, causing the stones above to tip in on themselves or spill off the wall onto the ground. A broken-down wall with its heart exposed to view may reveal interior hollows, inadequately filled spaces in the original construction.

Page 96

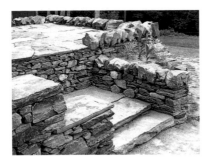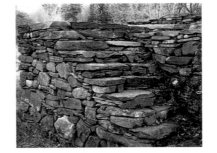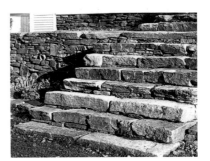

WALL, PATIO, AND STEPS

Location: Vernon, VT, 1986

Dimensions: 50 feet x 5 feet

Description: Built on subsoil

Origin of stone: Fieldstone gathered from the site and quarried flat stone from forty miles south

Time to complete: 14 days

A lot of walling techniques and design ideas were combined in a small area on this project. Shelves for potted plants line the staircase, a triangular planter is on the right, and an edging of cope stones completes the patio. The owner's needs and wishes were blended with my ideas and skills to come up with this satisfying plan.

Page 99 (top left)

TERRACE RETAINING WALL NOTCHED BY STEPS

Location: Marlboro, VT, 1984

Dimensions: 20 feet x 7 feet angled staircase and wall

Description: Built on subsoil

Origin of stone: Fieldstone gathered from derelict walls on the property

Time to complete: 7 days

Terrace walls do increase the area of flat ground around a home, but they can also be a hazard to health. While I was building this high terrace wall, I often had the company of a rambunctious five-year-old boy who was fascinated by what I was doing and wanted to help. Whenever his mother lost sight of him in the area he was supposed to play in, she knew where to find him. She had to haul him away from the construction site many times during the day for his own safety. Soon after I left the completed work, I got word that the inevitable had indeed happened. Playing around the top edge of the wall, the boy had slipped and broken his arm.

Page 99 (top center)

STAIRCASE AND WALLS

Location: Newfane, VT, 1999

Dimension: 8 feet wide

Description: Built on a 2-foot-deep base of 1½-inch crushed stone

Origin of stone: Imported block-field stone from one town north

Time to complete: 10 days

When a large number of thick slabs are combined to create a staircase, I plan their placement in advance. I measure what I have in the stockpile and assign each piece a place in the plan by marking it with a grease crayon.

All of the square edges on the stones were natural shapes; I didn't cut or break any of them. I feel that the earth's offering of loose stone is a blessing and I thank her for it every day.

Page 99 (top right)

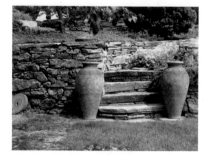 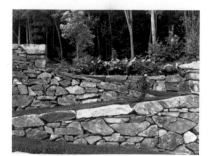

DETAIL RETAINING WALLS AND STAIRWAY WITH URN

Location: Walpole, NH, Property B, 1987

Dimensions: 20 feet x 4 feet

Description: Built on a ledge and 1½-inch crushed stone

Origin of stone: Imported block-field stone

Time to complete: 10 days

At the most rudimentary level, a wall is a barrier. As helpful as a retaining wall can be in the creation of a terrace, it ultimately bars foot passage across the area it crosses. Stairways break open the barrier to passage and invite movement.

Page 99 (bottom)

RAMP PATH AND RETAINING WALLS

Location: West Dummerston, VT, Property A, 1988

Dimensions: 65 feet x 8 feet

Description: Built on a 2-foot-deep base of 1½-inch crushed stone

Origin of stone: Imported block-field stone from two towns north

Time to complete: 16 days

The grassy footpath that switches back and forth through this expansion of walls served as staging ramps during the construction. I piloted each loader bucket full of stone up the ramps as I completed them. A system of walls must also be a system to work in. Designs that develop out of a working process speed the construction along. The completed structures often leave no clues as to how they were built.

Page 101